PARVA Convivia

Ivan Foletti — Adrien Palladino eds

Inventing Medieval Czecho~slovakia 1918—1968

Between Slavs, Germans, and Totalitarian Regimes

Masaryk University Press, Brno — Viella, Rome → 2019

PARVA Convivia series 6

This book was carried out as a part of the project "The Heritage of Nikodim Pavlovič Kondakov in the Experiences of André Grabar and the Seminarium Kondakovianum" (Czech Science Foundation, Reg. Nº 18–20666S).

EDITORS → Ivan Foletti, Adrien Palladino
EDITORIAL BOARD → Ivan Foletti (dir.), Petra Hečková, Ondřej Jakubec, Jan Klípa
EXECUTIVE EDITORS → Klára Doležalová, Sarah Melker, Adrien Palladino
TYPESETTING & GRAPHIC DESIGN → Petr M. Vronský
PUBLISHER → Masaryk University Press, Žerotínovo nám. 9, 60177 Brno & Viella editrice, via delle Alpi 32, 00198 Rome
EDITORIAL OFFICE → Seminář dějin umění, Filozofická fakulta Masarykovy univerzity, Arna Nováka 1, 60200 Brno

PUBLISHED → 1st edition, 2019
ISBN 978-88-3313-310-2 (Viella)
ISBN 978-80-210-9478-9 (Masaryk University Press)

MUNI ARTS — Seminář dějin umění, Centrum raně středověkých studií VIELLA

TABLE OF CONTENTS

→

MEDIEVAL ART AND CZECHOSLOVAKIA
Between Nationalist Discourse and Transcultural Reality, an Introduction

IVAN FOLETTI — ADRIEN PALLADINO

The field of research that deals with the history of art history has become more and more popular in the last decades. After seminal studies by Wilhelm Waetzoldt and Lionello Venturi but also crucial reflections by members of the Vienna School such as Otto Benesch or Julius von Schlosser in the 1920s and 1930s, a synthesis was first formulated by Udo Kultermann in 1966.[1] However, it is since the 1990s that this field has

1 Wilhelm Waetzoldt, *Deutsche Kunsthistoriker*, 2 vols, Leipzig 1921—1924; Lionello Venturi, *History of Art Criticism*, New York 1936; Otto Benesch, "Die Wiener kunsthistorische Schule", *Österreichische Rundschau*, 62 (1920), pp. 174—178; Julius von Schlosser, "Die Wiener Schule der Kunstgeschichte: Rückblick auf ein Säkulum deutscher Gelehrtenarbeit in Österreich", *Mitteilungen des Österreichischen Instituts für Geschichtsforschung, Ergänzungsband* 13/2 (1934), pp. 145—228; Udo Kultermann, *Geschichte der Kunstgeschichte. Der Weg einer Wissenschaft*, Düsseldorf 1966 [rev. ed. 1995].

become a real "trend". It is impossible to mention here all the important achievements, but it is worth recalling just some fundamental French, German, Anglo-Saxon, and Italian partly "nation-centric" research.[2] For the Czech milieu, we should note both the outstanding synthesis by Jiří Kroupa, as well as a small booklet focused on Czechoslovakian art history by Milena Bartlová, who is presently working on a project dedicated to expand on precisely this topic.[3] For Central Europe, some important collective contributions which adopt transnational approaches must also be mentioned.[4] Furthermore, the moments of deep struggles for the field, such as totalitarian regimes or forced emigration, have been increasingly investigated by scholars studying the history of art history in the last ten years.[5]

If one would wish to sum up the result of this almost one-hundred-year-long historiographical reflection, a particular aspect emerges with force: art history is determined by the political and social context. What appears important to underline, however, is its triple engagement with society. Firstly, some art historians, through their works and writings, were officially supporting political ideas.[6] Therefore, we can find traces of Nazi, Communist or other nationalistic ideologies directly within their art historical writing.[7] Secondly, a large group of scholars were trying not to be involved or compromised by given political situations. Paradoxically,

2 Cf. amongst others Michael Podro, *The Critical Historians of Art*, New Haven 1982; Germain Bazin, *Histoire de l'histoire de l'art de Vasari à nos jours*, Paris 1986; *Histoire de l'histoire de l'art*. Tome I: *De l'Antiquité au XVIIIe siècle*, Édouard Pommier ed., Paris 1995; *Histoire de l'histoire de l'art*. Tome II: *XVIIIe et XIXe siècles*, Idem ed., Paris 1997; *Histoire de l'histoire de l'art en France au XIXe siècle*, Roland Recht, Philippe Sénéchal, Claire Barbillon, François-René

Martin eds, Paris 2008; *Adolfo Venturi e la Storia dell'arte oggi*, Mario D'Onofrio ed., Modena 2008; Michela Passini, *La fabrique de l'art national: le nationalisme et les origines de l'histoire de l'art en France et Allemagne*, Paris 2012; *Eadem, L'œil et l'archive. Une histoire de l'histoire de l'art*, Paris 2017.

3 Jiří Kroupa, *Metodologie dějin umění* [Methodology of Art History], vol. 1. *Školy dějin umění* [Schools of Art History], Brno 2007, vol. 2. *Metody dějin umění* [Methodology of Art History], Brno 2010; Milena Bartlová, *Unsere "nationale" Kunst*, Ostfildern 2016 [2009]. Cf. also *Eadem*, "Continuity and discontinuity in the Czech legacy of the Vienna School of art history", *Journal of Art Historiography*, 8 (2013); *Eadem*, "Marxism in Czech Art History 1945–1970", *Kunsttexte.de*, 4 (2015), pp. 1–5; *Eadem*, "Jaroslav Pešina 1938–1977: čtyři desetiletí politických strategií českého historika umění" [Jaroslav Pešina 1938–1977: four decades of political strategies of a Czech art historian], *Opuscula historiae artium*, 66/1 (2017), pp. 74–85; *Eadem*, "'Není možno se vzdát svobody myšlení': Vincenc Kramář a marxismus 1945–1960" ['It is not possible to give up freedom of thought': Vincent Kramář and Marxism 1945–1960], *Umění*, 66/4 (2018), pp. 246–263.

4 Cf. *Die Kunsthistoriographien in Ostmitteleuropa und der nationale Diskurs*, Robert Born, Alena Janatková, Adam Labuda eds, Berlin 2004; *Art History and Visual Studies in Europe: Transnational Discourses and National Frameworks*, Matthew Rampley ed., Leiden 2012; *History of Art History in Central, Eastern and South-Eastern Europe*, 2 vols, Jerzy Malinowski ed., Toruń 2012.

5 See, e.g., Ulrike Wendland, *Biographisches Handbuch deutschsprachiger Kunsthistoriker im Exil*, 2 vols, Munich 1999; *Kunstgeschichte im Nationalsozialismus: Beiträge zur Geschichte einer Wissenschaft zwischen 1930 und 1950*, Nikola Doll, Christian Fuhrmeister, Michael H. Sprenger eds, Weimar 2005; *Kunstgeschichte in den besetzten Gebieten 1939–1945*, Magdalena Bushart, Agnieszka Gąsior, Alena Janatková eds, Cologne/Weimar/Vienna 2016.

6 In Czechoslovakia this is the case of Jaromir Neumann; about his figure and methodology see Milena Bartlová, "Punkva. Kde je marxismus v českých dějinách umění?" [Punkva. Where is Marxism in Czech art history?], *Sešit pro umění, teorii a příbuzné zóny* [Workbook for art, theory, and related zones], 14 (2013), pp. 6–16.

7 On the Nazi propaganda in art history see for example: Éric Michaud, *Un art de l'éternité. L'image et le temps du national-socialisme*, Paris 1996. In general, on art and totalitarian regimes, see *Medieval Art History in Prison*, Xavier Barral i Altet, Ivan Foletti eds, Brno 2017 (= *Convivium* IV/1 [2017]).

13

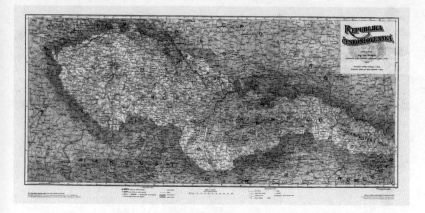

|01| ↑ Map of Interwar Czechoslovakia, 1933

however, this desire for neutrality is itself an intellectual decision, which can have a more or less important impact on research as such. Lastly, a group of scholars find within scholarship what may be termed a *hortus conclusus* — a place of a real "inner emigration".[8] This last group was trying not to get compromised in any sense by the diverse regimes, which often has as a consequence an almost complete absence of publications.

The present booklet — which given its size has no ambition of exhaustivity — would like to focus on the history of art in Czechoslovakia more or less from the end of the First World War until the 1960s, with a specific point of view. This point of view is imposed, we believe, by the exceptional situation of Czechoslovakia in this period. In one country, and often in one single city, there lived scholars and intellectuals writing in Czech, German, and Russian. Moreover, these three linguistic categories had a sense of belonging to three different "national" groups. This often created (in the case of authors writing in Czech and German) a dual narration constructed around the same monuments and same problems.[9] This dual discourse can serve as a clear filter of the impact

14

of the "national question".[10] As is well known, the tension between the diverse ethnic groups, sometimes also internal, was one of the main problems in Czechoslovakia between the two wars.[11] The problem is of course not limited to Czech Republic but shared by regions where

8 On this notion, see Hans Manfred Bock, "Tentation totalitaire, 'émigration intérieure' et exil des intellectuels sous le IIIe Reich", in *Pour une histoire comparée des intellectuels*, Michel Trebitsch, Marie-Christine Granjon eds, Brussels 1998, pp. 96–110; more recently, see also Josefine Preißler, "Der Topos 'Innere Emigration' in der Kunstgeschichte. Zur neuen Auseinandersetzung mit Künstlerbiografien", in *Vermacht, verfallen, verdrängt — Kunst und Nationalsozialismus: die Sammlung der Städtischen Galerie Rosenheim in der Zeit des Nationalsozialismus und in den Nachkriegsjahren*, Christian Fuhrmeister, Monika Hauser-Mair, Felix Steffan eds, Petersberg 2017, pp. 47–54.

9 On the formation of national ideologies in art history, cf. *The Art Historian: National Traditions and Institutional Practices*, Michael F. Zimmermann ed., Yale 2003; mostly in the German context, cf. Keith Moxey, *The practice of persuasion: paradox and power in art history*, Ithaca, NY 2001; cf. also Hans Belting, *Identität im Zweifel: Ansichten der deutschen Kunst*, Cologne 1999.

10 Mark Cornwall, "A Fluctuating Barometer: British Diplomatic Views of the Czech-German Relationship in Czechoslovakia, 1918–1938", in *Großbritannien, die USA und die böhmischen Länder 1848–1938*, Eva Schmidt-Hartmann, Stanley Winters eds, Munich 1991, pp. 322–326; Chad Bryant, "Either German or Czech: Fixing Nationality in Bohemia and Moravia, 1939–1946", *Slavic Review*, 61/4 (2002), pp. 683–706; Michael Walsh Campbell, *A Crisis of Democracy: Czechoslovakia and the Rise of Sudeten German Nationalism, 1918–1938*, PhD dissertation, University of Washington, 2003; *Czechoslovakia in a Nationalist and Fascist Europe, 1918–1948*, Mark Cornwall, R. J. W. Evans eds, Oxford 2007.

11 For a case study on the topic, cf., e.g., Milena Bartlová, "Je Znojemský oltář rakouský, německý, český nebo moravský?" [Is the altar of Znojmo Austrian, German, Czech, or Moravian?], *Bulletin Moravské galerie v Brně*, (2003), pp. 140–147; cf. also *Eadem*, "Německé dějiny umění středověku v Čechách do roku 1945" [German Art History in the Middle Ages in Bohemia until 1945], in *Německá medievistika v českých zemích do roku 1945* [German Medieval Studies in Czech Lands until 1945], Pavel Soukup, František Šmahel eds, Prague 2004, pp. 67–78.

German ethnicity had a strong cultural impact, like, for example Silesia.[12] For Czech Republic, the "German problem" would be "solved" after the Second World War with the expulsion of the German-speaking Czechoslovakian citizens.[13] Nevertheless, this dialogue persisted — at least intellectually — in later decades as well.

We should add to this dialogue a very exceptional situation, which occurred in Prague during the interwar period as well as the first years after WWII. In Prague, as a consequence of the "Russian Action" of support to Russian intellectual émigrés, an intellectual community of Russian art historians was born.[14] This community, gathered in the *Seminarium Kondakovianum*, later the Kondakov Archaeological Institute, became one of the major international research institutes in art history (and not only) in Czechoslovakia.[15] While belonging to Russian culture, and considering themselves a foreign institution, they were part of this transnational space of interwar Czechoslovakia. This institution was deeply supported by Czechoslovakian authorities as well as by the Slavic Institute of Prague. Specialized in Byzantine studies, the *Institutum Kondakovianum* seems to have been particularly interesting for Czechoslovakia especially because of its potential for pan-Slavic interpretation.[16] In one single country, we can then see the superposition of three different historiographies in dialogue or in the omission of one or another.

At the end of the First Republic, after the Munich Agreement, these three diverse historiographies faced two consecutive waves of totalitarian violence. The first one, with the Protectorate of Bohemia and Moravia, the second after February 1948 with the Communist putsch.[17] During both of these moments, art history was a barometer of the tensions between ethnic groups but also between official power and scholarly freedom.

12 In Silesia, e.g., with the case of Veit Stoss: Stephan Muthesius, "Aspekte der polnisch-deutschen Auseinandersetzung um Veit Stoss", *Ars sine scientia nihil est. Księga ofiarowana Profesorowi Zygmuntowi Świechowskiemu* [Ars sine scientia nihil est. Festschrift given to Professor Zygmunt Świechowski], Joanna Olenderek ed., Warsaw 1997, pp. 166—170; another example would be the Slovak-Hungarian tension, cf. Milena Bartlová, Dušan Buran, "Slovenský mýtus: slovenské umění 20. století v Moravské galerii" [The Slovak Myth: Twentieth-Century Slovak Art in the Moravian Gallery], *Art & Antiques*, 4 (2007), pp. 10—18.

13 Among the large bibliography, cf., e.g., Eagle Glassheim, "National Mythologies and Ethnic Cleansing: The Expulsion of Czechoslovak Germans in 1945", *Central European History*, 33/4 (2000), pp. 463—486; Raymond M. Douglas, *Orderly and Humane. The Expulsion of the Germans after the Second World War*, Yale 2012; Matěj Spurný, "Migration and Cleansing: Building a New Society in the Czech Borderlands after 1945", in *Seeking Peace in the Wake of War: Europe, 1943—1947*, Stefan-Ludwig Hoffmann [et al.] eds, Amsterdam 2015, pp. 163—182.

14 Zdeněk Sládek, "Prag: Das 'russische Oxford'", in *Der grosse Exodus. Die russische Emigration und ihre Zentren 1917—1941*, Karl Schlögel ed., Munich 1994, pp. 218—233; Elena Chinyaeva, "Russian Émigrés: Czechoslovak Refugee Policy and the Development of the International Refugee Regime between the Two World Wars", *Journal of Refugee Studies*, 8/2 (1995), pp. 142—162.

15 Lawrence Hamilton Rhinelander, "Exiled Russian Scholars in Prague: The Kondakov Seminar and Institute", *Canadian Slavonic Papers*, 16/3 (1974), pp. 331—352; Zuzana Skálová, "Das Prager Seminarium Kondakovianum, später das Archäologische Kondakov-Institut und sein Archiv (1925—1952)", *Slavica Gandensia*, 18 (1991), pp. 21—49; Martin Beißwenger, *Das Seminarium Kondakovianum in Prag (1925—1952)*, M.A. Thesis, Humboldt-Universität, Berlin, 2005 [2001]; Francesco Lovino, "Constructing the Past through the Present: The Eurasian View of Byzantium in the Pages of *Seminarium Kondakovianum*", in *Trends and Turning Points. Constructing the Late Antique and Byzantine World*, Matthew Kinloch, Alex MacFarlane eds, Leiden/Boston 2019, pp. 14—28.

16 See the still crucial reflection of Hans Kohn, "The Impact of Pan-Slavism on Central Europe", *The Review of Politics*, 23/3 (1961), pp. 323—333.

17 See for example William Lee Blackwood, "Socialism, Czechoslovakism, and the Munich Complex, 1918—1948", *The International History Review*, 21/4 (1999), pp. 875—899.

17

This small booklet wishes to broach all these questions by exploring specific case studies. It is opened by an article by Ondřej Jakubec describing the reaction of Czech historiography towards the Germanic one into the question of the national Middle Ages and early modernity. This first research is fundamental in order to show the importance of art history in the construction of a Czechoslovakian national identity after 1918. The "Czech Renaissance" becomes, in Jakubec's eyes, a perfect example of this intellectual self-redefinition.

The following article, by Ivan Foletti, explores the Russian émigré institute, the Kondakov Institute. The author emphasizes the international character of this institution as well as its importance for the self-perception of Czechoslovakia in terms of geopolitical strategies. Moreover, the article deals broadly with the situation of the Institute during the Second World War, when the leaders of the institution were obliged to face daily problems with Nazi cultural policy. In this case, it is precisely that scholarly silence which allowed it to survive without "contamination". In spite of this, the Institute would disappear after 1948.

Jan Klípa concentrates on the very case of Silesia, with once more the emphasis on a double narrative. He gives particular attention to the German point of view, with its attempts to justify the pan-Germanic theories regarding the Germanization of Slavic inferior lands, seeking their validation through history. Concentrating mainly on the example of late medieval paintings, Klípa shows how the very question of "artistic style" can become a powerful tool for racism. It is the perfect example of situations in which art history seems to be serving totalitarian regimes or contributing to their rise.

The next article, co-written by Adrien Palladino and Sabina Rosenbergová, is constructed in a sort of dance

between Czech-speaking and German-speaking historiography about one unique artistic figure: Anton Pilgram. The essay not only investigates a dual discourse in one single country, but also its continuation in the decades after the creation of the Iron Curtain. In this sense, it becomes not only a reflection on Czechs and Germans together, but also about the isolation of scholars caused by the division of space into two distinct blocks. In this text, national questions are therefore developed in a totally new situation: scholarship almost without exchanges or interactions.

Focusing on the city of Brünn/Brno, the last contribution, authored by Jan Galeta, proposes a *longue durée* exploration of the construction of a history of a city which was German and Czech, and which ends up becoming exclusively Czech. Galeta's investigation points out not only the discursive dimension but also the concrete transformations of the cityscape, constructed by inventions or destruction of *lieux de mémoire*.

With this first publication, the Center for Early Medieval Studies of the Department of the History of Art of the Masaryk University wishes to pursue the historiographical reflection launched in 2018 with the publication of *From Nikodim Kondakov to Hans Belting Library*.[18] Carried out as part of the ongoing project "The Heritage of Nikodim Pavlovič Kondakov in the Experiences of André Grabar and the Seminarium Kondakovianum" (Czech Science Foundation, Reg. No 18—20666S), this volume also wishes to contribute to redefining Central Europe as

18 *From Kondakov to Hans Belting Library: Emigration and Byzantium — Bridges between Worlds / Od Kondakova ke knihovně Hanse Beltinga: emigrace a Byzanc — mosty mezi světy*, Ivan Foletti, Francesco Lovino, Veronica Tvrzníková eds, Brno/Rome 2018.

a place of transcultural encounters and dialogues. The period under investigation is the one of the major crises of this transcultural model, which would lead to its almost complete destruction. It is, however, extremely important for us to understand its roots and its significance.

As outlined above, the investigation of the history of art history clearly demonstrates the impact of the social and historical context on historical studies. It is therefore the moment to ask what is the context in which we are writing these lines, why it is so important today to understand the deep transformation of multi-ethnic Czechoslovakia, why it is so important to analyze the Russian Action and the extraordinary welcoming of Russian émigrés in the same country. The answer is not difficult: migration is today one of the main issues of the globalized world. Nationalistic and ethnic tensions have once more become burning issues, at least of European culture. We believe that the richness and openness of interwar Czechoslovakia can be seen as an impressive model of intellectual fertility. In spite of all the difficulties mentioned in this volume, meeting the other, at least for scholarship, means producing outstanding research. On the contrary, isolationism — cultural, linguistic, or political — has always led to negative outcomes.

It is with the hope that Czech Republic and Central Europe will maintain these spaces of dialogue with diversity that we wish to conclude this volume. Furthermore, we would like to express our gratitude to all the project participants, as well as to the Department of the History of Art for its constant support. Finally, our immense gratitude goes to the endless patience of Sarah Melker.

→

NATIONAL STEREOTYPES AND THE SLAVIC CHARACTER OF ART IN THE CZECH LANDS
The Middle Ages and the "Czech Renaissance" in Czech Historiography of the Nineteenth and Twentieth Centuries

ONDŘEJ JAKUBEC

> *The historian must accept that the patterns discerned in the past serve the cultural, ideological, and often nationalist needs of the present.*[1]

Keith Moxey's statement provides a point of departure for the following discussion of some of the ethnic-national stereotypes reflected in the nineteenth- and twentieth-century debates about the character of art in the Czech lands. From the Middle Ages on, Bohemian art was considered to have stemmed from a universal, and rather abstract, base which differentiated it from German art. These ideas underpinned evaluations of medieval art in particular, but they also gave rise to the concept of "Bohemian Renaissance" referring to sixteenth-century Bohemian art. This historiographical term emerged in the Czech milieu in the 1880s and, like many other schematic and simplifying interpretations of the past, it has only quite recently lost its attractiveness.

1 Keith Moxey, *The Practice of Persuasion: Paradox and Power in Art History*, Ithaca/London 2001, p. 41.

This text outlines the concept's origin, evolution and modifications between the end of the nineteenth century and the end of the twentieth century. Emphasis is placed on describing circumstances that helped maintain this historiographical construct, such as the specific cultural and conceptual environment shaping art historians' perspectives. Writing, or rather, constructing and interpreting (art) history naturally takes place within a discourse, with each new generation redefining its parameters all over again. To promote their own discourse, art historians use specific rhetorical strategies and methods of persuasion. Art historian Ján Bakoš described the situation as follows:

The history of art-historical knowledge maintains its character of relentless conflict between ideologies or denominations, in which our broadening knowledge only functions as a weapon in ideological combat.[2]

Upon closer observation, individual historiographical problems reveal the personal worldviews of art historians whose interpretation of art-historical phenomena are deeply rooted in cultural, national, and ideological stereotypes of their respective periods.[3]

Despite its popularity among researchers in the nineteenth and twentieth centuries, the concept has been largely abandoned in contemporary Renaissance studies. But the "Bohemian Renaissance" had a strong presence in Czech art history for more than a hundred years. In his article on Renaissance revival architecture, art historian Jindřich Vybíral defines the ideological frame of the concept's origin: "To speak about politics, architecture or any other form of spiritual life in nineteenth-century Czech society means above all to deal with nationalism".[4] The idea of a Bohemian Renaissance as a specific stylistic

category first appeared in the third quarter of the nineteenth century in parallel with the rise of its other national variations, particularly the German Renaissance (but also the so-called *Sondergotik*), the roots of which, however, reach somewhat deeper in time.[5] In the Czech-German social and cultural milieu, any such accent on the nationally specific culture led to competitiveness and confrontation.

The first attempts to define the nationally specific, Bohemian Renaissance emerged from an interest in renovating some of the local Renaissance monuments. In 1830, Josef Kranner, a prominent Prague architect, recommended that architects look for inspiration in one of the most interesting examples of early Renaissance, the Royal Summer Palace (Belvedere) at the Prague Castle dating to the 1530—1550s. In 1866, the prominent Renaissance-revival architect, Josef Schulz, presented

2 "*Dejiny umeleckohistorického poznania si naďalej zachovávajú charakter neúprosného sváru doktrín či konfesionálnych sporov, v ktorom narastajúce poznanie funguje iba ako zbraň v ideologickom zápase*", Ján Bakoš, *Štyri trasy metodológie dejín umenia* [Four paths of the methodology of art history], Bratislava 2000, p. 14.

3 Moxey, *The Practice* (n. 1), pp. 8—9; Vernon H. Minor, *Art History's History*, Englewood Cliffs 1994, pp. 161—182.

4 "*Hovořit o politice, architektuře nebo jiné formě duchovního života české společnosti 19. století znamená především zabývat se nacionalismem*", Jindřich Vybíral, "Počátky české národní architektury" [The beginnings of Czech national architecture], *Ars*, XXX/1—3 (1997), pp. 167—173.

5 Thomas DaCosta Kaufmann, "What is German about the German Renaissance?", in *Artistic Innovations and Cultural Zones*, Ingrid Ciulisová ed., Bratislava/Frankfurt am Main 2014, pp. 257—283. The author sees the art of "German Renaissance" from the contemporary perspective of "global/world art history" as a cosmopolitan and culturally diversified phenomenon excluding any national implications, *Ibidem*, esp. pp. 276—277. For more about this feature of the trans-Alpine art, see Peter Burke, *Hybrid Renaissance: Culture, Language Architecture*, Budapest/New York 2016, pp. 23—25.

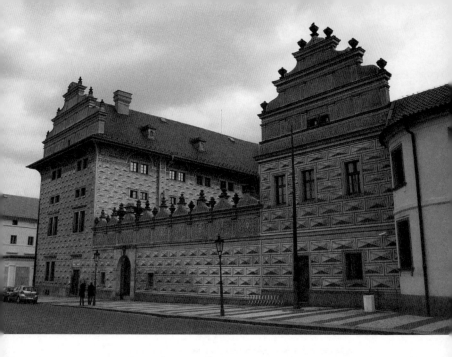

|01| ↑ Schwarzenberg Palace (former Lobkowicz), Prague, 1540—1560

|02| → Antonín Wiehl, portrait photo, c. 1890s

the summer palace in several lectures in the forum of the art association *Umělecká beseda* (Art Club). In the 1870—1880s, Schulz helped renovate several buildings which would later play a key role in defining the Bohemian Renaissance (esp. Schwarzenberg Palace at the Prague Castle and Horšovský Týn Chateau) |01|. Beginning in the 1860s, art experts and cultural historians praised contemporary historicist architects, such as Josef Zítek, František Schmoranz and Ignác Ullman for using some of the characteristic motifs of local Renaissance architecture in their projects.[6] It is therefore not surprising that the "Czech" version of the Renaissance revival was first defined by Prague architects, namely Antonín Wiehl (1846—1910) whose apartment buildings on Poštovní Street and K. Světlé Street (built in 1876—1879) became the first representations of this idiosyncratic local style |02|.[7] Wiehl's buildings from the 1870—1890s have

several characteristic features — flat facades without significant plastic elements and decorated with sgraffito (often depicting motifs from national mythology), gables or attics and lunette cornices — which Wiehl and his followers took over from a relatively small group of Bohemian structures dating to around the mid-sixteenth century. Aside from the above-mentioned Horšovský Týn Chateau and the Schwarzenberg Palace at the Prague Castle, these buildings also included the Pilsen city hall. The choice of models was not incidental: all these buildings were built by architects from the Ticino region in the borderland between today's Switzerland and Italy. Their aesthetic diverged from the classical Renaissance of Tuscany and Rome and their diverse, largely decorative forms, picturesqueness and "playfulness" was closer to the distinctive tradition of Lombardy or Northern Italy in general. This style suited the nationalist Czech Neo-Renaissance architects who had a hard time accepting the "transnational" style of Italian (international) Renaissance revival architecture

6 Martin Horáček, "Bernhard Grueber a jeho příspěvek k počátkům novorenesance v Čechách" [Bernhard Grueber and his contribution to the beginnings of Neo-Renaissance in Bohemia], Umění, LI (2003), pp. 37—38; Zdeněk Wirth, Antonín Wiehl a česká renesance [Antonín Wiehl and the Czech Renaissance], Prague 1921, pp. 1—3; Mojmír Horyna, "Architektura přísného a pozdního historismu" [Architecture of strict and late historicism], in Dějiny českého výtvarného umění, III/2, Taťána Petrasová, Helena Lorenzová eds, Prague 2001, pp. 178—185.
7 For the most recent study, see Antonín Wiehl, Irena Bukačová ed., Plasy 2010.

because of its official "state" character — ever since the construction of the Viennese *Ringstrasse*, this was the officially recommended architectural style in Austro-Hungarian monarchy.[8] For this reason, Wiehl focused on creating a Czech variation of modern Neo-Renaissance which would keep all its aspects expressing the views of the liberal and emancipated middle class. At the beginning of the 1880s, Wiehl's buildings became the foundation for the theoretical reflection of "Czech Renaissance revival" by aesthetician and art historian Miroslav Tyrš (1832—1884) who formulated the style's conceptual principles and program |03|.[9]

Inspired by Hippolyte Taine, Tyrš based his theory on the idea that the essence of all art is connected to its specific, national character. In his art-historical conception, there are characteristic "signs pertaining to any developed and independent art which differentiate it [contemporary Czech art] from that of other nations and periods" because art "also stems from the climate and soil of the country the nation inhabits".[10] In 1882, Tyrš published his key article entitled "*Ve prospěch renaissance české*" [In Defense of the Bohemian Renaissance] in which he defined the style's characteristic features. Quite understandably, he omitted the classical-Renaissance, Habsburg-commissioned Royal Summer Palace (Belvedere) in Prague which did not fit in his conception. Instead, Tyrš turns his attention to a strictly defined group of buildings: the Schwarzenberg (former Lobkowicz) Palace at the Prague Castle, the Nelahozeves Chateau and burgher houses in South Bohemia. The style's main features as defined in Tyrš's article would then become the foundation for further interpretations. They include above all the "silhouette of tall gables" ("*silhouetta vysokých štítů*"), a motif that is, according to Tyrš, rooted in the local Gothic tradition, and the lavish sgraffito decoration on

the flat facades, which featured ornamental depictions of local vegetation (apple and pear blossoms, sunflowers, etc.). Tyrš believed that there was enough of the "precious vestiges" (*"pozůstatků vzácných"*) to support the claim that there indeed was a local, "Bohemian" Renaissance with "its own distinctive character" (*"svůj vyslovený ráz"*). He points out that "if the French and Germans cultivate their respective Renaissances, we should not forget about our Czech Renaissance".[11] Further on, he urges architects to follow Wiehl and build apartment buildings and even whole new blocks and avenues in this Czech (Neo-) Renaissance style. For Tyrš, the style was particularly topical because it implied individuality and citizenship, qualities that the nineteenth-century Neo-Renaissance theorists connected with what they thought were ethical values of Renaissance Italy.

In this period, the Czech patriotic circles saw the sixteenth century as the "golden age" of Czech history. It

8 Jindřich Vybíral, "'Česká' versus 'italská' neorenesanční vila: Antonín Wiehl, Anton Barvitius a jejich mecenáši" [Czech versus Italian Neo-Renaissance villa: Antonin Wiehl, Anton Barvitius and their patrons], *Zprávy památkové péče*, LXXIV (2014), pp. 83–90, esp. p. 84.

9 For the most recent study about Tyrš, see Robert Sak, *Miroslav Tyrš: Sokol, myslitel, výtvarný kritik* [Miroslav Tyrš: Sokol, thinker, art critic], Prague 2012.

10 Tyrš pointed out (in Czech) *"odznaky, jimiž ono jako každé vyvinuté a samostatné umění od umění jiných národů a dob se odliší*, [nebot] *má kořeny svoje především též v povaze podnebí a země, již národ obývá"*, Miroslav Tyrš, *O umění V: Úvahy a posudky o výtvarných pracích z výstav a porot z let 1880–1881* [About art V: Reflections and reviews on art works from exhibitions and juries from 1880–1881], Prague 1936, p. 193.

11 "[...] *pěstují-li Francouzové a rovněž Němci renaissanci svou, nezapomínejme my na renaissanci* českou", Miroslav Tyrš, "Ve prospěch renaissance české" [In defense of the Bohemian Renaissance], in *Dra Miroslava Tyrše: Úvahy a pojednání o umění výtvarném II* [By Dr. Miroslav Tyrš: Reflections and treatises on art II], Renata Tyršová ed., Prague 1912, pp. 227–231.

|03| ↗ Miroslav Tyrš, photo c. 1880

was generally believed that the Renaissance society was liberal and even democratic, and that Czech language held an important position in both politics and culture. According to this rather idealist notion, the glorious era culminated during the reign of Emperor Rudolf II whose court art, however cosmopolitan, was (and generally still is) perceived as evidence of "Czech" cultural sophistication. As the sixteenth century did not see major political disturbances, such as the medieval Hussite wars or the Baroque re-catholization process, it was, in the public mind, unproblematic and peaceful period, defined by an autonomous Czech culture to boot.[12] This perception found its way to literature, theatre and

later also film as evident from the popular *The Guild of Kutná Hora Virgins* from 1938 (director Otakar Vávra). Situated against the picturesque backdrop of medieval Kutná Hora, the film was a clear reflection of patriotic and anti-German sentiments in the interwar period (it was prohibited under the Protectorate of Bohemia and Moravia after 1939). In a similar vein, Tyrš's study of 1882 defined the Bohemian Renaissance style as "picturesque and, however aesthetically impressive, quite unassuming kind of Renaissance" characterized by a certain "Slavic character" and "humour".[13] His principles of "joyfulness" and "picturesqueness" fully correspond with the context of the romantic and somewhat distorted interpretation of this period of Czech history.

Tyrš's 1882 text on Bohemian Renaissance was soon followed by further studies. One year later, Czech architect and Wiehl's collaborator Jan Koula (1855–1919) elaborated on the theme in his own contribution on the subject, written during the renovation of the Schwarzenberg palace and published in the architects' periodical *Zprávy Spolku architektů a inženýrů v Království českém* [Newsletter of the Association of Architects and Engineers in the Kingdom of Bohemia]. His goal was to define the style with more precision and find more examples to support such a definition. He voiced the need to determine "exactly what constitutes the buildings' character" ("*přesně, v čem ráz staveb podobných záleží*") because, according to him, it is obvious that the Renaissance style "underwent great change under the influence of Czech

12 Zdeněk V. David, "Národní obrození jako převtělení Zlatého věku" [National Revival as the incarnation of the Golden Age], *Český časopis historický*, IC (2001), pp. 486–518.

13 "[...] *malebný a při vší působivosti umělecké předce nikoliv nákladný druh renaissance*" Tyrš, "Ve prospěch renaissance české" (n. 11), pp. 229–230.

spirit and climate, gaining an utterly special character".[14]
Expressions of this special character included architectural motifs of richly articulated gables, lunette cornices and sgraffito facades. Koula also added new items to the group of typically "Bohemian" structures (chateaus in Jindřichův Hradec, Pardubice, Opočno, Český Krumlov and others) |04|.[15] He continued to emphasize Wiehl's role in defining the Bohemian Renaissance:

Wiehl struggles for new architectural expression based on examples typical of Prague and Bohemia in the

sixteenth and seventeenth centuries, having first point-
ed to them in his "sgraffito house" on Poštovská Street.
He then began collecting the monuments of our Renais-
sance, studying them and, where possible, using them
in his buildings. It is thanks to Wiehl that we speak of
a "Bohemian Renaissance"; we feel this name is justi-
fied.[16]

In the same period, another Czech Neo-Renaissance architect, Ondřej Saturnin Heller (1840—1884), supported the theory of a "local Bohemian Renaissance", a style characterized by the presence of sgraffito facades and lunette cornices.[17] In parallel with the opinions of architects, theorists and historians strove to find a scholarly, historical basis for the idea. Art critic and historian Karel B. Mádl (1859—1932) was the first to shed light on Bohemian Renaissance architecture in his study *Renaissance v Čechách* [*Renaissance in Bohemia*] of 1885. He

14 *"[...] duchem i podnebím českým takovou proměnu vykonala, jež jí do-*
 dává rázu zvláštního", Jan Koula, "Majorátní dům knížat Schwar-
 zenbergů na Hradčanech" [The Major House of the Schwarzenberg
 Princes at Hradčany], *Zprávy Spolku architektů a inženýrů v králov-
 ství Českém*, XVIII/3—4 (1883), pp. 2—3.

15 *Ibidem.*

16 *"Wiehl bojuje o nové vyjádření architektonické na základě vzorů, pro*
 Prahu a Čechy XVI. a XVII. století typických, a ukázal k nim po prvé,
 když postavil svůj ,sgrafitový domek' v Poštovské ulici. Od té doby
 *pilně sbíral památky naší renesance, studoval je, a kde mu bylo mož-
 no, hleděl jich užíti na svých stavbách. Wiehlovým přičiněním mluví*
 se o ,české renesanci'; cítíme oprávněnost tohoto názvu", Jan Koula,
 "Výklad o vývoji a stylu A. Wiehla" [Explanation on the develop-
 ment and style of A. Wiehl], *Zprávy Spolku architektů a inženýrů
 v království Českém*, XVIII/4 (1883), pp. 7—8.

17 Ondřej Saturnin Heller, "Renaissance moderních průčelí našich
 a vztah její k renaissanci původní II" [The Renaissance of our mod-
 ern facades and its relation to the Renaissance II], *Zprávy Spolku
 architektů a inženýrů*, XVIII/3—4 (1883), pp. 4—13.

first describes the idiosyncratic structures (Royal Summer Palace and Star Villa in Prague) and then maps the preserved monuments, including, for the sake of objectivity, the vestiges of "German" Renaissance in North-East Bohemia. But the vast majority of his text is dedicated to advocating the distinct, Bohemian architectural style of the sixteenth century which "paved its own road, unique, authentic [...] which we now call the Bohemian Renaissance" ("*šel cestou svojí, zvláštní, sobě vlastní* [...] *kterýž my sami dnes nazýváme českou renaissancí*"). Here, the Schwarzenberg Palace with its gables, sgraffito and lunette cornice again serves as a *pars pro toto*. If Tyrš sees picturesqueness as the essential visual quality of Bohemian Renaissance, Mádl believes Bohemian Renaissance architecture was historically destined to "add subtlety to German architecture and create a transition of sorts between the soaring south and the harsh north". He also adds that this style is marked by "richness and gracefulness of forms" ("*bohatství a ladnost útvarů*"). Even later on, Mádl uses the gracefulness concept to differentiate Czech Renaissance buildings from contemporary German architecture.[18]

The idea of a Bohemian Renaissance as formulated by Tyrš, Koula and Mádl was preceded by the theories of German architect and art historian Bernhard Grueber (1807—1882) whose evaluation of Renaissance architecture in the Czech lands was, however, largely negative; he referred to it as *Mischstil* (mixed style) of mediocre quality. His idea of small-mindedness and lack of sophistication on the part of Bohemian and generally Slavic art and its dependence on German culture clearly stemmed from the same nationalism that characterized the thinking of his Czech counterparts. Unsurprisingly, the Czechs fought back, calling Grueber "a willful and spiteful denier of our local art".[19] Yet, Grueber made

a few interesting observations, finding several vernacular (*"einheimische"*) features in local monuments (such as, again, the Schwarzenberg Palace) which, in his view, exhibited a certain bizarre originality. Aside from listing these features — tall gables (*"ein den slawischen Gegenden eigenthumliches Motiv"*), the sgraffito facades — Grueber suggests that these specific forms result from the way Italian architects accommodated the local, largely Gothic traditions.[20] Even later on, German researchers continued to see the essence of the vernacular style in the mixing of Renaissance forms with local Gothic traditions.[21] The fact that most of the buildings in the style

18 "[...] *aby německou architekturu zjemnila a tak vytvořila jakýs článek mezi vzletným jihem a drsným severem*", Karel Mádl, "Renaissance v Čechách" [Renaissance in Bohemia], *Zprávy Spolku architektů a inženýrů v království Českém*, XX (1885), p. 82; Beda L. Mrak [Karel B. Mádl], "Renaissance v Čechách" [Renaissance in Bohemia], *Národní listy*, XXIX/104; 106 (1889), 15. IV.; 17. IV., pp. 1—2.

19 "*Vědomý a zúmyslný zapíratel domácího umění*", Jindřich Vybíral, "Petr Parléř dle Bernharda Gruebera: K recepci gotiky v 19. století" [Peter Parler by Bernhard Grueber: About the reception of Gothic in the nineteenth century], in *Idem, Česká architektura na prahu moderní doby: Devatenáct esejů o devatenáctém století* [Czech architecture on the threshold of modern times: Nineteen essays on the nineteenth century], Prague 2002, pp. 49—50.

20 Bernhard Grueber, "Charakteristik der Baudenkmale Böhmens", *Mitteilungen der k. k. Central-Commission zur Erhaltung und Erforschung der Baudenkmale*, I (1856), pp. 246, 248.

21 For this reason, German speaking authors generally avoided the Bohemian Renaissance concept, see for example August Prokop, *Die Markgrafschaft Mähren in kunstgeschichtlicher Beziehung*, vol. III, Vienna 1904. Other German authors to share this approach include Wilhelm Lübke, *Geschichte der deutschen Renaissance*, Stuttgart 1873, pp. 621—623, 638—644. In passages about art in the Czech lands, Lübke refers to Grueber as his source of information. This applies to the book's second edition as well, Wilhelm Lübke, *Geschichte der Renaissance in Deutschland*, vol. II, Stuttgart 1882, p. 92; Oskar Pollak, *Studien zur Geschichte der Architektur Prags 1520—1600*, Vienna/Leipzig 1910, p. 104; Horáček, "Bernhard Grueber" (n. 6), p. 37.

of the Bohemian Renaissance were built by Italians presented a major problem for Czech advocates of the national style. In his 1883 article, Koula rationalizes the contradiction as follows: "our Italian Master did not build the palace according to his own taste — he had to conform to the style that had been customary here in Bohemia".[22] The narrative that the cultural hegemony of the Bohemian environment forced foreign artists to adapt to the national artistic tradition had a strong appeal and was still used in the second half of the twentieth century for characterizing the "Bohemian Baroque" phenomenon.[23]

The Czech debate concerning Bohemian (Neo)Renaissance in the nineteenth century was dominated by categories such as "picturesqueness", "coziness", "softness" and even "humour". Stemming from the local intellectual tradition, these terms would play an important role in defining Bohemian Renaissance throughout the twentieth century. Their origin can be traced back to the local patriotic society around 1800 which, inspired by Georg Wilhelm Friedrich Hegel and Johann Gottfried Herder, presented a romantic vision of a culturally unique Slavic world (Josef Jungmann, Ján Kollár, Pavel Josef Šafařík). The Slavic character was largely defined in contrast with the German historical mentality and culture. Herder himself emphasized the Slavic "dovelike nature", a characterization dating back to the Middle Ages — namely, the twelfth century when Cosmas the chronicler interpreted the old Czech history based on the ethnic Czech's "meekness, temperance and modesty" (*"mírnost, střídmost a zdrženlivost"*) (the theory became the binding norm for medieval and early modern chroniclers such as so-called Dalimil and Václav Hájek of Libočany).[24] This definition of Slavic nature underpins modern Czech historiography as well, with the

contrast between the Germanic world of coarse and imperious conquerors and the calm, "democratic" world of the Slavs forming the axis of Czech history in the work of František Palacký (1798—1876), the key Czech modern historian. Palacký, who shaped Czech historical consciousness like no other author, typically argues thus:

> [...] *while the German, by way of conquest, attached himself to great old Rome, the meek Slav followed quietly, settling beside him* [...] *the Slav never used weapons to attack, only to defend himself, did not seek power but defied enslavement, only asking for peace to till the land and make crafts.*[25]

This perspective soon found its way to Czech art history, another area of Palacký's expertise. In his 1831 article on the Prague painter's guild, he proposed there existed "a Czech painting school which fundamentally differed

22 *"Nestavěl palác náš italský mistr podle vkusu svého — podříditi se musil zde v Čechách již ustálenému rázu staveb"*, Koula, "Majorátní dům" (n. 14), p. 3.

23 Jaromír Neumann, *Český barok* [Czech Baroque], Prague 1969 (2nd edition Prague 1974).

24 *Kosmova kronika česká* [The Czech Chronicle of Cosmas], Zdeněk Fiala ed., Praha 1972, p. 13; Jiří Rak, *Bývali Čechové: České historické mýty a stereotypy* [They used to be Czechs: Czech historical myths and stereotypes], Prague 1994, pp. 113, 119—120; Vlasta Dvořáková, "Osvícenci a romantikové" [Enlighteners and Romantics], in *Kapitoly z českého dějepisu umění I* [Chapters from Czech Art History I], Rudolf Chadraba ed., Prague 1986, pp. 70—74.

25 *"[...] jakmile Němec uvázal se byl výbojem u velikého starého Říma, Slovan mírný tiše za ním postoupiv, usadil se vedle něho* [...] *Slovan odjakživa neužíval zbraně k útoku, ale k obraně, nebažil po panství, ale zdráhal se porob, nežádal nežli v pokoji a úklidu těžiti orbou a řemesly"*. See František Palacký, *Dějiny národu českého I* [History of the Czech nation I], Olga Svejkovská ed., Prague 1968, s. 56; *Idem, Stručný přehled dějin českých doby starší* [A brief Overview of the History of the Bohemian era], Rudolf Havel ed., Prague 1976, pp. 12—13.

from both the German school and any other schools at the time". Its characteristic features include "neatly drawn, noble faces, natural lightness and gracefulness, casually formed hands and feet".[26]

In this period, the contrast between the Slavic "softness" and Germanic "hardness" was a key topos for Czech national revivalists who compared the supposedly harmonious Slavs to Italians.[27] In his uncritically celebratory Panslavic conception, poet and linguist Ján Kollár (1793—1852) associates the (southern) Italian Renaissance culture with the ancient Slavic substratum, and in his 1843 *Cestopis* [Travelogue],[28] he even delimits a geographical border between the two worlds — the "harsh" Germanic world and the "graceful" Slavic world. For Kollár, the physiognomy of Venetians has something "Slavic, round-shaped, amiable, merry, chattery and singing" ("*slavský, okrouhlotvárný, přívětivý, veselý, štěbetavý a zpěvavý*") in it. Further on, he develops a bizarre idea that the large population of pigeons in Venice attests to the city's "kinship with our dove-natured nation" ("*pokrevnost s naším holubičím národem*").[29] Such musings were far from uncommon. In the nineteenth century, old Czech painting attracted much attention and, in his article of 1842 *O starobylé české malbě* [On Ancient Bohemian Painting], a Russian art expert, Alexander Popov characterizes them as "pure Slavic, Czech". Popov, too, defines the formal features of Slavic painting, emphasizing its anti-German character. Slavic painting is marked by "a special softness and pleasantness" ("*zvláštní měkkost i příjemnost*"), "the faces are oval or round, soft, with round cheeks" ("*obličej vejčitý, více okrouhlý, měkký, okrouhlé tahy lící*") in contrast with "the squareness that betrays the German type" ("*hranatost rozeznávajíc typ německý*").[30] As part of the period's "international" competitiveness, Popov claims that Bohemian painting was

in many respects more advanced than German painting. An elaboration of Popov's argument, the article *Myšlénky o slovanském malířství* [*Ideas on Slavic Painting, 1848*] by journalist and aesthetics scholar Ludvík Ritter von Rittersberg advocates for a distinct Slavic aesthetic, again based on the Slavic-German polarity: "the difference between Slavic and Germanic nations consists, as far as I know, in softness and subtlety of Slavic faces in comparison with the slightly sharper Germanic features". Like Popov and Palacký, he sees further signs of the Slavic type in "slender proportions" ("*outlé poměry*"), "round shape" ("*obloukový tvar*") and "sweet fullness" ("*líbeznou plnost*").[31]

Nineteenth-century art offers ample opportunity for studying how these views were visualized or rather, how this visualization fits with the above-discussed narrative. Czech painter Josef Mánes (1820—1871) was the most

26 "[...] *české malířské školy, kterážto jak od německé, tak i od jiných tehdejších škol, podstatně se dělila*"; "*čistě kreslený ušlechtilý ráz obličejů, přirozenou lehkost a gracii, nedbalost ve formách rukou a nohou*", František Palacký, "Starý řád malířský v Čechách" [The old order of painting in Bohemia], in *Františka Palackého spisy drobné III: Spisy aesthetické a literární* [František Palacký Minor Writings III: Aesthetic and Literary Writings], Leander Čech ed., Prague 1900, p.254.

27 Vladimír Macura, *Znamení zrodu: České obrození jako kulturní typ* [Birth Sign: Czech revival as a cultural type], Prague 1983, pp.105—106.

28 *Cestopis, obsahující cestu do Horní Itálie a odtud přes Tyrolsko a Bavorsko se zvláštním ohledem na slavjanské živly r. 1841 konanou.*

29 Jan Kollár, *Cestopis obsahující cestu do Horní Italie* [A travelogue containing a trip to Upper Italy], Jan Jakubec ed., Prague 1907, pp. 115—126, 144, 164—165, 219, 354, 391, 544.

30 Alexandr Popov, "O starobylé české malbě" [About ancient Czech painting], *Časopis českého muzea*, XX (1846), pp. 501—516, 627—637.

31 Ludvík Ritter von Rittersberg, "Myšlénky o slovanském malírství" [Thoughts about Slavic painting], *Kwěty a plody*, III (1848), pp. 64, 86—87. In the Czech original text: "*Rozdíl mezi slovanskými a germánskými národy záleží, pokud mi známo, u větší měkkosti a jemnosti tváří slovanských a v trochu ostřejších tvrdších tazích germánských*".

prominent artist to embrace the Panslavist ideas. He created a heroic, ancient-Slavic type representing the clash between two cultures — Pagan-Slavic and Christian-German (present especially in his successful illustrated travelogues, 1846–1854 and illustrations for *Rukopisy* [Manuscripts], 1857–1860).[32] The above-mentioned Tyrš highly valued Mánes' rendition of the ideal, "primordial" Slavic type whose typical qualities included "fluidity and harmonious rhythm of lines" (*"plynulost a harmonický rhytmus linií"*), "tenderness and softness" (*"něha a měkkost"*) and "natural elegance and lyricism" (*"přirozená elegance a způsob lyrický"*).[33] Tyrš's aesthetic theory was strongly marked by the conflict of what he saw as barbaric-Germanic and Slavic-Hellenic spirits, and the same polarity dominated the debates about the Bohemian Renaissance (for example, Mádl's Czech-German stylistic polarity). Grueber, too, regarded the peculiar, non-classical and picturesque gables on Czech Renaissance buildings as *"slawische"*, an adjective that, in his case, implied lowliness and inferiority.[34]

The definitions of Slavic mentality, culture and art clearly fed the period's meditations on the Bohemian Renaissance: Kollár's concept of Slavic "joyfulness" is an analogue of Tyrš's "humour", while his "softness" and "roundness" is close to Rittersberg's "roundness of arches" and "lyricism". The latter term would later become a traditional topos in interpretations of Bohemian medieval art.[35] Within this conceptual framework, the Bohemian Renaissance received the epithet "picturesque," a quality that Tyrš perceived as pertaining to "Slavic" architecture.[36] In terms of architectural form, picturesqueness was associated with richly articulated gables, lavish sgraffito facades and the lunette cornice creating a play of light and shadow on the facade. The local (Slavic) character was also found in the sgraffito iconography.

For Koula, the "sunflowers and apple and pear tree twigs" ("*květy sluneční a haluze jablkové i hruškové*")[37] were an expression of the unique *genius loci*, a place where, as Kollár writes, "in green groves, the fair Slav sings her songs" ("*kde spanilá v zelených hájích pěla písně Slovanka*").[38]

By the turn of the twentieth century, the concept of Bohemian Renaissance as formulated in the 1880s by Tyrš, Mádl and Koula was generally accepted among

32 Jindřich Šámal, "Mánesovy ilustrace z Bellamnových *Erinnerungen* v české publikaci" [Mánes' illustrations from Bellamn's *Erinnerungen* in a Czech publication], *Umění*, II (1954), p. 157; Antonín Matějček, *Mánesovy ilustrace* [Mánes' illustrations], Prague 1952; for more about (pan)Slavic ideology and anti-German nationalism during the Czech national revival, see Frank Vollman, *Slavismy a antislavismy za jara národů* [Slavisms and antislavisms in the Spring of Nations], Prague 1968; František Kutnar, *Obrozenecké vlastenectví a nacionalismus: Příspěvek k národnímu a společenskému obsahu češství doby obrozenectví* [Revival patriotism and nationalism: Contribution to the national and social content of Czech revival period], Prague 2003.

33 Tyrš, *O umění* (n. 10), pp. 12, 45, 47, 52, 54.

34 Rudolf Chadraba, "Miroslav Tyrš", in *Kapitoly I* (n. 24), p. 162; Tyrš, "Ve prospěch renaissance české" (n. 11), p. 230; Mádl, "Renaissance v Čechách" (n. 18), p. 82. For more about the nationalism behind the Czech neo-Renaissance, see Martin Horáček, *Přesná renesance v české architektuře 19. století: Dobová diskuse o slohu* [Precise Renaissance in Czech nineteenth-century architecture: The contemporary discussion on style], Olomouc 2012.

35 Milena Bartlová, "Rustikalizace a lyrismus jako příznaky českého umění" [Rustikalization and lyrism as symptoms of Czech art], in *Dějiny umění v české společnosti. Otázky, problémy, výzvy: Příspěvky přednesené na Prvním sjezdu českých historiků umění* [History of art in Czech society. Questions, problems, challenges: Contributions presented at the First Congress of Czech Art Historians], *Eadem* ed., Prague 2004, pp. 188–194.

36 Tyrš, "Ve prospěch renaissance české" (n. 11), p. 230.

37 Koula, "Majorátní dům" (n. 14), p. 3.

38 Jan Kollár, *Slávy dcera* [The Daughter of Fame], Jan Jakubec ed., Prague 1903, p. 20.

architects, theorists, historians and art historians. Czech historians had been interested in finding distinct national features in local Renaissance architecture since the 1880s when the historian Josef Strnad claimed that "it is undeniable that these buildings feature peculiarities we could hardly find in Italian architecture" and that it is necessary "for experts on our architectural monuments to examine this phenomenon, so we [historians] can honestly participate in this spiritual labor [of researching Czech history]".[39] By this time, however, the concept of national uniqueness was well established, along with the morphological triad "gables — lunette cornice — sgraffito" and the aesthetic category of (Slavic) picturesqueness. None of the above-cited experts could have known they were creating a *cliché* which would survive in Czech Renaissance studies with astonishing persistence.

The national definition of Bohemian Renaissance further spread after 1918, in the independent Czechoslovak state. In his essay on Wiehl, art historian Zdeněk Wirth (1878—1961) explains the phenomenon of the Czech Renaissance revival as a result of the specific social milieu in the 1880s while fully accepting the existence of an "objectively" unique Bohemian Renaissance, an assumption he elaborates on in his other contributions on the subject.[40] In the interwar period, architect Antonín Balšánek (1865—1921) was the main promoter of the Bohemian Renaissance. His monograph entitled *Štíty a motivy attikové v české renaissanci* [*Gables and Attic Motifs in Bohemian Renaissance*] |05|, first published in 1902, was reprinted posthumously in 1929 with the intention to refresh the idea of Bohemian Renaissance as part of

|05| ↑ Antonín Balšánek, *Štíty a motivy attikové v české renaissanci*, Praha 1929, cover sheet

an open polemic with the Czech cosmopolitan modern architecture. The idea that the Czech Renaissance style is the only alternative to modern architecture resembles the late nineteenth-century debates when the local Renaissance was promoted as an alternative to the international Italian Neo-Renaissance. Balšánek aimed to "publish a theory about forms of the Renaissance that flourished on our Czech soil with its local tone constituting its character that is quite different from contemporary styles in Germany, Holland and France". Balšánek prioritizes national criteria over quality: "It is a mere variation of the style, a dialect of sorts, but it is ours". Without a pejorative undertone, he adds that rather

39 *"Nelze ovšem popírati, že se jeví na stavbách těchto někdy zvláštností, kterých bychom marně hledali na stavbách italských [...] to však rozřešiti, přísluší znalcům našich památek stavitelských, což aby brzy se stalo, již v zájmu čestného účastnění se našeho v duševní práci té"*, see Josef Strnad, "Vlachové v Plzni v XVI. století usedlí" [Vlachs settled in Pilsen in the sixteenth century], in *Sborník dějepisných prací bývalých žáků dra. Václava Vlad. Tomka* [Proceedings of historical works of former pupils of Dr. Václav Vlad. Tomek], Prague 1888, p. 24. For similar argument see Jan Koula, "Dům architekta A. Wiehla na Václavském náměstí" [The house of architect A. Wiehl on Wenceslas Square], *Zprávy Spolku architektů a inženýrů v království Českém*, XXXII (1898), pp. 3–5; Karel Chytil, "Architektur der Renaissance und Neuzeit", in *Die österreichisch-ungarische Monarchie in Wort und Bild. Böhmen. 2. Abth.*, Vienna 1896, pp. 290–292; *Idem*, "U kolébky architektů" [At the cradle of architects], *Dílo*, V (1907–1908), p. 89; *Idem*, "Mistři lugánští v Čechách v XVI. století" [Masters of Lugano in Bohemia in the sixteenth century], in *Ročenka Kruhu pro pěstování dějin umění za rok 1924* [Yearbook of the Circle for the Cultivation of Art History in 1924], Prague 1925, pp. 49–51; Antonín Balšánek, *Štíty a motivy attikové v české renaissance* [Gables and Attic Motifs in Bohemian Renaissance], Prague 1929; Josef Braniš, *Katechismus dějin umění* [The Catechism of art history], Prague 1896, p. 198; Zikmund Winter, *Český průmysl a obchod v XVI. věku* [Czech industry and trade in the sixteenth century], Prague 1913, pp. 443–449.

40 Wirth, *Antonín Wiehl* (n. 6), p. 5.

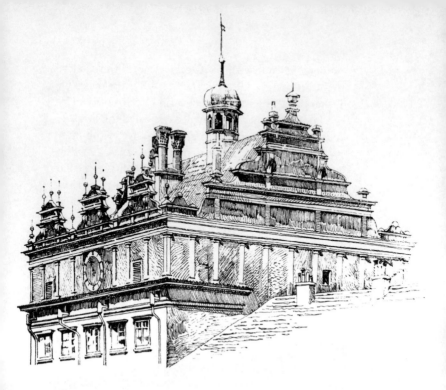

|06| ↑ Plzeň/Pilsen, gables of the city hall

than monumental, the Bohemian Renaissance is "purely external, decorative" — "it is a facade style par excellence", albeit "more intimate" and marked by "purity and innocence". Unsurprisingly, Balšánek's main criteria are again "picturesqueness" and "picturesque beauty".[41]

However, there were also more rigorous, art historical interpretations of the Bohemian Renaissance, such as the contributions by Olga Frejková (1905—1991) and Zdeněk Wirth. Antonín Matějček (1889—1950), the founder of art history in the newly established Czechoslovakia, researched the Bohemian Renaissance in the 1920s and 1930s as did another art historian, Emanuel Poche (1903—1987). The former fully accepted the assumption that Italian architects adapted to the local Gothic tradition, thus creating the eclectic "stylistic

44

variation which is rightly called the Bohemian Renais-
sance" ("*slohová odrůda, jež se zve právem renesancí
českou*"), characterized by "picturesqueness" ("*malebný
ráz*"). Poche, too, evaluates the style from a national
perspective: "[...] but the local tradition was so powerful
that, by mixing the old with the new, a unique stylistic
variation of Bohemian Renaissance was created" |o6|.[42]
He was, however, harsher in his judgement, blaming lo-
cal sixteenth-century architecture for misunderstand-
ing the principles of Italian Renaissance, resulting in
"jovial eclecticism" ("*bodrý eklekticismus*").[43]

Olga Frejková's study *Palladianismus v české renesanci*
[*Palladianism in Bohemian Renaissance*, 1941] marked the
turn toward an unambiguously positive evaluation of the
style, in part due to the book's origin during the war and
occupation. Frejková largely elaborates on the previously
defined principles: the Bohemian Renaissance presents
a "unique type" characterized as "non-architectural, even
decorative style", "giving an impression of flatness rather
than spatiality", an aesthetic resulting from "mixing of
Italian models with the spirit of the Northern artist".

41 "*Vydati jakousi nauku o formách Renaissance, tak jak vykvetla na
naší české půdě s tím zabarvením lokálním, který tvoří její ráz, značně
odchylný od soudobých slohů v Německu, Holandsku a Francii*"; "*Jest
to pouze odrůda slohu, jakési nářečí, však naše vlastní*", Balšánek,
Štíty a motivy (n. 39), pp. 7, 12, 14, 18, 120.

42 "*[...] ale síla domácí tradice byla taková, že z míšení starého s novým
vznikla zvláštní slohová odrůda renesance české*", Antonín Matějček,
Dějepis umění 4 [History of Art 4], Prague 1929, pp. 185—186; *Idem*,
"Umění Italů v českých zemích" [Italian Art in the Czech lands], in
Idem, O umění a umělcích [On art and artists], Prague 1948, p. 79.
However, the text was written as early as in 1931.

43 Emanuel Poche, "Renesance: Architektura" [Renaissance: Architec-
ture], in *Československá vlastivěda*. Tome 8. *Umění*, Václav Dědina
ed., Prague 1935, pp. 90—91. The text also appears in *Dějepis výtvar-
ných umění v Československu* [History of fine arts in Czechoslova-
kia], Zdeněk Wirth ed., Prague 1935.

45

She maintains the style's national definition, claiming it was a product of "the Czech land and its cultural world". Frejková was the first to specify the period when the style was used (1530—1580), also including, somewhat unusually, what she called the "shadow of Palladianism", that is, the work of local sixteenth-century architect, Boniface Wolmut. Again, she uses the picturesqueness category, describing the style as a "picturesque decorative backdrop" (*"malebné dekorativní kulisy"*).[44] After the war, Czech historian Vladimír Denkstein (1906—1993) also evaluated the style positively as "a picturesque, charming and unique style of Bohemian Renaissance" and associated it largely with the burgher milieu.[45]

Zdeněk Wirth writes about the Bohemian Renaissance with similar fondness. In 1952, he characterizes it, along the lines of Taine and Tyrš, as an idiosyncratic style which was "adapted to local climate, local materials and the local national milieu". For him, the Bohemian Renaissance is "structurally lively" and "joyful" (a parallel to Tyrš's term "humour").[46] In 1961, Wirth authored the first comprehensive monograph about the Bohemian Renaissance meant largely for the international public. Here, he defines the style's main principles as Gothic survival, the imported character of Renaissance and its blending with traditional local forms (*"rustikalisierten Renaissance [...] von der einheimischen Tradition beeinflußt wurden"*) and, the morphological triad: Gothic-inspired gables, attics, and lunette cornices. The style is, in Wirth's words, traditional, combinative and decorative, determined by the style of Norther-Italian architects. Wirth creates a picture of "charming local style" (*"půvabný místní sloh"*), as he later called the Bohemian Renaissance, finding its main quality in their "color and spontaneous naivety" (*"ihre Farbigkeit und spontane Naivität"*). In another text, he adds that "this is not tectonic

thinking but eclecticism of architectural and decorative motifs freely paraphrasing the chosen model [...]; it is the colourful forms, picturesqueness and colors of the whole and the natural naivete of the composition that makes the style so impressive" |07|.[47]

In the same period, art historian Eva Šamánková (1923–1996) formulated the principles of the Bohemian Renaissance — a "self-contained stylistic trend" ("*do sebe uzavřený slohový proud*") — in the only existing monograph about Renaissance architecture in the Czech lands after 1961. Elaborating on the existing arguments, she sees the Bohemian Renaissance as the style of Northern-Italian architects who adopted the local Gothic tradition — Šamánková speaks of a "Bohemizing trend" ("*počešťovací směr*"). She extends the established morphology (gable, sgraffito) to include diamond vaults and

44 Olga Frejková, *Palladianismus v české renesanci* [Palladianism in the Czech Renaissance], Prague 1941, pp. 1, 23–25, 29, 181; *Eadem, Česká renesance na Pražském hradě* [The Czech Renaissance at Prague Castle], Prague 1941, pp. 1–2.

45 "*Malebný, půvabný a osobitý styl české renesance*", Vladimír Denkstein, Zoroslava Drobná, Ludmila Kybalová, *Lapidarium Národního muzea. Sbírka české architektonické plastiky XI. až XIX. století* [Lapidarium of the National Museum. Collection of Czech architectural sculptures from the eleventh to the nineteenth century], Prague 1958, pp. 65–66.

46 "[...] *podlehl tu jak zdejšímu podnebí, zdejším materiálům, tak zdejšímu národnímu prostředí*", Zdeněk Wirth, "Období pozdně-gotické a renesanční architektury" [Late-Gothic and Renaissance architecture], in *Architektura v českém a slovenském národním dědictví* [Architecture in the Czech and Slovak national heritage], Prague 1952, pp. 33–34.

47 "[...] *není to tektonické myšlení, ale eklektismus architektonických a dekorativních motivů ve volné parafrázi zvolené předlohy* [...] *působí však právě barevností svých forem, malebnosti a barevností celku a přirozenou naivitou skladby*", Zdeněk Wirth, "Die Böhmische Renaissance", *Historica*, III (1961), pp. 87–107; *Idem, Architektura v českém národním dědictví* [Architecture in the Czech National Heritage], Augusta Müllerová ed., Prague 1961, pp. 83, 84, 96, 98.

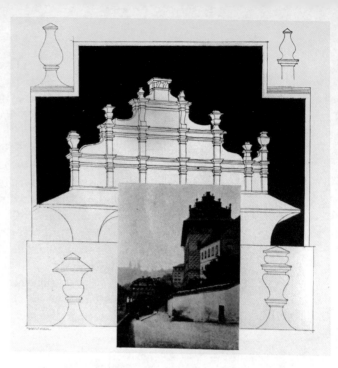

|07| ↗ Schwarzenberg
Palace at Prague —
Hradčany, details of
gable

arcade courtyards. Again, the style is characterized as picturesque, a term Šamánková uses very often, sometimes as many as four times in one paragraph. The monograph's main problem consists in its inability to present a coherent group of monuments built in this style, a downside of the Bohemian Renaissance concept as a whole (and that of any other generalizing stylistic category). Šamánková basically includes everything except for early Renaissance, Wolmut's works and the architecture of the Rudolfine circle. This way the concept comprises entirely different buildings such as the chateau in Kostelec nad Černými Lesy and St Adalbert's Chapel at the Prague Castle, on the one hand, and the provincial chateau in Uherčice, the bizarre churches in Volenice and Dobrš and the diamond vaults in Slavonice on the other. At the same time, Šamánková mentions Italianate

48

structures built according to contemporary mannerist principles (Moravský Krumlov Chateau, Kratochvíle). A similarly disparate collection of monuments also appears in the above-discussed study by Wirth.[48]

In her review of Šamánková's book, art historian Jarmila Krčálová (1928–1993) strictly refutes this approach as inconsistent. However aware of the unique form the Renaissance had taken in the Czech lands, Krčálová was one of the few experts to contest the whole Bohemian Renaissance concept. Yet, she still used the by then rather outworn term "picturesqueness" to characterize the local burgher architecture.[49] Pavel Preiss (born 1926) assumed a similarly reserved approach toward the Bohemian Renaissance concept despite mentioning "certain specific features of the Bohemian milieu" largely due to the surviving Gothic tradition.[50]

Despite these reserved voices, the concept remained alive and attractive. Oldřich Stefan (1900–1969), a historian of architecture, again defined the style as a unique

48 Eva Šamánková, *Architektura české renesance* [Architecture of the Czech Renaissance], Prague 1961, pp. 41–77; *Eadem*, "Über die Anfänge der tschechischen Renaissance-Architektur", *Acta Historiae Artium Academiae Scientiarum Hungaricae*, XIII (1967), pp. 116–118, 122.

49 Jarmila Krčálová, "Ke knize Evy Šamánkové *Architektura české renesance*" [About Eva Šamánková's book *Architecture of the Czech Renaissance*], *Umění*, X (1962), p. 75; *Eadem, Centrální stavby české renesance* [Central buildings of the Czech Renaissance], Prague 1974, p. 5; *Eadem*, "Renesanční architektura v Čechách a na Moravě" [Renaissance architecture in Bohemia and Moravia], in *Dějiny českého výtvarného umění* [History of Czech fine arts], II/1, Jiří Dvorský, Eliška Fučíková eds, Prague 1989, p. 7; *Eadem*, "Renesance" [Renaissance], in *Nová encyklopedie českého výtvarného umění* [A new encyclopedia of Czech fine arts], Anděla Horová ed., Prague 1995, p. 679.

50 Pavel Preiss, *Italští umělci v Praze: Renesance, manýrismus a baroko* [Italian artists in Prague: Renaissance, Mannerism and Baroque], Prague 1986, pp. 17, 38–42.

set of forms resulting from the eclectic blending of an imported Renaissance with local (Gothic) tradition. He strongly associates it with the local burgher milieu, referring to it, in keeping with Tyrš, as the "burgher style" (*"měšťanský sloh"*). However, Stefan enriches the concept by interpreting the style from a Marxist perspective, a compulsory position at the time. Using the concept of "class identity and consciousness" (*"třídní příslušnost a vědomí"*), he emphasizes the contrast between the burgher and aristocratic architecture with the Bohemian Renaissance representing the "progressive" bourgeoisie in opposition to feudal nobility.[51] However, the Marxist interpretation required that the style be associated with the "most progressive" class, the common folk. In the late 1950s, Jaroslav Pešina (1912–1992), a historian of medieval art, takes the Bohemian Renaissance for granted, naming all its typical features including the established aesthetic categories such as "softness" and "joyfulness" (*"změkčení"*, *"veselost"*), and also adds the obligatory reference to the "Czech countryside" as the place where it flourished the most.[52] This preference for the Bohemian Renaissance reflected the official current in architecture and architectural theory — socialist realism — which, in the 1950s, drew from local sixteenth-century architecture (gables, sgraffito, lunette cornices). It was precisely its local, folksy character and the alleged class identity that justified this inspiration.[53]

Essentially just a modification of the style's national definition, this theoretical (ideological) redefinition of the Bohemian Renaissance in the 1950–1960s was later abandoned. In the 1970–1980s, the concept was used in its original sense: for example, art historian Jarmila Hořejší promoted the "picturesque interpretation of the Renaissance".[54] The last art historian to devote attention to the theoretically defining the Bohemian

Renaissance was Jiří Kropáček who, in 1983, called for the "renewal of [the concept's] noetic function and value". Kropáček's text is the first attempt since Koula to apply the concept to other art forms such as painting, print making, sculpture and decorative arts. The style's typical features include "decorativism" and an idiosyncratic figural type based on the Gothic figural canon and described as "largely elongated, with a small head, dynamic" (*"vesměs protáhlá [figura], s malou hlavou, hybně formulovaná"*). This way, Kropáček arrives back at the "picturesque" human type as described by Palacký, Popov and Ritter.[55] The theory of the unique, specifically Bohemian Renaissance has been on the decline and

51 Oldřich Stefan, "K dějezpytným otázkám naší renesanční architektury" [About the insidious questions of our Renaissance architecture], *Umění*, XII (1964), pp. 429–431; *Idem*, "K počátkům klasicismu v renesanční architektuře Čech" [On the beginnings of Classicism in the Renaissance architecture of Bohemia], *Sborník prací Filozofické fakulty brněnské univerzity*, X/F 5 (1961), p. 237.

52 Jaroslav Pešina, "Znovuupevnění feudalismu (1436–1620): Výtvarné umění" [Reinforcement of feudalism (1436–1620): Fine arts], in *Přehled československých dějin I* [Overview of Czechoslovak History I], Josef Macek ed., Prague 1958, pp. 402–403. For more about J. Pešina and his relationship to Marxism, see Milena Bartlová, "Jaroslav Pešina 1938–1977: Čtyři desetiletí politických strategií českého historika umění" [Jaroslav Pešina 1938–1977: Four decades of political strategies of the Czech art historian], *Opuscula historiae artium*, LXVI/1 (2017), pp. 74–85.

53 Pavel Halík, "Ideologická architektura" [Ideological architecture], *Umění*, XLIV (1996), pp. 438–460.

54 *"Malebná interpretace renesance"*, Jarmila Hořejší, "Review of Jan Białostocki, *The Art of the Renaissance in Eastern Europe*", *Umění*, XXVI (1978), p. 379; Dobroslav Líbal, "Umění renesance a manýrismu: Architektura" [The Art of Renaissance and Mannerism: Architecture], in *Praha na úsvitu nových dějin* [Prague at the dawn of new history], Emanuel Poche ed., Prague 1988, p. 147.

55 Jiří Kropáček, "K výměru termínu 'česká renesance'" [On the definition of the term 'Czech Renaissance'], in *Itálie, Čechy a střední Evropa* [Italy, Bohemia and Central Europe], Prague 1986, pp. 182–191.

even its one-time promoters have largely abandoned it (Šamánková).[56] Yet, the national undertone is still resonant in Czech art historical texts on the local Renaissance albeit with increasing reservation.[57]

CONCLUSION

The above historical outline of the Bohemian Renaissance can be summarized as follows: In the 1880s, an atmosphere of cultural competition between nations and the growing popularity of Czech Neo-Renaissance architecture, gave rise to the concept of Bohemian Renaissance — a unique style allegedly typical of local sixteenth-century architecture. It was defined based on a few architectural monuments and characterized by several alleged locally specific morphological elements. In their attempts to classify the style's aesthetic features, theorists emphasized the Slavic "picturesqueness" as an antithesis of German "harshness", categories that had been rooted in Czech nineteenth-century theory since Kollár. This evaluation, based on the need at the time to define the pan-Slavic against the pan-German, survived in Czech art history until the end of the twentieth century. This national, stylistic-aesthetic construct gained further strength during the first republic period when art historian Václav V. Štech (1885–1974) coined his theory of "rusticalization as an agent of stylistic development" ("*rustikalizace jako činitel slohového vývoje*"). In his eponymous study (1933), Štech pointed to the importance of artistic periphery which absorbs high art in the process of rusticalization, preparing ground for the rise of national art. His considerations are clearly analogous to the concept of the Bohemian Renaissance. A new national style, says Štech, emerges from the "mixing of the foreign and the local" ("*smíšením*

cizího a vlastního"), a process accompanied by the "loss of the tectonic idea" (*"ztráta tektonické představy"*) with the imported forms "incorporated in the national culture" (*"přivtěleny do národní kultury"*). Štech even suggested that the "rusticalization" principle be applied to the evolution of local art in its full scope.[58] It is therefore not a coincidence that in his 1960s text on the Bohemian Renaissance, Wirth uses terms such as "spontaneous rusticalization" (*"živelná rustikalizace"*) etc.[59] The key ideas in Štech's rusticalization theory included the assumption that forms are transferred from the top to lower social classes (the periphery) — art forms "are appropriated by new social classes, becoming peasant-like, rusticalized" (*"stávají majetkem nových společenských tříd, jsou poselštěny, rustikalizovány"*). Such consideration naturally leads to Stefan's Marxist interpretation of

56 Ivan P. Muchka, *Renesanční architektura: Deset století architektury* [Renaissance architecture: Ten centuries of architecture], Prague 2001, pp. 13—15; Eva Šamánková, *Pozdně gotická a renesanční Praha* [Late Gothic and Renaissance Prague], Prague 1993. Even though the term "Bohemian Renaissance" was used by some historians (for example in *Dějiny zemí koruny české I* [History of the Czech Crown Countries], Petr Čornej [*et al.*] eds, Prague/Litomyšl 1995, p. 254), most of them are cautious about it, see Marie Koldinská, *Každodennost renesančního aristokrata* [The daily life of a Renaissance aristocrat], Prague/Litomyšl 2001, p. 31.

57 Tomáš Knoz, "Renesanční zámky na Moravě: 'Zámeckost', 'renesančnost', a 'moravskost' moravských renesančních zámků" [Renaissance castles in Moravia: 'Castle', 'Renaissance', and 'Moravianism' of Moravian Renaissance castles], in *Morava v době renesance a reformace* [Moravia during the Renaissance and Reformation], Tomáš Knoz ed., Brno 2001, pp. 46—58.

58 Václav Vilém Štech, "Rustikalizace jako činitel slohového vývoje" [Rusticalization as a factor of stylistic development], in *Idem*, *Dohady a studie: Výbor studií a článků* [Speculation and studies: Anthology of studies and articles], Prague 1967, pp. 68—74.

59 Wirth, "Die Böhmische Renaissance" (n. 47), p. 89; *Idem*, *Architektura* (n. 47), p. 83.

the Bohemian Renaissance as an idiosyncratic burgher style contrasting with art of "reactionary feudal lords". Štech's ideas reflect his patriotic sensibility but also the contemporary trends in Czech architecture where traditional Czech or Slavic motifs inspired modernist architects such as Dušan Jurkovič (vernacular modernism), Pavel Janák and Jan Gočár (rondocubism). For these architects, formal homogeneity in architecture was a manifestation of national identity.[60]

The emphasis on the national, provincial and "picturesque" character of the Bohemian Renaissance likely also stemmed from the fact that for a long time, Czech art historians were somewhat hesitant to use the term "Renaissance" for art in sixteenth-century Bohemia.[61] Hořejší, for example, asks: "Is it really Renaissance art in the true sense of the word that we have in the Czech lands?" Her answer is a tentative no, largely due to the surviving Gothic elements.[62] These views stem from the broader tendency to deny the existence of Renaissance in Czech history based on the assumption that the period between 1450 and 1600 was dominated by the Reformation rather than Renaissance humanism.[63] This problem had a particular urgency for Wirth. In his view, Renaissance art in Bohemia either just imitated imported models or took the form of a locally specific, "homemade" picturesque style, the Bohemian Renaissance. Here, Wirth says explicitly what had always been present in the literature about this "national" style: the praise for its non-classical, rustic picturesqueness and locally specific morphology was an escape of sorts from the painful fact that sixteenth-century Bohemian architecture could not stand comparison with its Italian models. In his mock-Freudian interpretation of Czech art history, Jindřich Vybíral diagnoses this way of reasoning as a symptom of psychic frustration and substitution.[64]

54

The use of "rusticalization" as an explanatory principle in defining a national style reaches beyond the Bohemian Renaissance. Polish historiography chose a similar approach in the second half of the twentieth century when it entertained the idea of a specific "vernacular" style resulting, like the Bohemian Renaissance, from the mixing of imported and local forms. Such a mixing was thought to have given rise to the national *"Manierismus und 'Volkssprache' in der polnischen Kunst"*.[65] At the end of the 1970s, American art historian Thomas DaCosta Kaufmann criticized this approach, using Jan Białostocky's theory of "vernacularity" as an example.[66] He above all disproved the general idea of specific local, autochthonous forms characteristic of the individual

60 Jaroslav Slavík, "Václav Vilém Štech", in *Kapitoly z českého dějepisu umění II* [Chapters from Czech art history II], Rudolf Chadraba ed., Prague 1987, pp. 145—146. For more on that question, see *Budování státu: Reprezentace Československa v umění, architektuře a designu* [State building: Representation of Czechoslovakia in art, architecture, and design], Milena Bartlová, Jindřich Vybíral [*et al.*] eds, Prague 2015; *Co bylo Československo?: Kulturní konstrukce státní identity* [What was Czechoslovakia?: Cultural construction of the state identity], Milena Bartlová [*et al.*] eds, Prague 2017.

61 Poche, "Renesance: Architektura" (n. 43), p. 90.

62 *"Jde však vskutku v českých zemích o umění renesanční v pravém smyslu toho slova?"*, Jarmila Hořejší, "Tvář pozdně středověkých historismů" [The face of late medieval historisms], *Umění*, XVII (1989), pp. 122—123.

63 Josef Macek, "Hlavní problémy renesance v Čechách a na Moravě" [The main problems of the Renaissance in Bohemia and Moravia], *Studia Comeniana et Historica*, XVIII/35 (1988), pp. 8—43.

64 Jindřich Vybíral, "Co je českého na umění v Čechách?" [What is Czech about art in Bohemia?], in *Dějiny umění* (n. 35), pp. 200—207.

65 Wirth, "Die Böhmische Renaissance" (n. 47); *Idem*, *Architektura* (n. 47), p. 83.

66 Jan Białostocki, "Manierismus und 'Volkssprache' in der polnischen Kunst", in *Idem*, *Stil und Ikonographie: Studien zur Kunstwissenschaft*, Dresden 1966, pp. 48—49. For the first mention of this principle, see *Idem*, "Pojęcie manieryzmu i problem odrębności sztuki polskiej w końcu XVI i początku XVII wieku" [The concept of

Renaissances (such as the gable-lunette cornice-sgraffito triad in the Czech case) by showing that these forms are in fact imported and that they appear throughout Europe without being limited to any narrow national territory. At the same time, DaCosta Kaufmann offers a solution to the question of how to evaluate these undeniably unique monuments. He suggests that art history broaden its perspective, shedding the strictly (nationally) defined stylistic categories which he sees as "examples of the dialects of an international language". Rather than preserving the belief in unique national styles, a notion born in the second half of the nineteenth century, art history should focus on studying cultural-historical principles (artistic exchange, disintegration and transformation of forms as a life process).[67] This is also how current historians perceive the stylistic diversity of the trans-Alpine artistic milieu.[68] In the field of art history, Slovakian author Ján Bakoš offers a particularly multilayered analysis of the pluralistic Central-European milieu with its various ideologies and historiographical concepts of "national cultural history".[69]

The Bohemian Renaissance comes across as an *a priori* concept lacking a sufficiently large and coherent group of monuments that would justify it. The style's characteristic features are not specifically Czech, and the monuments chosen by the concept's advocates have little in common aside from their ethnically defined territory. Ernst Hans Gombrich points to a similar mechanism in the evolution of the term "mannerism":

[...] *like any such intellectual category, it was created a priori, as it were, to meet a historiographical need, and that it finally triumphed as an idea that had as yet scarcely proved its value in contact with the facts of the past.*[70]

Architecture in sixteenth-century Bohemia undoubtedly has distinct features but these features are neither locally specific nor particularly unique. Moreover, we need to be circumspect about any attempt to associate a certain

mannerism and the problem of the separateness of Polish art at the end of the sixteenth and the beginning of the seventeenth century], *Materiały do studiów i dyskusji z zakresu teorii i historii sztuki, krytyki artystysznej oraz badań nad sztuka*, II (1953), pp. 179—198. See also *Idem*, "Some Values of Artistic Periphery", in *World Art. Themes of Unity in Diversity: Acts of the XXVIth International Congress of the History of Art I*, Irving Lavin ed., University Park/London 1989, pp. 49—58. The idea of Polish Renaissance art's national specificity ("*styl rodzimy*") is still present in Polish art history, see for example Ksavery Piwocki, "Zagadnienie rodzimości sztuki polskiej późnego renesansu" [The issue of native Polish late Renaissance art], in *Renesans: Sztuka i ideologia* [Renaissance: Art and ideology], Tadeusz S. Jaroszewski ed., Warsaw 1976, pp. 227—249. For a critique of this approach see Kinga Blaschke, *Nasze własne, nasze polskie: Mit renesansu lubelskiego w polskiej historii sztuki* [Our own, our Polish: The myth of the Lublin Renaissance in Polish art history], Kraków 2010.

67 Thomas DaCosta Kaufmann, "Review of Jan Białostocki, *The Art of Renaissance in Eastern Europe*", *The Art Bulletin*, LXVIII (1978), pp. 164—169; *Idem*, *Court, Cloister and City: The Art and Culture of Central Europe 1450—1800*, London 1995, p. 230; *Idem*, "Italian Sculptors and Sculpture Outside of Italy (Chiefly in Central Europe): Problems of Approach, Possibilities of Reception", in *Reframing the Renaissance: Visual Culture in Europe and Latin America 1450—1650*, Claire Farago ed., New Haven/London 1995, pp. 51—57. Most recently, see Thomas DaCosta Kaufmann, *Toward a Geography of Art*, Chicago 2004.

68 Marina Dmitrieva, *Italien in Sarmatien: Studien zum Kulturtransfer im östlichen Europa in der Zeit der Renaissance*, Stuttgart 2008.

69 Ján Bakoš, "Idea východnej strednej Európy ako umeleckého regiónu" [The idea of Eastern Central Europe as an artistic region], in *Problémy dejín výtvarného umenia Slovenska, Idem* [*et al.*] eds, Bratislava 2002, s. 10—18; *Idem*, "Peripherie und kunsthistorische Entwicklung", *Ars*, XXIV (1991), pp. 1—11.

70 Ernst Hans Gombrich, "Introduction: The Historiographic Background", in *The Renaissance and Mannerism: Studies in Western Art II: Acts of the Twentieth International Congress of the History of Art*, Ida E. Rubin ed., Princeton 1963, p. 165.

morphology with a nation. The Bohemian Renaissance is an ideological construct rooted in the specific, late nineteenth-century situation and the attempts to define it must be understood in the context of contemporary nationalism and cultural competitiveness with the German element.[71] In Germany itself, the idea of a Germanic Renaissance as an "Old-German style" became popular beginning in the 1850s.[72] That "Slavic picturesqueness" and the alleged anti-German spirit of the Bohemian Renaissance gained special importance in this context is hardly surprising. But it is its persistence until the end of the twentieth century that makes the whole concept remarkable. The national (and Slavic) ethos of the Bohemian Renaissance proved extraordinarily powerful in all its interpretations — the nationalistic "war of styles" (Tyrš and others), polemics with cosmopolitan modernism (Balšánek), anti-fascism (Frejková), Marxism (Wirth, Stefan) as well as singular theories (Štech, Kropáček) — pushing actual art historical methods to the margins. The above outline shows how the repetition of and emphasis placed on a few basic characteristics produced a stereotype, approachable and attractive in its simplicity, and apparently hard to give up. The Bohemian Renaissance is a part of Czech art historical mythology as an appealing construction that is, as Keith Moxey says, "not found in the past, but placed there in the present by the pattern-making activity of the historian".[73]

71 Vybíral, "Počátky české národní architektury" (n. 4).

72 The wealth of literature on the subject includes for example Harold Hammer-Schenk, "Architektur und Nationalbewußtsein", in *Kunst: Die Geschichte ihrer Funktionen*, Werner Busch, Peter Schmoock eds, Weinheim/Berlin 1987, esp. pp. 506—507; Georg Ulrich Grossmann, "Die Renaissance der Renaissance-Baukunst: Eine Einführung mit Blick auf den Weserraum", in *Renaissance der Renaissance: Ein bürgerlicher Kunststil im 19. Jahrhundert*, Georg Ulrich Grossmann, Petra Krutisch eds, Munich/Berlin 1992, pp. 201—223; Marek Zgórniak, *Wokół neorenesansu w architekturze XIX wieku. Podstawy teoretyczne i realizacje* [Around the neo-Renaissance in nineteenth century architecture. Theoretical foundations and implementations], Kraków 1987, pp. 107—112; Małgorzata Dastek, "Fasady szczytowe w architekturze handlowej wrocławskiego Starego Miasta na poczatku XX wieku — fundatorzy, architekci, geneza typu" [Gable facades in the commercial architecture of Wroclaw's Old Town at the beginning of the twentieth century — founders, architects, genesis], *Dzieła i interpretacje*, VI (2000), pp. 57—86.

73 Moxey, *The Practice* (n. 1), p. 13. I thank Martin Horáček for his valuable advice and recommendations.

Translation: Hana Logan

→

RUSSIAN INPUTS IN CZECHOSLOVAKIA: WHEN ART HISTORY MEETS HISTORY
The Institutum Kondakovianum *During the Nazi Occupation*

IVAN FOLETTI

This paper was originally intended to provide a brief reflection on the role that a phenomenon such as Russian emigration in general, and that of the *Institutum Kondakovianum* in particular had in Czechoslovakia in the interwar years. However, recent discoveries made in the Columbia University archives in New York impel me to partly reconsider this objective.

The first part of this essay will still be dedicated to Russian emigration and the Kondakov Institute between the two World Wars. The second part will be however devoted to a time that has been little investigated in critical studies: the life of the *Institutum* during the Nazi regime. My aim is not to merely relate facts and events. As far as possible, I would like to offer a broader reflection on the dialectic relation between art history (here framed in the life of an institute) and a totalitarian regime, even when the latter does not make direct use of violence.

FROM NIKODIM KONDAKOV TO THE *INSTITUTUM*: THE INVENTION OF A NEW CONTINENT

When Nikodim Kondakov (1844—1925), the father of art history in Russia, left his country in 1920, he was seventy-five years old. At that age emigration would have seemed an act of definitively bowing out, and he could certainly not have conceived of the fact that he was yet to experience moments that were to be fundamental in his career |01|.[1] An internationally-recognized Byzantinist, Kondakov had behind him a lifetime of study on medieval art: beyond Byzantine art, he had written many pages on medieval art of Russia and of the whole Mediterranean. A scholar of the Positivist school, he was convinced of being the model of objectivity; but in reality, from the contemporary point of view, Kondakov was a man of his time. It is difficult now to gauge how aware he would have been of this, but his vision of a "Byzantine Commonwealth" was very close to the contemporary Russian *Weltanschauung*.[2] In Kondakov's view, Russia was the rightful heir of Byzantium, while art history could be a particularly useful tool in defending the positions of the tsarist empire for domestic politics |02| — such as the Caucasus — but also in foreign policy, where it was used to establish to whom Macedonia belonged.[3] From humble beginnings — Kondakov was a freed serf — he would rise to an extraordinary career that allowed him to draw near, in very real terms, to the throne. However, his "fall" was more rapid still, with the October Revolution causing him to lose all his privileges and properties. In 1920 he left Odessa, poor but with two suitcases and as many manuscripts of incomplete books. After Istanbul and Sofia, in Bulgaria, where he found favor, the scholar decided to move to Prague.[4] Among those who welcomed him in the newly-founded republic were his friends and

admirers Lubor Niederle (1865—1944) and Jiří Polívka (1858—1933), as well as the president, Tomáš Garrigue Masaryk (1850—1937).[5] The two knew each other from

1 For Kondakov, see Irina L. Kyzlasova, *Istorija izučenija vizantijskogo i drevnerusskogo iskusstva v Rossii. F. I. Buslajev, N. P. Kondakova: metody, idei, teorii* [The history of the study of Byzantine and ancient Russian art in Russia. F. I. Buslajev, N. P. Kondakov: methods, ideas, theories], Moscow 1985; *Eadem, Istoria otečestvennoj nauki ob iskusstve Vizantii i drevnej Rusi 1920—1930 gody. Po materialam arkhivov* [The history of patriotic studies dedicated to the art of Byzantium and of ancient Russia, 1920—1930. Based on archival material], Moscow 2000; *Eadem,* "Kondakov N.P.", in *Pravoslavnaja Enciklopedija,* Moscow 2014, Vol. 36, pp. 599—601; Ivan Foletti, *From Byzantium to Holy Russia. Nikodim Kondakov and the Invention of the Icon,* Rome 2017 [2011].

2 Gerold I. Vzdornov, *Istoria Otkrytija i izučenija russkoj srednevekovoj živopisi, XIX věk* [Discovery and study of medieval Russian painting, the nineteenth century], Moscow 1986; *Idem,* "Nikodim Pavlovič Kondakov, V zerkale sovremennoj vizantinistiki" [Nikodim Pavlovič Kondakov. In the mirror of contemporary Byzantine studies], in *Restavracija i nauka. Očerki po istorii otkrytija i izučenija drevnepusskoj živopisi* [Restoration and science. Observations on the history of the discovery of studies on ancient Russian painting], Moscow 2006, pp. 291—306.

3 Nikodim P. Kondakov, *Opis' pamjatnikov drevnosti v nektorikh khramakh Gruzii* [Description of ancient monuments in some temples in Georgia], Saint Petersburg 1890; *Idem, Makedonia. Arkheologičeskoe putešestvie* [Macedonia. Archaeological voyage], Saint Petersburg 1909. For the analysis, see Ivan Foletti, "The Russian view of a 'peripheral' region: Nikodim P. Kondakov and the Southern Caucasus", in *The Medieval South Caucasus = Convivium Supplementum III,* Ivan Foletti, Erik Thunø, with the collaboration of Adrien Palladino eds, Brno 2016, pp. 20—35.

4 Ivan Foletti, "Nikodim Kondakov et Prague: comment l'émigration change l'histoire (de l'art)", *Opuscula Historiae Artium,* 62/2 (2014), pp. 2—11.

5 Lubomíra Havlíková, "Lubor Niederle (1865—1944)", *Akademický bulletin,* 6 (2004), pp. 24—25; *Slavista Jiří Polívka v kontexte literatúry a folklóru I.—II.* [Slavist Jiří Polívka in the context of literature and folklore I—II]., Hana Hlôšková, Anna Zelenková eds, Bratislava/Brno 2008.

the time when Kondakov had backed Masaryk for a professorial position in Saint Petersburg. At the time, Masaryk's application had been refused for political reasons (according to Nikolaj Andrejev), but there remained between the two men mutual esteem and respect.[6] Personal reasons aside, however, Kondakov's arrival was part of a much wider project — termed the "Russian Action" — in which the Czechoslovak government decided to support the Russian intellectuals who had been forced to flee their country.[7] The aim of this plan, beyond supporting emigrants in need, was to lay the ground for an exclusive relationship between Czechoslovakia and Russia once the revolutionary phase had finished. During the years of the New Economic Policy (NEP), Masaryk was convinced that Bolshevism would have a limited duration.

History proved the Czechoslovak president wrong, and the "Russian Action" did not come to a glorious end; nevertheless, for two decades, Prague became one of the capitals of Russian emigration.[8]

Kondakov died in February 1925; his time in his new country was too short for him to truly make an impact on local historiography. However, his original studies from those years opened up an interesting direction: after years in which he had studied Byzantium and Russia, he devoted his last studies to the culture of nomadic peoples, who connected Asia and Europe with their migrations |∅3|.[9] Kondakov concentrated in

6 Nikolay Andreyev, "Material supplied by Dr. N. E. Andreyev, Formerly Student, Fellow and Acting Director of the Kondakov Institute in Prague", Columbia University Libraries, Manuscripts collections, Bakhmeteff Archive, Vernadsky Collection, box 158, p. 2.

7 Elena Chinyaeva, *Russians outside Russia. The Émigré Community in Czechoslovakia 1918–1938*, Munich 2001; Irina Mchitarjan, *Das "russische Schulwesen" im europäischen Exil. Zum bildungspolitischen Umgang mit den pädagogischen Initiativen der russischen Emigranten in Deutschland, der Tschechoslowakei und Polen (1918–1939)*, Bad Heilbrunn 2006; *Eadem*, "Prague as the Centre of Russian Educational Emigration: Czechoslovakia's Educational Policy for Russian Emigrants (1918–1938)", *Paedagogica Historica*, XLV/3 (2009), pp. 369–402.

8 Chinyaeva, *Russians outside Russia* (n. 7), pp. 53–54; See also Chapin W. Huntington, *The Homesick Million. Russia-out-of-Russia*, Boston 1933, p. 123.

9 Nikodim P. Kondakov, "Les costumes orientaux à la Cour Byzantine", *Byzantion*, 1 (1924), pp. 7–49. The complete list of Kondakov's lectures in Prague is listed at the end of Vernadskij's article of 1926: Georgij Vernadskij, "Nikodim Pavlovič Kondakov", in Aa.Vv., *Recueil d'études dédiées à la mémoire de N. P. Kondakov. Archéologie. Histoire de l'art. Études byzantines*, Prague 1926, pp. XXVI–XXVII, (n. 3).

N. P. KONDAKOV

PŘÍSPĚVKY

K DĚJINÁM STŘEDOVĚKÉHO UMĚNÍ

A KULTURY

PRAHA 1929
VYDALA ČESKÁ AKADEMIE VĚD
A UMĚNÍ

Н. П. КОНДАКОВЪ

ОЧЕРКИ И ЗАМѢТКИ

ПО ИСТОРІИ СРЕДНЕВѢКОВАГО ИСКУССТВА

И КУЛЬТУРЫ

ПРАГА 1929
ИЗДАНІЕ ЧЕШСКОЙ АКАДЕМІИ НАУКЪ
И ИСКУССТВЪ

|**03**| ↗ Nikodim Kondakov, *Příspěvky k dějinám středověkého umění a kultury / Очерки и заметки по истории средневекового искусства и культуры*, Prague 1929

particular on the Slavic populations and thus, as I have written elsewhere, we cannot rule out that he was looking for a subject that would interest his adoptive (Slavic) country. In the background, there must have have also been another concept, that was very popular among Russian émigrés — Eurasianism — considered to be a response to the new situation that had been created.[10] Having "lost" their country, they found a sort of answer to their sentiments in the supranational structure of Eurasia, an element around which to fashion their identity and belonging.

After Kondakov's death, his legacy would be taken up by a group of scholars and friends who had gathered around him in the last years of his life |**04**|. Their first step was to prepare a collection of essays in his honor (published in 1926), followed by informal gatherings that paved the way for the founding, in 1925, of the *Seminarium Kondakovianum*.[11] It was a seminar for intellectual exchange, as well as the eponymous title of a journal for studies devoted to the Byzantine world, as well as that of the Steppe. Alongside this, the same group *Seminarium Kondakovianum*, which became the *Institutum Kondakovianum* in 1931, brought forth two series of monographs,

dedicated to both these fields of study — *Skythika* and *Zografika*. The Institute's activities were highly visible internationally: there were subscribers all across Europe and in the United States of America, including individuals and organizations |ᴏ5|.[12]

10 Foletti, "Nikodim Kondakov et Prague" (n. 4); Francesco Lovino, "Constructing the Past through the Present: The Eurasian View of Byzantium in the Pages of Seminarium Kondakovianum", *Trends and Turning Points Constructing the Late Antique and Byzantine World*, Matthew Kinloch, Alex MacFarlane eds, Leiden/Boston 2019, pp. 14—28. In general on the notion, see *Between Europe and Asia: The Origins, Theories, and Legacies of Russian Eurasianism*, Mark Bassin, Sergey Glebov, Marlene Laruelle eds, Pittsburgh 2015 and Michel Bruneau, *L'Eurasie. Continent, empire, idéologie ou projet*, Paris 2018.

11 *Recueil d'études* (n. 9). On *Seminarium*, see Lawrence Hamilton Rhinelander, "Exiled Russian Scholars in Prague: The Kondakov Seminar and Institute", *Canadian Slavonic Papers / Revue Canadienne des Slavistes*, 16/3 (1974), pp. 331—352; Zuzana Skálová, "Das Prager Seminarium Kondakovianum, später das Archäologische Kondakov-Institut und sein Archiv (1925—1952)", *Slavica Gandensia, A Thousand—Year Heritage of Christian Art in Russia*, 18 (1991), pp. 21—43; Věra Hrochová, "Činnost Institutu N. P. Kondakova v Praze a jeho mezinárodní význam" [The activities of the N. P. Kondakov Institute in Prague and its international significance], in *Ruská a ukrajinská emigrace v ČSR v letech 1918—1945* [Russian and Ukranian emigration in Czechoslovakia between 1918—1945], Václav Veber [*et al.*] eds, Prague 1995, vol. 3, pp. 32—41; Martin Beißwenger, *Das Seminarium Kondakovianum in Prag (1925—1952)*, M.A. Thesis, Humboldt-Universität, Berlin, 2005 [2001]; Francesco Lovino, "Leafing through *Seminarium Kondakovianum*, I. Studies on Byzantine Illumination", *Convivium*, III/1 (2016), pp. 206—213; *Idem*, "Southern Caucasus in Perspective. The Scholarly Debate through the Pages of *Seminarium Kondakovianum* and *Skythika* (1927—1938)", in *The Medieval South Caucasus* (n. 3), pp. 36—51; *Idem*, "Communism vs. *Seminarium Kondakovianum*", in *Convivium*, IV/1 (2017), pp. 142—157.

12 All the correspondence of *Seminarium* is preserved in Prague in the Archives of the Department of Art History, of the Academy of Sciences of Czech Republic (ÚDU AV). See in particular Boxes KI-12 to KI-18. For the numbers of subscribers, see Věra Hrochová, "Les études byzantines en Tchécoslovaquie", *Balkan Studies*, 13 (1972), pp. 22—26.

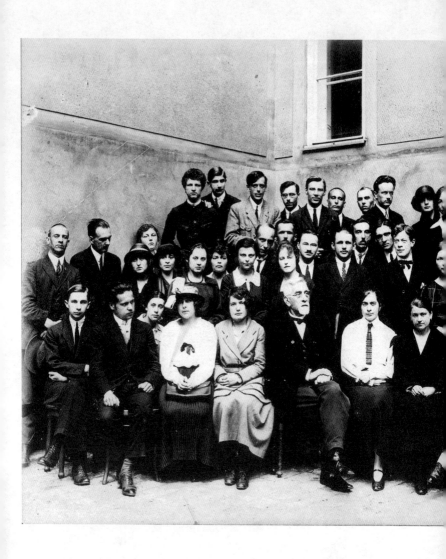

|04| ↖ Nikodim Kondakov and
his pupils in Prague, 1924 c.

|05| ↑ Two images of the
Trinity, from Nikodim
P. Kondakov, *Russkaja Ikona*,
4 vols, Prague 1928—1933

After the first, fertile years, the Institute continued, carrying on through the second half of the 1930s, when the situation in Europe became ever more difficult, while the Czechoslovak government became increasingly less generous towards Russian émigrés.[13] Thanks to the support of patrons and sales, the Institute survived, but fear of an imminent outbreak of war was such that in 1938 it was decided that a second institute in Belgrade would be established; the Institute was welcomed there by Prince Paul of Yugoslavia (1893–1976), regent of the last king of Yugoslavia, Peter II (1923–1970).[14] Unpublished archival documents bring to light a fact of great interest: contact with Belgrade was established by an unexpected figure — the connoisseur and historian of modern art, Bernard Berenson (1865–1959).[15] Nearly all of the library and a part of the collections were transferred to Yugoslavia just before the Munich Agreement, the first tragic act that brought Czechoslovakia under the Third Reich, marking the start of one of the most difficult periods in the country's history.[16] The director, Nikolaj P. Toll', left the country, and the communication between the two Institutes was carried out exclusively by letter and was not without tensions, mostly caused by the question of how the revenue from sales would be distributed.[17] When Belgrade was invaded by Nazi forces, part of the *Institutum Kondako-vianum* was destroyed by bombings; two individuals lost their lives in these tragic events, and the books that survived were sent back to Prague by the occupying troops.[18] At the end of the war, the Institute came back to life, and was incorporated in 1952 into the newly established Czechoslovak National Academy.[19] All elements honoring the memory of Kondakov, however, were to disappear.

As mentioned above, albeit with some notable variance, for the duration of its existence, the Institute's priorities followed along the same lines as those promoted

by Kondakov. Interestingly, however, the positions put forward were closest to those in Kondakov's last works. Byzantium was no longer studied as the precursor to the glorious empire of the tsars, but rather as a supranational structure — a sort of bridge uniting the different cultures. This was a logical element in the Institute's new context: Russian studies of Byzantium had lost their hegemonic status, in part due to the revolution. In the nineteenth century, Russia aspired to be considered the heir of the ancient Eastern empire, and the other states granted this ambition; the new era brought in the concept of a Byzantium that was a hub for many. The

13 Chinyaeva, *Russians outside Russia* (n. 7), pp. 61–66. For the overall spending by the Czechoslovak government on the Russian Action by years see *Ibidem*, p. 64.

14 Aa. Vv., "Prince Paul Karadjordjević regent of Yugoslavia", *Encyclopaedia Britannica*, 1998, [online: https://www.britannica.com/biography/Prince-Paul-Karadjordjevic, last accessed 5.6.2019].

15 The letters are conserved in ÚDU AV, KI 12. Berenson N. sv. 15. For Berenson in general, see Ernest Samuels, *Bernard Berenson: the making of a Connoisseur*, Cambridge/London 1979.

16 The bibliography is extensive; see for example the general reflection of Jeffrey Record, *The Specter of Munich: Reconsidering the Lessons of Appeasing Hitler*, Washington 2007. For an overview from the Czech perspective, see Robert Kvaček, *Poslední den: Mnichov — Praha, 1938* [The last day: Munich—Prague, 1938], Prague 2018.

17 Josef Myslivec, "Archeologický ústav N. P. Kondakova" [The Archeological institute of N. P. Kondakov], *Ročenka Slovanského ústavu v Praze*, 12 (1947), pp. 221–222; Roman Zaoral, "Karel VI. Schwarzenberg. Student, spolupracovník a mecenáš Kondakovova ústavu" [Karel VI. Schwarzenberg. Student, associate, and patron of the Kondakov institute], in *Schwarzenbergové v české a středoevropské kulturní historii* [The Schwarzenbergs in Czech and Central European cultural history], České Budějovice 2008, pp. 547–556, 552.

18 Myslivec, "Archeologický ústav N. P. Kondakova" (n. 17); Hrochová, "Les études byzantines" (n. 12), p. 305; Lovino, "Communism vs. *Seminarium Kondakovianum*" (n. 11); Andreyev, "Material supplied by Dr. N. E. Andreyev" (n. 6), pp. 43–44.

19 Zaoral, "Karel VI. Schwarzenberg." (n. 17), pp. 555–556.

Pan, ~~Paní, Sl.~~

Karel Schwarzenberg
jméno a příjmení

je Předsedou
předseda, ~~člen, atd.~~

MÍSTNÍHO NÁRODNÍHO VÝBORU
v
Čimelioích.

v Čimelioích dne 17.VIII.1945

Vlastnoruční podpis majitele.

Poznámka: Není-li v průkazce podobenka,
prokazuje osobní totožnost le-
gitimace občanská (úřední)
čís.

|ø6| ↗ Identity card for the chairman of local committee in Čimelice on the Karl Schwarzenberg name, 1945

perception of nomads (or migrants, as they would now be called) was much the same: their movement was a visible point of union between Asia and Europe. Kondakov's last works already emphasized the different ethnic identities of the various tribes — the aggressive Germanic peoples, contrasted with the peaceful and creative Slavs.[20] The idea of nomad peoples (Slavs) as the epicenter of cultural transfers thus became fundamental also for the work of the *Istitutum*.

It would be more difficult to gauge the impact of these themes on the Czechoslovak intellectual world, however. Of course, Myslivec became a member of the Institute, and Prince Karel Schwarzenberg (1911–1986) |ø6| was an active supporter, but it remained overall a niche phenomenon.[21] I believe there are two principal reasons for this: the first is in a way linked to Russian action, and more specifically the fact that the Russian diaspora in Czechoslovakia lived in relative (but significant) isolation.[22] Convinced, as was Masaryk, that they would soon return to Russia, many émigrés did not attempt to integrate, and while Czech was not a difficult language for a Russian to pick up, many did not even learn the

74

language of the country. The publications of *Seminarium* were in Russian for the most part, with summaries in French, English, and German. Little to nothing was published in Czech. This was a decision taken with the targeted audience in mind: international languages of scientific communication were used — among which, at the time, was Russian, at least for Byzantine studies. It is no accident that, for example, as attested in the Prague archives, Prince Schwarzenberg himself spoke and wrote, in the context of the Institute, solely in Russian.[23] From this point of view, it made no sense to translate the more important publications into Czech, but this choice meant that the Institute's activities were almost exclusively for the cosmopolitan élite. This internationally renowned Institute was located in Prague, but all things considered it was deeply isolated within the country itself. And this holds true despite the fact that among its members and supporters were individuals of note such as Jan (1886—1948) and Alice Masaryk (1879—1966), the children of the Czechoslovak president.[24]

The second reason for the Institute's niche position, I believe, is the fact that for Czech medievalists the true

20 Nikodim Kondakov, *Příspěvky k dějinám středověkého umění a kultury / Очерки и заметки по истории средневекового искусства и культуры* [Contributions to the history of medieval art and culture], Prague 1929, p. 61.

21 *Slovník historiků umění, výtvarných kritiků, teoretiků a publicistů v českých zemích a jejich spolupracovníků z příbuzných oborů (asi 1800—2008)* [Dictionary of art historians, art critics, theoreticians, and journalists in Czech lands and their collaborators from related fields (c. 1800—2008)], Lubomír Slaviček ed., Prague 2016, vol. 1, pp. 964—965. Hrochová, "Les études byzantines" (n. 12), p. 303 discusses the fact that it was a foreign institution, which thus would not have had an impact on Czechoslovak Byzantinology.

22 Chinyaeva, *Russians outside Russia* (n. 7), pp. 160—169.

23 ÚDU AV, KI-16 Schwarzenberg.

24 ÚDU AV, KI-14 Masaryková A.

challenge in the early decades of the newly-formed republic was to compose their own national art history.[25] After centuries under the dominion of the Habsburgs, where a multicultural discourse was necessarily an affair of state, the nascent republic was building itself through a nationalist discourse (including the invention of a Czechoslovak national art). It is not that the country lacked interest in other cultures, but as for Adalbert Birnbaum, for them the question of national art was truly important.[26] There was naturally the (pan-) Slavic matter, for which Byzantium could serve as a fundamental passage way.[27] However, this role in the "intellectual market" had been filled since 1929 by the journal *Byzantinoslavica*, under the aegis of the Slavic Institute, and clearly set up for this objective |07|.[28]

|07| → Cover of the journal *Byzantinoslavica*, vol. 1, Prague, 1929

The phenomenon of Kondakov's Institute therefore had a clear weight in the interwar period, fashioning an image of Prague that was cosmopolitan and open to the outside world. Within the country, and especially for national historiography, its impact was marginal, all things considered. The lack of a relationship with the university did not help, and *Institutum* nearly vanished without a trace, just like the émigrés who had established it, in their westward flight.

THE *INSTITUTUM KONDAKOVIANUM* AND THE PROTECTORATE

As written above, I do not intend to only analyze the impact of *Seminarium* on Czechoslovak historiography. In the archives of Georgij Vernadskij, one of the greatest Russian historians of the twentieth century, Karolina Foletti has recently discovered an unpublished text, nearly sixty pages long |08|, written by Nikolaj Andrejev (1908—1982). Andrejev was the next to last director of the

Institute, and in this text from the 1960s he decided to tell the story of the last tormented years of the Institute,

a text which he subsequently sent to Vernadskij |09|.[29] The text is far from being devoid of personal concerns: more than twenty years after the events, Andrejev provided his version of a highly complicated situation, and reading the text, it is hard to shake the feeling that he wanted to justify his actions once and for all. This frame does not detract from my aim, and the text is absolutely fundamental here. The text itself is accompanied by a letter in which Andrejev explains to Vernadskij that his recounting of the story was born almost by chance, at first as in reply to a request, with the text then exceeding this scope. Indeed, beyond the internal

25 See notably the article by Sabina Rosenbergová and Adrien Palladino in the present volume.

26 On Birnbaum, see Petra Hečková, *Vojtěch Birnbaum a jeho stanovisko ve vědeckém sporu Orient oder Rom. Příspěvek k výzkumu pozdně antické architektury po roce 1900* [Vojtěch Birnbaum and his position in the scientific dispute Orient oder Rom. Contribution to the research on Late Antique architecture after 1900], PhD thesis, Palacký University Olomouc 2009.

27 Hrochová, "Les études byzantines" (n. 12), pp. 301—303.

28 *Ibidem*; Francesco Lovino, "Seminarium Kondakovianum / Byzantinoslavica: a comparison", in *From Kondakov to Hans Belting Library*, Ivan Foletti, Francesco Lovino, Veronika Tvrzníková eds, Brno/Rome 2018, pp. 38—55.

29 Part of this text, never published in its integrality, was finally printed in the memoirs of Nikolay Andreyev, *A Moth on the Fence. Memoirs of Russia, Estonia, Czechoslovakia, and Western Europe*, Kingston-upon-Thames 2009.

По просы 9|17|68 G. Vernadsky

MATERIAL SUPPLIED BY Dr. N.E. ANDREYEV

formerly Student, Fellow and Acting Director of the

KONDAKOV INSTITUTE IN PRAGUE

It would seem desirable to give at the beginning of the work
a list of books and articles on N.P. Kondakov, as well as of his own
publications, so that the reader may realize from the start the extent
and depth of his scholarship and the fact that he was the very first
to establish the study of Byzantine art on a scientific foundation by
analyzing, on the basis of their dates, Byzantine illuminated manu-
scripts, thus becoming, as expressed by S.A. Zhebelev in the obituary
published in the Recueil "the creator of methods for Russian archaeo-
logical research".

A list of such works can be culled from the Recueil and
the sborniki.

It may also be interesting to mention that, for instance,
N.V. Lazarev, at present member of the USSR Academy of Sciences and
one of the leading authorities on Byzantine and old Russian art, pub-
lished in Moscow in 1925 a pamphlet entitled "N.P.Kondakov".

It should be emphasized that the activities of the
founders of the Seminarium Kondakovianum were the outcome of their
wish first to honour their teacher's memory (publication of the
Recueil) and subsequently to continue his line of research (Sborniki
and series).

T.G. Masaryk, President of the Czechoslovak Republic, held
Kondakov in the highest esteem as a scholar and it was on his initia-

conflicts following the Institute's split into the Prague
and Belgrade branches, Andrejev also recounts how the
Institute was able to survive the war: what concessions
were made, what dangers were overcome, how fortune
smiled on the Institute, and finally how his personal
bravery contributed to the feat.

In general, the Institute was able to survive thanks
in large part to the economic and moral support of
Prince Karel Schwarzenberg, who in times of the Insti-
tute's greatest need provided the funds necessary to save
it |10|.[30] Schwarzenberg was a noted sponsor; nevertheless,
his stance with regard to an institute composed mainly

of immigrants might seem surprising. The explanation offered by Zaoral, the author of an excellent article on the subject, seems robust. What drew Schwarzenberg to the *Institutum* was his interest for heraldry — from Russia to the West, and from the Middle Ages to the contemporary world — as well as his passion for icon painting.[31] Michal Řoutil has delved further into the latter element, including the fact that Schwarzenberg took classes on icon-painting, organized by the *Institutum*.[32] This aspect, closely linked to the dissemination activities of the Institute in the 1930s when, in addition to painting courses, it also promoted an exhibition of medieval icons, held in 1932. Cosmopolitan, and an accomplished speaker of Russian, the young Karel Schwarzenberg thus became a crucial figure for the difficult wartime years, before taking up the directorship of the Institute in 1945, after Andrejev was arrested; he would hold this role until the Communist putsch of February 1948.[33]

Another key element in Andrejev's text is the dense (and ever-difficult) dialogue between the Institute and the occupying forces. In his recounting of events, Andrejev sketches a very precise profile of the life of an international institution under the Protectorate. Although there is no apparent brutality to be found in the text, the

30 Zaoral, "Karel VI. Schwarzenberg" (n. 17); for the archival documents see ÚDU AV, K—16 Schwarzenberg.
31 Zaoral, "Karel VI. Schwarzenberg" (n. 17), pp. 548, 554.
32 Michal Řoutil, "Kníže Karel VI. Schwarzenberg a jeho učitel ikonomalby Pimen Maximovič Sofronov (na materiálu archivu Archeologického institutu N. P. Kondakova v Praze)" [Prince Karel VI. Schwarzenberg and his teacher of icon painting Pimen Maximovič Sofronov (from materials of the archive of the Archeological institute of N. P. Kondakov in Prague)], *Parrésia. Revue pro východní křesťanství*, 7 (2013), pp. 261—282.
33 Zaoral, "Karel VI. Schwarzenberg" (n. 17), pp. 555—556; ÚDU AV, sv. 2; 10.

|09| ↑ Nicolay Andreyev in front
of the Kondakov's Institute,
Prague, 1940(?)

|10| → Letter to Karel
Schwarzenberg, Prague, 1940

V Praze, dne 7.září 1940.

J. J.
Kníže Karel Schwarzenberg,

 P r a h a II.
 Voršilská 6.

Vaše Jasnosti,

 Potvrzuji příjem Vašeho jednorázového členského příspěvku v obnose K.65.000.- /šedesáti pěti tisíc korun/. Tato částka dle Vašeho přání bude určena na zařízení a zvětšení místností Institutu za účelem umístění jeho sbírek a na vydávání jeho prácí.

 Váš velkorysý čin jest projevem Vašeho vzácného pochopení významu vědecké činnosti našeho Institutu a jeho současných úkolů. Tímto jest umožněno prodloužení práce kněžny N.G.Jašvilové a starší skupiny zakladatelů a spolupracovníků Institutu a udržování vědecké a umělecké tradice.

 Jménem Archaeologického Institutu N.P.Kondakova dovoluji si vysloviti Vám, Vaše Jasnosti, nejsrdečnější a nejvroucnější díky.

 S projevem dokonalé úcty

 za Institut

tensions described are powerful, with a series of recurring dangers: the menace of closure, of merging with the Slavic Institute, or (Andrejev's seemingly greatest fear) inclusion in an explicitly pro-regime institution, such as the Free Russian University, or the German University.

As a concrete example of these pressures, the Institute was "infiltrated" twice during the course of the war, by agents working for different sides. The first to be mentioned is a man by the name of Dedio, who presented himself as a German employee, interested in learning Russian. After a few meetings, during which Andrejev gave language lessons to the young man, it was Dedio who showed himself in a different light:

On one occasion Dedio invited his teacher to his rooms. When Dr. Andreyev came in, he gasped: Dedio met him wearing the uniform of an S.S. officer. He was apparently amused by the effect produced. Smiling, he said: "Have no fear. I have been appointed to work here with the Gestapo and I am one of the experts on Russian émigrés, but you had better not mention it elsewhere. Silence is sometimes highly advisable".[34]

A paradoxical element emerges here, as Andrejev shows that it was precisely thanks to this agent that the *Institutum* avoided danger first, since the Gestapo found nothing problematic in the Institute, and even allowed the *Seminarium* to maintain its independence from the German University, as well as from the associations of Russian émigrés who explicitly collaborated with the Nazi regime.[35]

The second infiltration was carried out by a young Czech woman from Vienna, who started out by offering help to the Institute. In this case as well, however, the agent revealed herself after a few meetings, as a spy from

the resistance, tasked with checking whether the Institute was collaborating with the regime.[36] According to Andrejev, she too helped the Institute, protecting it from potential reprisals once the war came to an end.

Another powerful protector for the Institute came in the figure of the vice rector of the German University, Herwig Hamperl (1899–1976).[37] The latter had an absolutely decisive role during a moment of peril for Andrejev and the whole Institute:

Unexpectedly, at one p.m. an urgent message came by hand from the Rectorate of the German University addressed to Dr. Andreyev that Professor Hamperl would expect him the following morning at 10 o'clock and that he would be required to comment on a letter received by Professor Hamperl from Prof. G. A. Ostrogorsky, which was attached. The purport of the letter was as follows: Ostrogorsky, writing in his capacity as Chairman of the Board of the Kondakov Institute, said that it had come to his knowledge that Dr. Andreyev, the youngest member of the Institute left in Prague after the departure of the Institute for Belgrade, in order to liquidate various pending matters, is now taking the liberty of misinforming the German authorities by creating the impression of fictitious scientific work done in Prague, makes unauthorized

34 Andreyev, "Material supplied by Dr. N. E. Andreyev" (n. 6), p. 19.

35 *Ibidem*, p. 20.

36 *Ibidem*, p. 42.

37 Alena Mišková, "Die deutsche Universität Prag im Vergleich mit anderen deutschen Universitäten in der Kriegszeit", in *Universitäten in nationaler Konkurrenz: zur Geschichte der Prager Universitäten im 19. und 20. Jahrhundert*, Hans Lemberg ed., Munich 2003, p. 192; Hamperl himself wrote of the period in his memoirs, see Herwig Hamperl, *Werdegang und Lebensweg eines Pathologen*, Stuttgart 1972, pp. 97–147, 192–193.

*statements on behalf of the Institute, where he has no
scientific or administrative standing, and appropriates
property and funds belonging to the Kondakov Institute.*[38]

In his text Andrejev expands on the consequences such
a letter could have had if it had fallen into the wrong
hands:

*It was clear that this letter was meant not only to under-
mine the respect in which Andreyev was held, but to ex-
pose him to reprisals on the part of the German authori-
ties including the Gestapo, perhaps even to arrest and,
in any case, lead to his final dismissal from the manage-
ment of the Institute in Prague.*[39]

Decades later, recounting these events had an emotion-
al impact on Andrejev, who felt some rancor still. Fur-
thermore, I think this is one of the passages that best
accounts for the introduction to the text, in which the
scholar declares that he wishes to explain certain misun-
derstandings. He carries on with the story:

*Dr. Andreyev did not doubt for a single moment that Os-
trogorsky was inspired to write this shameful denunci-
ation to the Nazis by Rasovsky's foolish hatred, but was
shocked that Ostrogorsky, whom Andreyev deeply re-
spected and who had influenced him in the methodolog-
ical treatment of his doctorate thesis, could have sunk so
low as to write to the Nazi authorities, from a safe dis-
tance, with spiteful lies about a "Kondakovian".*

*Fortunately, a meeting of the Council had been called
for the same evening, at which Ostrogorsky's insinua-
tions were fully analyzed. All the members were stunned
by Ostrogorsky's action and greatly worried by its pos-
sible effect on the Institute and on Andreyev personally.*

Dr Myslivec and Professor Savitsky — by analogy with cases known to them — expected the matter to be passed to the German police and even to the Gestapo, but Prince Schwarzenberg thought that if this were so Hamperl would not have communicated Ostrogorsky's letter to Andreyev, but would simply have sent for him and taken him by surprise with these accusations. Schwarzenberg and Chernavin believed that the following day Andreyev would be given the chance to supply all the pertinent explanations. The Council's session lasted nearly all night, a collective memorandum being drawn up informing about all the steps taken by Dr. Andreyev after Dr. Toll's departure and giving the reasons which had led to the divergence of opinions between Prague and Belgrade. The memorandum was clear, logical and strictly factual. It was translated by Prince Schwarzenberg into faultless German.[40]

It is apparent that Ostrogorskij did not realize how dangerous the situation was in the protectorate, and the consequences of such accusations. Economic crimes, especially those that could damage the Reich, were punished with extreme severity in those years.[41] In any case, Hamperl intervened decisively:

Thank your God that this vile letter was addressed to me, otherwise you would already be in prison. I believe your

38 Andreyev, "Material supplied by Dr. N. E. Andreyev" (n. 6), pp. 37–38.
39 *Ibidem*, p. 38.
40 *Ibidem*, pp. 38–39.
41 On the juridical situation in general see Jaromír Tauchen, "Law in the Protectorate of Bohemia and Moravia", in *Plundered, But By Whom? Protectorate of Bohemia and Moravia and Occupied Europe in the Light of the Nazi-Art Looting*, (Proceedings of an international academic conference held in Prague, 21–22 October 2015), Prague 2015, pp. 43–56.

interpretation of the facts, for all the data we have on you
absolutely contradicts Ostrogorsky's assertations. Besides,
we know Schwarzenberg and Savitsky. I am surprised
that such a well-known scientist as Ostrogorsky should
appear so foolish and dishonest. I must report all this to
my superiors. Of course you need not answer Ostrogor-
sky's letter; he probably imagines that you will never see
it. I shall duly inform you of my superiors' decision.[42]

Andrejev was saved, and his position at the *Seminarium*
was likewise definitively stabilized. It was once again
thanks to Hamperl that the Institute was able to main-
tain its independence throughout the war. In the dif-
ferent accounts in which Andrejev plays a main role, it
is always clear how difficult the situation was for him.
Hamperl offered several times to join the German in-
stitution, and it was only thanks to a certain element
in Andrejev himself, and the constant help of Prince
Schwarzenberg that such a situation could be avoided.

A constant comes up again at different points in the
story: regularly, the Istitutum is saved thanks to its great
international fame. Emblematic is an episode that in-
volved a Bavarian art historian, Johan Joseph Morper
(1899—1980). The latter appeared in military uniform to
visit the institute:

The Institute received an unexpected visit from a Ger-
man in uniform [...] who in high-sounding terms started
praising Kondakov and his work and made a [...] speech
in front of his portrait, expressing his delight at finding
himself in "this temple of scholarship". The only execu-
tive present, Dr. Andreyev, was finally able to ascertain
that he was Dr. Morper, an art historian from Munich,
who in fact had previously written on Kondakov and
the Institute's publications. Andreyev immediately took

86

a file from a shelf to show to Dr. Morper, containing off-prints of all Morper's work sent to the Institute. (At the Institute's library Dr. Toll had organized a very efficient system of such files for the publications of the members and of other scholars, where all these off-prints were kept, with a list of contents on the outside). Morper was greatly pleased by 'such attention to my feeble works' and became the Institute's firm friend. He said that though he had been conscripted as a private, he had been transferred to the Cultural Department of the Protectorate and that he was to "write a special report on the Institute, which was a jewel not only of the Protectorate but of the Third Reich" and so on.[43]

The German scholar had been attracted by the Institute's international renown. This visit, however, nearly induced a catastrophe, since it was precisely the high scientific quality of the Institute that made Morper wish to better integrate it into the Reich's academic structures. The peril finally passed, but what emerges from Andrejev's account is that the Institute's prestige was not impaired by the war. On the contrary, and paradoxically given its Russian identity (or perhaps more accurately "non-Czechoslovak"), together with its international visibility, the Institute was precious to the Germans: on the one hand, they wished to integrate the émigrés, in order to then involve them in the war against the Communists — a constant theme in the Reich's propaganda. On the other, for use in propaganda abroad, maintaining international institutions within the Protectorate was a very useful card to hold. An interesting fact is that what has been described above as a barrier to assimilation in

42 Andreyev, "Material supplied by Dr. N. E. Andreyev" (n. 6), p. 39.
43 *Ibidem*, pp. 20—21.

the local Czechoslovak society became somewhat of an advantage in the context of the Protectorate.

|11| → Kondakov's Institute, Hastalská 6, Prague, 1944 c.

The paradox is reinforced by a further element: the Institute's position during the war improved economically year on year. Thanks to the sale of color reproductions of Russian icons (very popular among Catholic Germans), and a happy accident of a stock of high quality paper which had by mistake not been declared at the start of the conflict, the Institute grew considerably wealthier.[44] Moreover, thanks to a donation of icons by Josef Girsa (1874–1967), a former Czechoslovak ambassador to Moscow, the Institute had the possibility to undergo an important transformation:[45]

The impulse was given by J. J. Girsa, formerly Czechoslovak Consul in Moscow, who had brought from there part of the magnificent collections of icons previously owned by the Soldatenkov, a family of Old Believers. He kept these icons in cases in the basement of his house. J. Girsa, an elderly widower, now that the war had started and the Gestapo had begun to arrest a number of high-ranking public men of the First Czechoslovak Republic, was anxiously wondering what would become of the collection in case anything happened to him. He called at the Institute and after a lengthy discussion a decision was arrived at: as the collection could easily be confiscated on various grounds, the best way of protecting it would be to exhibit it permanently, preferably in the Institute's premises.[46]

This donation, followed soon after by the Institute's move to a new residence, with the support of Karel Schwarzenberg, made the Institute into a bona-fide museum |11|.[47]

Andrejev's account is exciting and rich in impressive detail; but as noted above, throughout the sixty pages of

text it is hard not to have the impression that the author was trying to justify his behaviour during the conflict. From this point of view, it is revealing that he narrates his actions both in first person and third person contemporaneously (sometimes switching in the middle of a paragraph).[48] A reason for such conduct can be found in how he explains and justifies the conflict with the

44 For the documents see ÚDU AV, KI-1, sv. 9; Andreyev, "Material supplied by Dr. N. E. Andreyev" (n. 6), pp. 25–49; Hrochová, "Činnost Institutu" (n. 11), p. 34; Zaoral, "Karel VI. Schwarzenberg" (n. 17), p. 552.

45 Jindřich Dejmek, "GIRSA Josef 6.10.1874–22.11.1967", in *Biografický slovník*, [online: http://biography.hiu.cas.cz/Personal/index.php/GIRSA_Josef_6.10.1874–22.11.1967, last accessed 10.7.2019].

46 Andreyev, "Material supplied by Dr. N. E. Andreyev" (n. 6), p. 24.

47 Zaoral, "Karel VI. Schwarzenberg." (n. 17); ÚDU AV, KI-16 Schwarzenberg letter of the 7.9.1940.

48 In general, for the problems of autobiographical writing, see Ivan Tassi, *Storia dell'io. Aspetti e teorie dell'autobiografia*, Rome/Bari 2007.

Belgrade branch. Once that had been resolved, it seems that Andrejev wished to free himself from all possible accusations. Nevertheless, I do not believe that this means that Andrejev really did carry out any action of which he should be ashamed. What he describes is the environment of occupied Prague, where it was necessary, *nolens volens*, to take part in a dangerous dialogue with the occupier, and where disaster lurked around every corner.

This sort of situation, though with slightly reduced violence, emerged again between 1948—1989. However, in that case, the *Institutum* did not survive. There is an element in this that I find very interesting: in his text Andrejev declares that, once the situation had stabilized, after the split from Belgrade, and with regular funding available, the Institute decided unanimously not to publish anything during the war.[49] Pragmatic reasons were given, but I think that Andrejev was aware of the fact that in those conditions it would have been impossible to write in an "impartial" way. He was capable of doing many things to save his Institute, entering a deeply perilous contact with the Nazi authorities; nevertheless, he did not wish to stain the prestige of the Institute with a publication complicit with the regime.

Unfortunately, however, these efforts were in vain: in the sphere of Russian influence there was no space for an institution established by White Russian émigrés. Andrejev and Savikov were arrested by the Soviet secret police (SMERSH) on the 23rd of May 1945, a few days after the Russians entered Prague. Andrejev could never return to Prague and was imprisoned in Bautzen.[50] Two years later, he was freed thanks to the intervention of Hana Benešová (1885—1974), the wife of President Edvard Beneš (1884—1948), but the destiny of the Institute by that time was more or less sealed.[51] In scholarly texts, there is a slight contradiction given that according to

Hrochová, who at the time was the youngest eye-witness of the events, the decision to annex it to the Academy of Sciences was taken as early as 1948, and attributed to Zdeněk Nejedlý (1878–1962), director of the Academy.[52] However, according to Zaoral, on the basis of the scarce sources conserved, this all happened later, in the spring of 1952.[53] The sources held in the archives of the Academy of the Sciences in Prague also seem to support this version of events.[54] In any case, this makes little difference to the core of the matter: the *Institutum Kondakovianum* disappeared, and all memory of it was evidently obscured, as demonstrated in the studies by Hrochová, who in her 1972 essay provides a very partial history of the Institute, and subsequently opened her 1995 article with genuine joy at being able to finally recount the "truth".[55]

CONCLUSION

Considering the trajectory of the *Institutum Kondakovianum*, including its experiences during the war, a few observations can be made. Firstly, from its conception to its dissolution, this project was formulated in an exquisitely international way. Born in a moment of Russian cosmopolitan emigration, the *Institutum* was anchored from the start in a transcultural reality. This fact can be clearly seen in the vision of the world that it presented:

49 Andreyev, "Material supplied by Dr. N. E. Andreyev" (n. 6), pp. 44–45.
50 Beißwenger, *Das Seminarium Kondakovianum* (n. 11), p. 63.
51 Zaoral, "Karel VI. Schwarzenberg." (n. 17), p. 554.
52 Hrochová, "Činnost Institutu" (n. 11), p. 34.
53 Zaoral, "Karel VI. Schwarzenberg." (n. 17), p. 556.
54 ÚDU AV, KI–1, sv. 3.
55 Hrochová, "Les études byzantines" (n. 12); *Eadem*, "Činnost Institutu" (n. 11), p. 32.

in the wake of Kondakov's studies, Byzantium and the nomads of the Steppe became a visible thread in the history of a Eurasian reality, and at the same time, one that was transnational.

For these reasons, however, the Institute barely took root in the Czechoslovak context, to the point where the move to Belgrade (both a pragmatic and an economic decision) was automatic for many of its members.

Nevertheless, it was the Institute's international dimension that saved it during the tumultuous years of the Second World War: it suited the Third Reich to maintain these institutions that put it in a good light, in the eyes of its allies and of neutral states.

Having disappeared when the Communists took power, the Institute left relatively few traces in Czechoslovakia, apart from the activities of Myslivec. Its existence as a cosmopolitan island in the center of Europe was nearly forgotten, but the memory of a place where art history encountered history and became inextricably intertwined, remains.

This article was carried out as part of the ongoing project "The Heritage of Nikodim Pavlovič Kondakov in the Experiences of André Grabar and the Seminarium Kondakovianum" (Czech Science Foundation, Reg. Nº 18—20666S).

MEDIEVAL ART IN SILESIA
A Battlefield of National Historiographies

JAN KLÍPA

I f we wanted to see the "Middle Ages in the mirror of the twentieth century", modern research on medieval art in Central Europe would be a very fitting field to form an idea of the plurality of these "mirror" views. Medieval art in Silesia has been the object of attention for researchers coming from several cultural and linguistic milieus for almost one and a half centuries. This reflects the fact that the Silesian territory, which has not even experienced a short period of autonomous existence, was part of several political bodies throughout the ages |ø1|. Within the nationalist frameworks of history constructed during the twentieth century, Silesia's past, culture, and art were viewed through the prism of either the German, Polish, or Czech perspective.[1] Medieval art was

1 Austrian art historical science has not participated in these historiographical constructions of mutual relations and connections by any comprehensive concepts, although Silesia was subject to the Habsburg monarchy for more than two centuries.

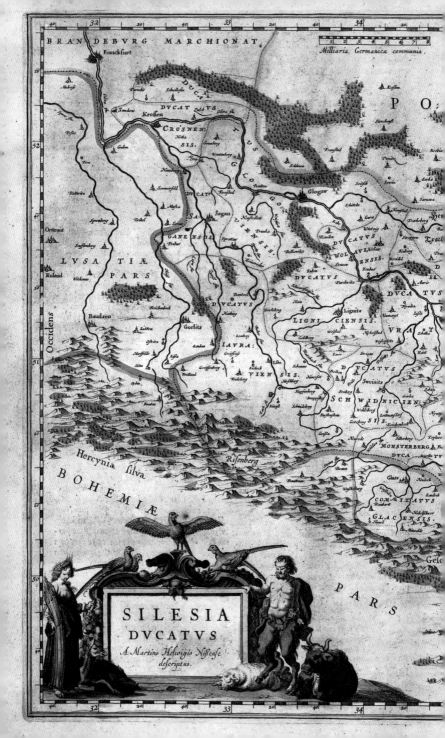

BRANDEBURG MARCHIONAT.

Franckfurt

Milliaria Germanica communia.

DUCATUS GLOGOVIENSIS

CROSNEN SIS.

DUCAT. GLOGOVIENSIS

Krossen

Kosten

PO.

Franstad

Glogaw

Schlichtingsheim

DUCATUS SAGANENSIS

Sagan

DUCATUS WOLAVIENSIS.

DUCATUS

LUSATIAE PARS

Ortrant

Occidens

Kaland

Baudzen

Gorlitz

DUCATUS IAVRA

VIENSIS.

Legnitz

LIGNICIENSIS.

URAT

DUCATUS

SCHWIDNICIEN SIS.

Rißenberg

Hercynia silva

BOHEMIAE

MONSTERBERG

DUCA

COMITATUS

GLACENSIS.

PARS

SILESIA
DUCATUS

A Martino Helwigio Nissense
descriptus.

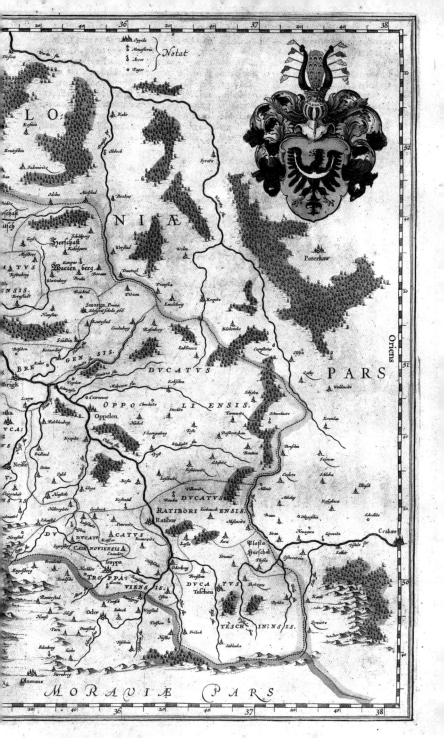

Schlesische Malerei und
Plastik des Mittelalters

Herausgegeben von

Heinz Braune und Erich Wiese

MIT 232 LICHTDRUCKTAFELN

ALFRED KRÖNER VERLAG IN LEIPZIG

|02| ↑ Cover of
Heinz Braune,
Erich Wiese,
*Schlesische Malerei
und Plastik des
Mittelalters.
Kritischer Katalog
der Ausstellung
in Breslau 1926*,
Leipzig 1929

often precisely that which offered a convenient breeding ground to these constructions: its anonymous character as well as a lack of certainty regarding regional origin — and often even regarding its dating — frequently allowed specific artworks to enter into contradictory contexts without committing apparent violations of the methods of historical science.[2] In the case of Silesian art, the question was primarily that of originality (assuming characteristic, autonomously and causally developing elements) or on the other hand the issue of relation with neighboring or even distant artistic centers — whether Prague or Bohemia, Thuringia, Rhineland, Nuremberg or Krakow, Greater Poland or Pomerania.

Below, on the main scholarly approaches and individual works from the twentieth century I will show how the ethnically and national conceived history of art formed and deformed the view of individual scholars. As *pars pro toto* I will focus on one selected section of medieval art in Silesia — namely the beginning of panel painting in the second half of the fourteenth century and the first half of the fifteenth century. Finally, I will demonstrate the breadth of the observed perceptions on a case study.

The first work that aimed to survey medieval Silesian sculpture and painting on the basis of formal and comparative analysis in monographic form was the critical exhibition catalogue *Schlesische Malerei un Plastik des Mittelalters* |02|.[3] The exhibition was held in the capital of Silesia, Breslau (Wrocław), in 1926 and the catalogue was published three years later. Its authors — the director of the *Schlesisches Museum der bildenden Künste* Heinz Braune |03| and his colleague and later successor

Erich Wiese |04| — grouped the preserved artworks into several categories of style or school. They classified the surviving examples of Silesian panel painting from the period under discussion into a chapter titled "Die Schlesisch-Böhmische Epoche",[4] and ascribed most works to a "Silesian-Bohemian master", without elaborating on this somewhat enigmatic label.[5] In the summary, they described the general situation of Silesian painting between 1350 and 1450, whose specific features cannot be explained without reference to closer or looser relations to the contemporary painting in Bohemia. Significantly, in this chapter the artworks omitted were those whose Bohemian provenance was debated.[6]

2 To the questions of national constructions in (mostly Czech) art history, see Milena Bartlová, *Unsere "nationale" Kunst*, Ostfildern 2016.

3 Heinz Braune, Erich Wiese, *Schlesische Malerei und Plastik des Mittelalters. Kritischer Katalog der Ausstellung in Breslau 1926*, Leipzig 1929.

4 *Ibidem*, pp. 77—82.

5 With the exceptions of the creator of the Madonna at Wroclaw Cathedral and that of the double-sided painted panel with the Madonna and Child on one side and the Crucifixion with the donor on the other (now lost, known only from an old photograph). These artists were identified by the authors of the catalogue as pupils of the Master of Třeboň, respectively Zátoň altarpiece (pp. 78 and 80). The artists of the St Hedwig Triptych, a votive panel from Brieg and the now missing Triptych with Crucifixion from the St Lazarus Hospital in Wrocław were, according to the both researchers, a "Silesian master" (p. 82). In his reaction to the catalogue Josef Opitz concretized his understanding of the nature of Bohemian-Silesian relations for the field of carving and sculpture. Unfortunately, he did not focus on the painting in detail here: Josef Opitz, "Von Schlesischer Kunst des Mittelalters und ihren Beziehungen zu Böhmen und Mähren", *Witiko. Zeitschrift für Kunst und Dichtung*, 2 (1929), pp. 91—95.

6 E.g. the polyptych from the Poor Clares' Convent in Wrocław. For the picture see: Małgorzata Kochanowska-Reiche, *The Mystical Middle Ages / Mistyczne średniowiecze*, Lesko 2003, p. 37.

|03| ↑ Heinz Braune
(1880—1957)

|04| ↗ Erich Wiese
(1891—1979)

Despite the fact that Braune and Wiese were both Germans born in Silesia, their approach at the end of 1920s surprisingly was still essentially free from all traces of German nationalism.[7] Sharply contrasted with this view were the content and concept of the annual journal *Die Hohe Straße*, published from 1938 onwards |05|. This anthology was bluntly determined by ideological convictions about the unique civilization and cultural influence of the German element in the region of the so-called *"Ostraum"*.[8] As the name of the volume suggests, the purpose of the essays was to demonstrate the existence of a close connection between the Silesian region and German imperial territories from the very beginnings of the local art. A notable contribution in this volume was the text written by Dagobert Frey |06|, ordinary professor at the *Breslauer Universität*, in which the author sought the "physiognomy of Silesian art".[9] Following on his programmatic work published earlier that year,[10] he developed a thesis about the national or "tribal" basis of artistic expression and style. Silesian art

100

can, according to Frey, only be considered with respect to German settlement and may be clearly distinguished from the art of the surrounding regions. From this position he subsequently criticized the overused epithet *"böhmisch-schlesischer"* and enumerated the characteristic features found in what he considered "genuine Silesian art" from the Middle Ages, Renaissance and the Baroque: flatness, staticity, an emphasis on symmetry,

7 Their approach was integral and has certain consequences in the life of both scholars, especially of the younger one — Erich Wiese (1891—1979). He became Braune's successor in 1928. His preferences are apparent in the fact that he acquired paintings by expressionists Otto Dix or George Grosz for museum collections. Immediately after the onset of National Socialism in 1933, Erich Wiese vacated the position of director at the Schlesisches Museum and until the end of the Second World War he lived and worked as an antiquarian in Hirschberg (Jelenia Góra) in the Giant Mountains. Being German, he was forced to exile from Silesia in 1945 and in the postwar period in 1950 he was appointed by the director of Hessen Landesmuseum in Darmstadt, where he devoted himself again primarily to the development of a collection of modern and contemporary art. See Magdalena Palica, Dagmar Schmengler, "Erich Wiese. Schlesisches Museum der bildenden Künste in Breslau", in *Maler. Mentor. Magier. Otto Mueller und sein Netzwerk in Breslau*, Dagmar Schmengler ed., Heidelberg 2018, pp. 48—51.

8 *Die Hohe Straße: Schlesische Jahrbücher für deutsche Art und Kunst in Ostraum. Band I.*, Gustav Barthel ed., Wroclaw 1938. The editor Gustav Barthel (1903—1973) was the new director of the Städtische Kunstsammlungen Breslau (from 1937). He was also a member of the NSDAP and the leading ideologist of National-Socialist art history in the Third Reich. During the war he was personally engaged in extensive confiscations of works of art in occupied Poland (*Generalgouvernement*) and he co-authored the catalogue *Sichergestellte Kunstwerke im Generalgouvernement* (1940) that listed cultural confiscation in Poland.

9 Dagobert Frey, "Schlesiens künstlerisches Antlitz", in *Die Hohe Straße* (n. 8), pp. 12—45.

10 Dagobert Frey, "Die Entwicklung nationaler Stile in der mittelalterlichen Kunst des Abendlandes", *Deutsche Vierteljahrsschrift für Literaturwissenschaft und Geistesgeschichte*, 16 (1938), pp. 1—74.

|05| ↑ Cover of
*Die Hohe Straße:
Schlesische
Jahrbücher für
deutsche Art und
Kunst in Ostraum.
Band I.*, Gustav
Barthel ed.,
Wroclaw 1938

|06| ↗ Dagobert Frey
(1883–1962)

decorativeness and a tendency towards abstract ornamentalization of organic forms |07|.[11] By means of these characteristics, Frey then designated even those works in which he admitted a Bohemian influence as "Silesian" (The Holy Trinity from Świerzawa, St Anne from Strzegom). The typical elements of Silesian art are said to follow from the tribal character of the Silesian-German settlement, which Frey describes as "a practical sense for reality, an austere pragmatism, a strong, aimed and unbowed will…".[12]

The second relevant text in the above-mentioned collection of essays was authored by Ernst Günther Troche.[13] The dissimilar ideological basis of the approaches of these two scholars means that their texts have divergent relevancy today.[14] While we read Frey's contribution as an illustration of the methods characteristic of a certain historical period without any historically verifiable validity today, some of Troche's conclusions,

which are based on precise formal analysis and histor-
ical sources rather than on unfettered speculation re-
garding tribal character, remain at least partly valid.
Troche's essay too evinces a clear imperative to replace
connections between Silesian and Bohemian painting
with Silesian-German ties. However, Troche fulfilled this
period requirement in a rather factual manner and thus
often revealed the intricate and multi-layered nature
of artistic relations in Central Europe at the turn of the
fourteenth and fifteenth century, which we currently

11 Frey, "Schlesiens künstlerisches Antlitz" (n. 9), p. 45.

12 *"ein gegenwartsnahes Wirklichkeitsgefühl, nüchterne Sachlichkeit,
ein harter, zielstrebiger, unbeugsamer Wille...", Ibidem,* p. 44.

13 Ernst Günther Troche, "Das erste Jahrhundert schlesischer Tafel-
malerei", in *Die Hohe Straße* (n. 8), pp. 101–141.

14 Dagobert Frey (1883–1962) belonged to the highest Nazi establish-
ment in the General Government and was personally responsible
for the systematic theft of the collections from the Warsaw and
Krakow National Museums (See Dorota Folga-Januszewska, "Mu-
zeum Sztuk Pięknych i Muzeum Narodowe w Warszawie 1862–2004"
[Museum of Fine Arts and National Museum in Warsaw 1862–2004],
in *200 lat muzealnictwa warszawskiego – dzieje i perspektywy. Ma-
teriały sesji naukowej, Zamek Królewski w Warszawie 16-17 listopada
2005 roku* [200 years of Warsaw museology – history and perspec-
tives. Materials of the scientific session, Royal Castle in Warsaw
November 16-17, 2005], Andrzej Rottermund, Andrzej Sołtan, Marek
Werde eds, Warsaw 2006, pp. 57–77). Among his "special skills" dur-
ing the era of National Socialism were writing the ideologically cor-
rect and "clear" histories of cities – e.g. Kraków without mention of
Polish settlements (Dagobert Frey, *Krakau,* Berlin 1940) or a Lublin
city guide (1942) without mentioning Jews (See "Frey, Dagobert",
in *Dictionary of Art Historians,* [online: http://arthistorians.info/
freyd, last accessed 22.7.2019]. Although Ernst Troche (1909–1971)
held important positions in the art historical establishment in
Berlin and Wrocław even under National Socialism slightly before
World War II as well, at the outbreak of war, he left Wrocław and
lived in the USA. During the de-Nazification process after 1945 he
was appointed as first post-war director of the Germanisches Na-
tionalmuseum in Nuremberg. Finally, from 1951 he made the USA
his permanent home.

Breslau, Vinzenzkirche
Vertikalismus,
Symmetrie

Prag, Dom
Körperlichkeit, Verle-
bendigung

Breslau
Mittelachse, geschlossene
Kontur

Aus Krumau
Schraubenlinie, aufgelock‹
Kontur

consider a characteristic and constitutive feature of the so-called International Gothic Style.[15]

|07| ↑ Page with comparison of different tendencies in the art of single tribal forms, from *Die Hohe Straße: Schlesische Jahrbücher für deutsche Art und Kunst in Ostraum. Band I.*, Gustav Barthel ed., Wroclaw 1938

In the post-war era when Silesia become a part of the Polish Republic established in the new boundaries that had been moved west, we can observe a very quick response of Polish art historiography on the older, more or less aggressively conceived, great German concepts of *"Ostforschung"*. These Polish studies were called *"badania zachodnie"* [Western studies]. They were chiefly interested in the "reacquired" territories lying between the Polish border from 1918 and Nysa river — that is to say, Silesia, Lubusz and Pomerania. On purpose, these studies resembled those written by German historians — of course, coming from the opposite national perspective. The history of medieval art in the region was meant to legitimize the Polish claim to these territories by demonstrating the presence of the Polish or Slavic element

in individual artworks or even entire periods of development. It is indicative that the method differed very little from the "empathizing" procedure of Frey or Pinder.[16] So the effort of scholars such as Gwidon Chmarzyński, Zygmunt Świechowski or Mieczysław Zlat was directed in particular at seeking and describing Silesian-Polish relations. These were then justified by reference to a common framework composed equally of the Silesian dynasty of Piast in Silesia, and in Poland, the Polish clergy present in Silesia and the Silesian Slavic rural population. However, the earlier conception of Braune and Wiese was revived, which emphasized connections between Silesia and Bohemia.[17] Tadeusz Dobrowolski |ø8| stated:

Bohemian-Silesian art or – in a broad sense – Bohemian-Polish art of the fourteenth and beginning of the fifteenth c. is different from German art, except the latter has its models in the Bohemian lands and surrounding areas.[18]

15 E.g. he pointed out the connections between the Basler Diptychon or Nativity Panel from Östgerreichische Galerie and Silesian painting: Troche, "Das erste Jahrhundert" (n. 13), pp. 112–113.

16 Adam Labuda devoted a detailed and inspiring study to this topic in which he pointed out that the Polish *"badania zachodnie"* was not motivated by power-political and territorial aggression, but frustration over the loss of large territories in the east, playing an important historical role in favor of Ukraine and Belarus (the Soviet Union); it was also a clear political-ideological commission. These territories, of course, remained completely forbidden to post-war Polish art history and memory in general. Adam Labuda, "Polska historia sztuki a 'Ziemie Odzyskane'" [Polish Art History and 'Recovered Territories'], *Rocznik Historii Sztuki*, 26 (2001), pp. 45–60.

17 In this case, however, these adjectives do not refer to geographical-political entities, but primarily to ethno-racial ones.

18 *"Sztuka czesko-śląska, czy szerzej czesko-polska wieku XIV i początków XV jest inna od ówczesnej sztuki niemieckiej, chyba że ta druga wzoruje się w krajach sąsiadujących z Czechami"*, Tadeusz Dobrowolski, *Sztuka na Śląsku*, Katowice/Wrocław 1948, p. 335.

WYDAWNICTWA INSTYTUTU ŚLĄSKIEGO

TADEUSZ DOBROWOLSKI

SZTUKA
NA
ŚLĄSKU
Z 672 ILUSTRACJAMI

KATOWICE-WROCŁAW 1948

DRUK: KSIĘGARNIA I DRUKARNIA KATOLICKA, KATOWICE

|08| ↑ Cover of
Tadeusz Dobrowolski,
Sztuka na Śląsku,
Katowice/Wrocław
1948

Similarly to the language of Frey, Dobrowolski further noted that Slavic forms were characterized by finesse and an "amorphous nature", which gradually comes to life and gains melodic rhythm and lyrical expression. Thus, he came to repeat the characteristics of Slavic art previously named by Wilhelm Worringer, which served the national art historiographies as a tool for the art-historical localization of single works long into the latter half of the twentieth century.[19]

In the Czech art-historical literature, the response to the German "*Ostforschungen*" and the parallel Polish "*badania zachodnie*" is represented by a unique article written by Albert Kutal, ordinary professor at the Department of Art History of Brno University |09|. The article analyzes the complex relations between Silesian and Bohemian art in the Middle Ages.[20] Primarily, Kutal gives a concise assessment of the existing research:

We have not yet carried out a systematic effort to discover these connections. It should be said that German and Polish historiography have progressed much further in this respect, of course, concerning relations between Silesian art and the artistic sphere of Germany and Poland.[21]

With the exception of several corrections, the portrait presented by the author remains accurate to this day. It rests on the conviction that "whenever Bohemian art gained in stature so that its importance exceeded the boundaries of Bohemia and Moravia, Silesia was the first to come under its influence".[22] This was the case especially for the

period of the House of Luxembourg above all for the field of painting.[23] Kutal, however, goes on to claim it was not

[...] *merely the influence of Bohemian art that was felt in Silesia [...] in Silesia, it was otherwise. It absorbed Bohemian artistic tendencies so perfectly that it fused with Bohemia and Moravia in a single artistic region.*[24]

This alliance was, however, immediately dissolved by the Hussite Wars, following which Silesian art began drawing from German sources. Yet in this period too, Kutal underscored the element of mutual contact, such as the influence of Hans Olmützer at the turn of the fifteenth and sixteenth centuries. In any case, these were "haphazard

19 Wilhelm Worringer, *Die Anfänge der Tafelmalerei*, Leipzig 1924, p. 334.

20 Albert Kutal, "Slezské umění a české země" [Silesian art and Czech lands], in *Slezsko, český stát a česká kultura* [Silesia, Czech state and Czech culture], Opava 1946, pp. 75–91. Originally it was a lecture given as part of the eponymous cycle organized by the Matice opavská in cooperation with Masaryk University in Brno in 1946. The text can be read not only as a summary of earlier knowledge enriched with its own findings, but also as a programmatic definition of the research tasks that accomplished the author himself with his seminar at the turn of the 1940s. Kutal published the results of his research in several volumes of the *Slezský sborník*.

21 "*Soustavného úsilí o zjištění těchto spojitostí u nás dosud nebylo. Je třeba říci, že německá i polská historiografie umění je v tom už mnohem dále, ovšem pokud jde o souvislost slezského umění s výtvarnou oblastí německou a polskou*", Kutal, "Slezské umění" (n. 20), p. 75.

22 "*kdykoli české umění dospělo do takové výše, že jeho význam začal přesahovat hranice Čech a Moravy, bylo to především Slezsko, jež podlehlo jeho vlivu*", Ibidem, p. 76.

23 The second relevant period was the first half of the seventeenth century. *Ibidem*, p. 89.

24 "*[...] prostě jen vliv českého umění, který na Slezsko působil [...] ve Slezsku tomu bylo jinak. Vstřebalo do sebe české výtvarné popudy tak dokonale, že splynulo s Čechami a Moravou v jedinou výtvarnou oblast*", Ibidem, p. 88.

|09| ↑ Albert Kutal
(1904—1976)

|10| ↗ Alicja
Karłowska-Kamzowa
(1935—1999)

influences, which followed more from political and geographic unity rather than a joint artistic tradition" and for that reason differed considerably from the relations that characterized the preceding period.[25]

According to Adam Labuda, Polish research was emancipated from its political-ideological grounding and Slavic nationalism (in response to German National-Socialist historiography) sometime during the 1960s.[26] The new interpretation in the field of medieval painting was proposed by Alicja Karłowska-Kamzowa, professor at the University in Poznań |10|. She studied Silesian-Bohemian relations again and dwells on these topics several times during the 1970s and 1980s. In a paper delivered at a conference accompanying the Parler exhibitions in Cologne in 1978, Karłowska-Kamzowa attempted to draw finer distinctions vis-à-vis the vague term "influence", called-for by the older literature.[27] On the one hand, she presented direct imports from the center in Prague[28] and painters trained or coming from Bohemia.[29] On the other, she specified the formal elements of Bohemian provenance that were taken over and transformed by local artists or

basic artistic attitudes as whole derived from contemporary Bohemian production (such as the "Bohemian realism" of the 1370s and 1380s or "Beautiful Style" in the subsequent decades).[30] The influence of Bohemian painting between 1350 and 1420 is patent according to Karłowska-Kamzowa, and "the formal vocabulary of Bohemian painting, conveyed through imported works or murals, became a fundamental element of Silesia's own painterly tradition".[31] The author further elaborated her theses in a paper presented in Prague in 1978.[32] Among

25 "[...] *styky náhodné, jež vyplývají spíše z jednoty politické a geografické, než ze společného výtvarného úsilí* [...]", Kutal, "Slezské umění" (n. 20), p. 89.

26 Labuda, "Polska historia sztuki" (n. 16), p. 60.

27 Alicja Karłowska-Kamzowa, "Der Einfluß Böhmens auf die Entwicklung der Malerei in Schlesien, in Ordenspommern und Groß- und Kleinpolen in der Zeit von 1350—1420", in *Die Parler und der schöne Stil 1350—1400. IV.*, Anton Legner ed., Cologne 1980, pp. 160—164.

28 The Madonna and the Holy Face from Wrocław and several illuminated manuscripts which were scientifically analyzed by Barbara Miodońska, "Związki polsko-czeskie w dziedzinie iluminatorstwa na przełomie w. XIV/XV" [Polish-Czech connections in the field of illuminating at the turn of the fourteenth and fifteenth centuries], *Pamiętnik Literacki*, (1960), pp. 153—202.

29 The author of the Legends of St Hedwig from 1353, the painter of murals in Małujowice or the creator of the mosaic in Kwidzin.

30 Karłowska-Kamzowa, "Der Einfluß Böhmens" (n. 27), p. 161.

31 "*der Formenschatz der böhmischen Malerei, vermittelt durch importierte Werke oder Wandmalereien, wurde zu einem grundlegenden Element des eigenständigen malerischen Schaffens in Schlesien*", *Ibidem*, p. 163.

32 *Eadem*, "Der Einfluß Böhmens auf die Entwicklung der Malerei in Schlesien, in Deutschordensland Preussen und Kleinpolen in der Jahren 1350—1420", in *Doba Karla IV. v dějinách národů ČSSR. Mezinárodní vědecká konference pořádaná UK v Praze k 600. výročí úmrtí Karla IV. Sv.1: Materiály ze sekce dějin umění* [The time of Charles IV in the history of CSR nations. International scientific conference organized by the Charles University in Prague for the 600th anniversary of the death of Charles IV, vol. 1: Materials from the section of art history], Prague 1982, pp. 241—262.

MALARSTWO ŚLĄSKIE
1250-1450 *Alicja Karłowska-Kamzowa*

Ossolineun

|11| ↗ Cover of Alicja Karłowska-Kamzowa, *Malarstwo śląskie 1250–1450*, Wroclaw/Warsaw/Krakow/Gdansk 1979

other things, she noted that Silesia was not deprived of contact with Lesser and Greater Poland even during the reign of the Bohemian Luxembourgs. From this followed the author's conclusion that "the visual arts had [...] a broad sphere of action and so it was independent of the ruling feudal strata, be it spiritual or secular".[33] This quotation is worthy of attention especially in the context of the current range of methodological views concerning the relation between artwork and client or customer.

It is symptomatic that Karłowska-Kamzowa presented her findings regarding Bohemian-Silesian artistic relations at foreign or international conferences or incorporated them in shorter studies.[34] Whereas her seminal monograph on Silesian painting until 1450 written in the same period, intended for the domestic Polish reader, does mention these relations but nevertheless its conclusion is dedicated to relations between Silesian painting and art produced in Lesser and Greater Poland |11|.[35] The omission of the Bohemian elements sometimes comes off

as outright forced and the ideological motivations of this emphasis come into view in the final paragraph: "The presented relationships indicate that the interruption of formal political union has not cancelled other types of ties, such as, for example, continued artistic relations on both sides."[36]

In a summary text that concludes Karłowska-Kamzowa's span of interest in Bohemia-Silesian relations (among others), considerable attention is paid to the achievements of Polish art historiography, which focused on identifying artistic relations in the given region and time frame[37] and, between the lines, argued against the blanket conception of Braune and Wiese, which had been dominant even in Czech art historical

33 "die darstellenden Künste hatten [...] weit größeren Einflussbereich und waren darüber hinaus unabhängig von der herrschenden Feudalschicht, sei es der geistlichen oder der weltlichen", Karłowska-Kamzowa, "Der Einfluß Böhmens" (n. 27), p. 242.

34 Eadem, "Kontakty artystyczne z Czechami w malarstwie gotyckim Śląska, Pomorza Wschodniego, Wielkopolski i Kujaw" [Artistic contacts with the Czechs in the Gothic painting of Silesia, Eastern Pomerania, Greater Poland and Kuyavia], Folia Historiae Artium, 16 (1980), pp. 39—66.

35 Eadem, Malarstwo śląskie 1250—1450 [Silesian Painting 1250—1450], Wroclaw/Warsaw/Krakow/Gdansk 1979, esp. pp. 84—89.

36 "Przedstawione związki wskazują, że przerwanie formalnych więzów państwowych nie przekreśliło innego typu więzy, jak np. kontynuowanych nadal obustronnie związków artystycznych", Ibidem, p. 89.

37 See for example especially the works of Janusz Kębłowski, Anna Ziomecka or Zofia Białłowicz-Krygierowa. Cf. Alicja Karłowska-Kamzowa, "Stan polskich badań nad polsko-czeskimi stosunkami artystycznymi w średniowieczu" [The state of Polish research on Polish-Czech artistic relations in the Middle Ages], in Seminaria Niezickie I. Stan badań nad związkami artystycznymi polsko-czesko--słowacko-węgierskimi [Seminars of Niezickie I. The state of research on Polish-Czech-Slovak-Hungarian artistic associations], Lech Kalinowski, Franciszek Stolot eds, Kraków 1981, pp. 63—70.

production since the publication of Kutal's essay.[38] Although the period of Beautiful Style was a time of prosperity for Bohemian painting, still, the author believed it was not the case that every work of Beautiful Style in Central Europe must have drawn inspiration from Bohemian art — various regional schools also blossomed during the first half of the fifteenth century.[39]

In the Czech scholarly environment, most recently it was Milena Bartlová who followed the concept of Albert Kutal. Similarly to him, she deems Silesian art a "self-standing branch of Bohemian art" by virtue of the region's belonging to the Czech Crown.[40] Her attitude is already, of course, free of any traces of national or ethnic consideration. She understands the issue of influence (or rather similarity) to be closely related to the issue of its "agents" — namely painters who left Prague following the outbreak of the Hussite riots. The key artwork for her is the altar in Wielowies, which, like the altar from Hronský Beňadik in Upper Hungary, exhibits a stylistic orientation towards Franco-Flemish painting as mediated by the schools of miniature illustration which were active in Prague before 1420.[41]

In the first decade of twenty-first century Czech and Polish scholars collaborated in the framework of a great exhibition and research project bearing the significant title: "Silesia — a Pearl in the Bohemian Crown". The issue of the character of Silesian art in fourteenth and fifteenth century was there elaborated in the synthetic study by Romuald Kaczmarek. Its publication in Polish and Czech, but also in English and German, make it a widely accessible basis for all further study.[42] Against the idea of the artistic unity of Bohemia and Silesia during the rule of the Luxembourgs, Kaczmarek argues that matching phenomena observed on the both sides of the Giant Mountains could be understood rather as the expression

of a development rooted in the same initial conditions.[43] His assessment of the field of painting, however, mostly corresponds to the traditional view, insofar as "[...] in Silesia, we observe the presence of each succeeding stage in the development of Bohemian painting".[44] In the essay— published as part of a bilateral project mapping the relations between Bohemia, Moravia and Silesia from the Middle Ages until the late Baroque — Kaczmarek paid most attention to phenomena that problematize the mechanical view about the dominance of Bohemian influence in Silesia.[45] Among these is the issue of the origin of groin and net vaults in fourteenth-century Silesian

38 Cf. the paragraphs concerning Silesia in the essay of Jaroslav Pešina, Jaromír Homolka, "České země a Evropa" [Czech lands and Europe], in *České umění gotické 1350—1420* [Czech Gothic art 1350—1420], Jaroslav Pešina ed., Prague 1970, pp. 19—55.

39 Karłowska-Kamzowa, "Stan polskich badań" (n. 37), p. 67.

40 Milena Bartlová, *Poctivé obrazy. České deskové malířství 1400—1460* [Honest images. Czech Panel Painting 1400—1460], Prague 2001, p. 149.

41 *Ibidem*, p. 150.

42 Romuald Kaczmarek, "Art in Silesian Duchies and in the Lands of Bohemia in the Period of the Luxembourg Patronage. Between Complicated Neighbourhood Relations and Complete Acknowledgement?", in *Silesia — A Pearl in the Bohemian Crown: History, Culture, Art*, Mateusz Kapustka, Jan Klipa [*et al.*] eds, Prague 2007, pp. 115—147. In the same year Kaczmarek published a similarly focused study in the catalogue of the exhibition devoted to the art of the time of Charles IV, held at Prague Castle: Romuald Kaczmarek, "Schlesien — die Luxemburgische Erwerbung", in *Karl IV.: Kaiser von Gottes Gnaden: Kunst und Repräsentation des Hauses Luxemburg 1310—1437*, Jiří Fajt ed., Munich/Berlin 2006, pp. 309—317.

43 E.g. as well as the Czech high nobility, Silesian magnates travelled throughout Europe as part of imperial processions, and thus they could draw inspiration for their artistic representation directly from Western artistic centers — and not only vicariously: Kaczmarek, "Schlesien" (n. 42), p. 310.

44 "[...] *in Schlesien sind alle Entwicklungsetappen der bohmischen Malerei nachweisbar*", *Ibidem*, p. 316.

45 Cf. *Idem*, "Art in Silesian Duchies" (n. 42).

architecture, the phenomenon of opulent aristocratic mausoleums and gravestones, the hostile attitude of the Duchy of Świdnica-Jawor to Luxembourgs and its dynastic-cultural relationship to the Habsburgs, the complex and still current problematic of the Gothic motif of the Madonna on a lion, and so forth. He engages in a deeper examination of intricate questions concerning artistic import and artist migration, especially in the context of stone carving. Judging by the fact that he omitted panel painting from his analysis, we may assume he must have not considered as being problematic the fact that Silesian painting was under the strong artistic influence of the Bohemian center.

In the following section I would like demonstrate the complex nature of the issue on a concrete case.[46] It is not useful to devote attention to works whose stylistic situation is clear and the scholars discuss it no further.[47] On the contrary it is precisely those works regarding whose stylistic basis the existing literature has not reached consensus that have illustrative value in the frame of our theme. An artwork that stands out among these both in terms of size and formal refinement is the panel painting of Saint Anne from the Carmelite monastery in Strzegom |12|.[48] With the exception of Frey and Troche, who consider the painting to be of local Silesian production, the existing research can be divided into two branches: the first, represented especially by Dobrowolski and Karłowska-Kamzowa, see in it a work connected rather by the Western, Franco-Flemish environment (or even believe that it is the Western import); whereas the second, defended especially by Ziomecka, insists on its Bohemian origin. Since the publication of a monograph by Richard Ernst,[49] the Strzegom panel is considered to belong to the so-called Third Bohemian style, inspired by the

114

work of the Master of the Třeboň Altarpiece.[50] The most common arguments in favor of this filiation are: its peculiar conception of space, the relation between figure and architecture, the facial type and the drapery pattern. In contrast, architectural forms and especially a cool color hue[51] have always been features that testify to Western influence. Anna Ziomecka abandoned the purely stylistic paradigm in her line of argument and based her conviction about the Bohemian provenance of the panel on the fact that the Carmelite monastery in Strzegom had been founded in 1384 by Wenceslaus IV of Bohemia, whose

46 The following brief case study is a slightly extended and updated entry which I have elaborated in Czech in my book: Jan Klípa, *ymago de praga: Desková malba ve střední Evropě 1400–1430* [ymago de praga: Panel Painting in Central Europe 1400–1430], Prague 2012, pp. 16–19.

47 E.g. the Holy Trinity from Świerzawa, the Madonna from Wrocław Cathedral or the Holy Face from the same church.

48 The most recent exhaustive study that includes a commented overview of all previous literature was produced at two points by Anna Ziomecka, "Obraz Św. Anny Samotrzeciej" [The Image of Saint Anna Samotrzecia], in *Sztuka na Śląsku XII–XVI w. Katalog zbiorów* [Art in Silesia from the twelfth to the sixteenth century. Catalogue of the collection], Bożena Guldan-Klamecka ed., Wrocław 2003, pp. 217–220; Anna Ziomecka, "Obraz Św. Anna Samotrzeć" [The Image of Saint Anne "Samotrzecia"], in *Malarstwo gotyckie w Polsce*, t. 3.2: *Katalog zabytków* [Gothic Painting in Poland, catalogue of Monuments], Adam S. Labuda, Krystyna Secomska eds, Warsaw 2004, pp. 258–259.

49 Richard Ernst, *Beiträge zur Kenntnis der Tafelmalerei Böhmens im XIV. und am Anfang des XV. Jahrhuderts*, Prague 1912, p. 15.

50 The relation to the Master of the Třeboň Altarpiece was most thoroughly considered in the M.A. thesis by Elżbieta Kal, who likewise analyzed its iconographic relationships within the Bohemian environment: Elżbieta Kal, "Uwagi o ikonografii i genezie formalnej obrazu Świętej Anny Samotrzeciej ze Strzegomia" [Notes on the Iconography and the Formal Genesis of the Image of Saint Anne "Samotrzecia" from Strzegom], *Roczniki sztuki śląskiej*, 14 (1986), pp. 65–72.

51 Considering the state of the painting's colored layers, it is questionable whether elements such as hue or plasticity should be taken into account at all.

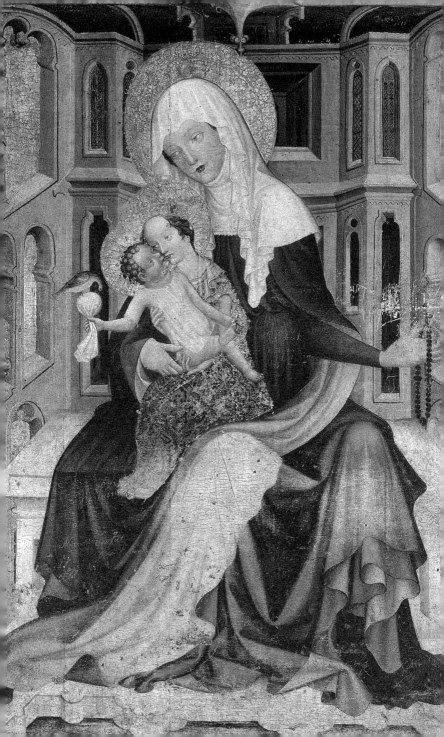

hypothetical funding of the artwork would have cele-
brated the patron saint of his mother, Anna of Świdnica.
However, several problems bar us from uncritically ac-
cepting this attractive thesis. First of all, the popular
cult of Saint Anne had a longer history in Silesia, re-
lated to the favourable reputation of the Bohemian wife
of Henry II the Pious.[52] Although the work presents the
first occurrence of this subject in Silesian panel painting,
we already find depictions of Saint Anne earlier in wood-
carving, particularly with the motif of the Madonna on
a lion.[53] There is no reason to assume a direct relation
with the emperor when we realize that this alleged in-
stance of his support does not harmonize with current
ideas about the character of Wenceslaus' artistic patron-
age.[54] The only work (outside the field of architecture

52 Anne of Bohemia — the daughter of Ottokar I and sister of St Agnes
 of Bohemia — revered locally almost as a saint, left a mark in Sile-
 sian history especially as a tireless supporter of various monasteries
 who also brought new orders into the land — the Knights of the
 Cross with the Red Star and the Poor Clares.
53 St Anne from the Church of St Laurence in Knurów, see Henryk
 Pyka, "St Anne with the Madonna and Child", in *Silesia: A Pearl in
 the Bohemian Crown: Three Periods of Flourishing Artistic Relations*,
 Andrzej Niedzelenko, Vít Vlnas eds, Prague 2006, p. 60.
54 To the question of the patronage of Wenceslas IV, cf. Milena Bar-
 tlová, Dušan Buran, "Comparing the Incomparable? Wenceslas IV
 and Sigismund, Their Queens and Their Images", in *Kunst als Herr-
 schaftsinstrument. Böhmen und das heilige Römische Reich unter den
 Luxemburgern im europäischen Kontext*, Jiří Fajt, Andrea Langer
 eds, Berlin/Munich 2009, pp. 368—376. Most recently, cf. Jan Klipa,
 "Dvorské umění a panovnická reprezentace posledních Lucemburků:
 Václav IV. a Zikmund Lucemburský" [Court Art and Royal Repre-
 sentation of the Last Luxembourgs: Wenceslas IV and Sigismund
 of Luxembourg], in *Imago, imagines: Výtvarné dílo a proměny jeho
 funkcí v českých zemích od 10. do první třetiny 16. století* [Imago, ima-
 gines: A Work of Art and the Transformations of its Functions in the
 Czech lands from the tenth to the first third of the sixteenth century],
 Klára Benešovská, Kateřina Kubínová eds, Prague 2019 [in print].

|12| ← Saint Anne from the
Carmelite monastery in Strzegom,
after 1420, National Museum in
Wrocław

117

and miniature illustration) known to be connected directly with him is a copy of the icon from Roudnice — the Black Madonna of Březnice.[55] It is also possible that the panel was created after 1400, during a period when the king's patronage ceased almost entirely due to the adverse circumstances of his rule. Even the origin of the work can be questioned: that it comes from the Carmelite monastery in Strzegom was heard by word of mouth from its last owner, the widow of a local teacher by the name of Hoffmann, in the 1860s.[56] It is at the very least worth considering that no other information concerning a painting — whose state reveals it was evidently the object of a cult — exists in the local chronicles.[57] In the light of what we know about the early history of the Strzegom monastery, it is also quite unlikely that it would have held a relic dating earlier than the 1430s.[58] These reservations, however, do not weaken the hypothesis of the Prague origin of the work's stylistic orientation. Reference to the art of the Master of the Třeboň Altarpiece is clearly present across central-European panel painting around 1400.[59] But it does not seem that the author of the Silesian painting adopted the Master's conception of visual space. Whereas the Prague painter limits the formal aspect of architectural niches to relatively schematic shapes and creates a convincing visual space not merely by means of a masterful vanishing point perspective but especially by an illusive plasticity of the figures, who genuinely fill the space they are allotted, the painter of the Strzegom panel let his fantasy loose to such a degree while rendering the saint's throne[60] that not only did he not maintain unity between the vanishing point of the side of the throne and its backrest but not even between its right and left sides. As a result, the three figures appear not to fill a designated niche but are applied onto the spatial arrangement in the manner of a wallpaper.[61]

The facial type also differs, lacking the softness and live-
liness of the figures from the Třeboň Altarpiece, and it
is rather a more refined variant of the female faces ap-
pearing in Bohemian samples of the late Beautiful style —
such as on the Reininghaus Altarpiece.[62] The same can
be said of the hair of the Infant Jesus, which lacks the
typical highly cultivated decorative nature of the high
Beautiful style and testifies to a less attentive, more
stereotypical rendering, which the older literature was
keen on referring to as a "mannerism".[63] Bohemian panel

55 Jan Klípa, "Madonna of Březnice", in *What the Eyes Cannot See: Un-
 derdrawing in the 14th—16th Century Panel Paintings from the Collec-
 tions of the National Gallery in Prague*, Helena Dáňová, Štěpánka
 Chlumská eds, Prague 2017, pp. 120—123.
56 She did so while donating the painting to the Silesian Antiquities
 Museum in Wrocław. Cf. Ziomecka, "Obraz Św. Anny" (n. 48).
57 *Ibidem*, p. 218.
58 During the first half-century of its existence, the monastery con-
 sisted of a group of wooden buildings outside the city walls and as
 such easily succumbed to the Hussite attack in 1428. A stone church
 within the walls was only built in the 1430s. Cf. Julius Filla, *Chro-
 nik der Stadt Striegau von den ältesten Zeiten bis zum Jahre 1889*,
 Striegau 1889, p. 113.
59 Klípa, *ymago de praga* (n. 46), pp. 218—219.
60 According to Jarosław Szelagowski, it is not a throne but rather a cham-
 ber, an image of Heavenly Jerusalem, in which St Anne is seated on
 a (wooden) bench. The author bases this conviction on, among other
 things, a rather arbitrary interpretation of the painting's dimensions
 and their subsequent symbolic exposition. Jarosław Szelagowski, "Die
 geometrische Kompositionsstruktur der hl. Anna Selbdritt aus dem
 Striegauer Karmelitenkloster", in *Die Parler* (n. 27), p. 45.
61 This remains the case even despite a relatively obvious effort at an
 organic connection, e.g., in the part of the cloak thrown across the
 bench by St Anne's right foot.
62 Jan Klípa, "The Reininghaus Altarpiece", in *What the Eyes Cannot
 See* (n. 55), pp. 158—163.
63 Jaroslav Pešina, Jaromír Homolka, "K problematice evropského
 umění kolem roku 1400" [On the issue of European art around 1400],
 Umění, 11 (1963), p. 172.

painting and miniature illustration from around and after 1400 offers an abundance of direct parallels to the arrangement of the drapery. The color-pointed motif on the folded underside of the cloak that wraps around St Anne's left arm, runs diagonally through her right knee and ends in a long corner at the foot of throne already has its influential model in Parler's decoration on the eastern side of the Prague Old Town Bridge Tower, in particular the seated figure of Charles IV.[64]

The abovementioned Western ties should not be overlooked either. However, they can be observed in an element that is often attested particularly in the Bohemian environment — the motif of Mary kissing Jesus, derived from the Byzantine *Eleusa*. A parallel with the Basel diptych is evident, even though the Bohemian origin of this work is almost unanimously rejected nowadays.[65] Most recently, Milena Bartlová convincingly related this work (on the basis of the motif of Mary's caressing the infant Jesus and in view of an almost identical pointing technique) to the circles of the so-called Master of Heiligenkreuz,[66] a painter patently of Franco-Flemish training, who left a number of works in the current territories of Austria during the first two decades of the fifteenth century. Jörg Oberhaidacher related the motif of the Virgin pressing her face to that of Jesus to the circles of Jacquemart de Hesdin.[67] A subtle motif that likewise points to the production of Franco-Flemish art centers is the decoration of the throne architecture with figurines of Moses and Isaiah.[68] Especially the figure of the prophet, which is turned towards the central figure in a daring rendering in lost profile, is unthinkable without direct Western prototypes. A certain parallel is offered by the figurines that adorn the architecture of Mary's cell on the left wing of the Dijon Altarpiece created by Melchior Broederlam.[69] Similar statuettes amply populate

the rich architectures depicted in manuscripts from the workshop of the Limbourg brothers, but they also appear as mandatory decoration on works of mediocre quality.[70]

These indications allow us to accept the conclusion formulated by Ziomecka: the painter was probably trained in Prague, which provided contact with the heritage of the Master of the Třeboň Altarpiece and allowed him to encounter the latest trends in Western art by mediation of miniature illustration workshops.[71] In contrast

64 It is therefore no coincidence that the drapery composition resembles Beautiful Style pietàs of Bohemian origin, whose inspiration lies in the same source: Troche, "Das erste Jahrhundert" (n. 13), p. 109.

65 For a discussion on this topic, see Mojmír Frinta, "Medieval Bohemica: Addenda et substrahenda", *Acta historiae artium Academiae scientiarum Hungaricae*, 26 (1980), pp. 13–26; Jaroslav Pešina, "Bohemica pravá a nepravá (Na okraj studie M. Frinty o českém gotickém deskovém malířstvi)" [Bohemica correct and false (around M. Frinta's study of Czech Gothic panel painting)], *Umění*, 29 (1981), pp. 418–425 (on pp. 418–419, Pešina also deals with the panel from Strzegom); Robert Suckale, "Das Diptychon in Basel und das Pähler Altarretabel. Ihre Stellung in der Kunstgeschichte Böhmens", *Zeitschrift für Schweizerische Archeologie und Kunstgeschichte*, 43 (1986), pp. 103–112; Klípa, *ymago de praga* (n. 46), pp. 148–151.

66 Bartlová, *Poctivé obrazy* (n. 40), pp. 132–133.

67 Jörg Oberhaidacher, "Westliche Elemente in der Ikonographie der österreichischen Malerei um 1400", *Wiener Jahrbuch für Kunstgeschichte*, 43 (1990), p. 77. In Bohemian painting, the motif already appears among Italian-oriented productions around 1350 – e.g., on the Nativity panel from the altarpiece in Vyšší Brod.

68 Kal, "Uwagi o ikonografii" (n. 50), p. 67.

69 The motif of the Virgin and Jesus pressing their faces against each other also appears in the Flight to Egypt on the right-hand wing of the altar.

70 Such as on the inner side of the triptych from c. 1415 originating in Maasland from the Van Beuningen Collection in Rotterdam. Cf. Erwin Panofsky, *Early Netherlandish Painting*, Cambridge 1953, fig. 105.

71 It is also possible that the Franco-Flemish models found expression in panel painting, but this can only be reconstructed on the back of secondary evidence. Cf. Bartlová, *Poctivé obrazy* (n. 40), pp. 64–166.

to the dating "before 1400" that has currency in the Polish scholarly literature, on the basis of the above analogies from the early decades of the fifteenth century, we must side with Pešina, who observed that "[...] the Silesian works of this era are usually dated too early"[72] and put the panel to the time slightly after 1420. This date could be related to the supposed departure of at least a certain part of artists from Prague after the outbreak of the Hussite wars. One of the most attractive destinations for them was certainly Silesia, which had already come to draw culturally from the Bohemian lands, and which then became the imperial base of Sigismund of Luxembourg.

On the above-mentioned basic concepts and scholar works which in the last century dealt with medieval art in Silesia and on the presented brief case study, it is possible to properly demonstrate the tendency of art historical science to collaborate with the ruling political regime. This applies especially to the formalistic art history, which was developed by the Vienna School of art history and which was dominant in historiography especially in Eastern Europe deep into the second half of the twentieth century. Art history, with its artificial, "gestaltpsychological" constructions (and fabulations, it could be said), helped to justify the interests of modern national states and nationalistic regimes.

In the case of Silesia it could be well documented how German nationalist scholars have tried to prove the independence of Silesian medieval art from the surrounding Slavic regions, in order to confirm the eternal alliance of Silesia to the German eastern settlements (*Ostsiedlung*). On the other side, Polish historiography has invested much effort in demonstrating and documenting the close relationship of forms and contents of

Silesian works with artistic production in Lesser Poland and its cultural center in Kraków. Especially remarkable is the approach of Alicja Karłowska-Kamzowa. In her life work on Silesian painting she emphasized this basic idea, obviously because the book was intended primarily for the domestic Polish reader. In contrast, in her articles for the international audience the question of the interconnection of Silesia with the surrounding regions was seen more distinctively and from the historical point of view was more appropriate. A comfortable position could have been held by Czech research — because the Czech state abandoned its territorial claims on the Silesian Duchy more than a quarter of millennium ago. On the contrary, the historically-justified view always has to take into account the close political union of Silesia and the Bohemian lands in the fourteenth and fifteenth centuries, which justifies the attempts to find a reflection of this political situation in the sphere of artistic relations, too.

Still, the latest Polish research carried out by Romuald Kaczmark — remarkable in the framework of a large bilateral Czech-Polish scientific and exhibition project — seems to be pointed in the right direction. He stresses the diversity of the artistic production of the Silesian principalities, the significant specificities of the region, and the relevant links to other milieus than merely the Bohemian one which was emphasized by Karłowska-Kamzowa including in the case of St Anne from Stzegom. Even in this diverse and historically perhaps more accurate picture, the relations between Silesia and the Prague cultural center during the reign of the Luxembourgs still

72 "[...] *slezské práce této doby bývají zpravidla příliš časně datovány*", Pešina, "Bohemica pravá" (n. 65), p. 419 (Pešina dates the painting to c. 1415).

occupies the primary place. Because not only now, or in the twentieth century, but also in the days of the House of Luxembourg these features were genuine tools of power, propaganda, and imperial policy.

The present study was written as part of the Project of the Charles University in Prague, Progres Nº 3, Centre for the Study of the Middle Ages [Centrum pro studium středověku FF UK]

AN ARTIST BETWEEN TWO WORLDS?
Anton Pilgram in Czech-speaking and German-speaking Historiographies

ADRIEN PALLADINO — SABINA ROSENBERGOVÁ

Anton Pilgram (Brno 1460? — Vienna 1515?) has been well-known by art historians for several generations. Within art historical narratives, he is often portrayed as one of the prototypical figures of an architect-builder and sculptor at the threshold between the Middle Ages and the early modern period. In this sense, far from being an "anonymous medieval craftsman", his two supposed self-portraits at the pulpit and *Orgelfuß* of the Viennese cathedral have especially attracted continuous scholarly attention |01|.[1] The artist was, however, also probably active in Brno (hypothesized to be

1 The very notion of the "self-portrait" has crystallized research on Pilgram, at least in the recent German-speaking scholarship, since it proposes an overarching narrative in which the national question can be, to some extent, eluded. See Michael Viktor Schwarz, "Altargucker und Predigtlauscher. Anton Pilgrams Selbstbildnisse in St. Stephan, Wien", in *Idem, Visuelle Medien im christlichen Kult*, Vienna 2002, pp. 217—249; Philipp Zitzlsperger, "Renaissance artists' portraits

his birthplace) where he participated in the construction of various buildings. Scholars trace back to him certain works inside the church of St Jacob (c. 1502), the Jewish Gate (c. 1508) as well as the portal of the city's old Town Hall (c. 1511) |02|. A number of decontextualized objects, such as various stone and wooden sculptures preserved in Vienna, Brno, or kept in other European museums, have also been attributed to the master. Precisely through the study of this corpus, scholars have been constructing Pilgram as a complex and psychologized "genius Renaissance artist", not unlike for example Tilman Riemenschneider or Albrecht Dürer.[2] The notion of genius artist, however, coupled with the difficulty of reconstructing a precise chronology for the life and work of Pilgram, is being revised and minimized by recent scholarship, which also tends to question dating and attributions to the artist.[3] Furthermore, the question of the relationship between Pilgram's sculptural career and the importance of his architectural works, mainly studied through his stonemason signs and the preserved architectural drawings, is still not solved.

The scope of this article is not to discuss these questions, but rather to use the figure of Pilgram as a case study to examine the historiographical tendencies within, and between, German-speaking and Czech-speaking scholarship. The particular focus on these two traditions reflects the historical parcellization of the Habsburg territory: from the relative unity before the First World War to the nationalization during the Interwar period, towards a progressive final cleavage that started with the Munich agreements, the creation of the Protectorate of Bohemia and Moravia, and subsequently, the expulsion of Germans and the Communist putsch of 1948.[4] These historical struggles are accompanied by new narratives and claims made regarding art historical objects.

The figure of Pilgram presents itself as an excellent object of study, since he was supposedly active across Central Europe, leaving artworks in the different modern nation-states. As such, he has been instrumentalized in order to put forward different ideological frameworks. Of course, the various renaissances of the national sentiment in art history have been explored and represent a topic which is becoming increasingly central in the last years, at a moment of increasing nationalism all

and the moral judgement of taste", *Journal of Art Historiography*, 17 (2017) [online]; *Idem*, "Anton Pilgrams letzter Streich: Hinterlist und Selbstdarstellung eines Künstlers im Wiener Stephansdom", in *Material Culture. Präsenz und Sichtbarkeit von Künstlern, Zünften und Bruderschaften in der Vormoderne*, Andreas Tacke, Birgit Ulrike Münch, Wolfgang Augustyn eds, Petersberg 2018, pp. 221–245.

2 On the thematization of the artistic genius, see Edgar Zilsel, *Zur Entstehung des Geniebegriffes: ein Beitrag zur Ideengeschichte der Antike und des Frühkapitalismus*, Tübingen 1926; in the same years, see the influential Ernst Kris, Otto Kurz, *Die Legende vom Künstler. Ein geschichtlicher Versuch*, Vienna 1934. It is not a surprise that Kris — not unlike other scholars encountered in the course of these pages — was also a student of Max Dvořák and Julius von Schlosser in the Vienna of the 1920s, but also close to the circle of Freud. On Riemenschneider's historiography, with similarities with Pilgram's situation, see the article by Keith Moxey, "History, Fiction, Memory: Riemenschneider and the Dangers of Persuasion", *Studies in the History of Art*, 65 (2004), pp. 202–213.

3 For the Czech milieu, see Kaliopi Chamonikola, "K autorské identitě architekta a sochaře Antona Pilgrama" [On the Identity of Architect and Sculptor Anton Pilgram], *Umění*, 52/5 (2004), pp. 414–426; *Eadem*, "Co zůstalo z Antona Pilgrama?" [What Remains of Anton Pilgram?], in *Doba jagellonská v zemích české koruny (1471–1526): konference k založení Ústavu dějin křesťanského umění KTF UK v Praze*, České Budějovice 2005, pp. 205–218; Lucie Valdhansová, *Geneze bádání o Antonu Pilgramovi* [The Genesis of Research on Anton Pilgram], M.A. thesis, Palacký University Olomouc 2009; *Eadem*, *Baumeister Anton Pilgram (1450/60–1515)*, Ph.D. thesis, Palacký University Olomouc 2019.

4 For the general bibliography on these events, see the introduction to the present volume, pp. 11–20.

across Europe.[5] The field of art history has been iden-
tified — especially in the years between 1870 and 1945
but also after — as particularly instrumental in the cre-
ation of national identities.[6] A concurrent analysis of
scholarly trends and dialogues or absence thereof on
Pilgram between German-speaking and Czech-speaking
milieus, as proposed here, outlines above all the fash-
ioning of Pilgram as a national figure. Starting with the
considerations of German scholarship in the first half
of the twentieth century, it will be shown how the fig-
ure of Pilgram was constructed as a Renaissance figure
of a German artist, whose genius is embodied mostly in
the late Viennese works, but not only. This tendency
seems to have been amplified during the Second World
War, when the notion of "German genius" received fur-
ther racializing and anti-Slavic undertones. However,

5 See notably Adam S. Labuda, "Einleitende Bemerkungen zur Rolle
 des nationalen Gedankens in der Kunstgeschichtsschreibung", in
 *Die Kunsthistoriographien in Ostmitteleuropa und der nationale
 Diskurs*, Robert Born, Alena Janatková, Adam S. Labuda eds, Berlin
 2004, pp. 31—40. For a reflection on the German example, see Hans
 Belting, *The Germans and Their Art. A Troublesome Relationship*,
 New Haven 1998 [1993], esp. pp. 49—60.
6 On these notions, see for example Ján Bakoš, "From Universal-
 ism to Nationalism: Transformations of Vienna School Ideas in
 Central Europe", in *Die Kunsthistoriographien* (n. 5), pp. 79—101;
 Milena Bartlová, "Creating Borders: The Uses of Art Histories
 in Central Europe", *Ars*, 40/2 (2007), pp. 129—133; Marta Filipová,
 "The Construction of a National Identity in Czech Art History",
 *Centropa. A Journal of Central European Architecture and Related
 Arts*, 8/3 (2008), pp. 257—271; for more general frames, see Michaela
 Marek, *Kunst und Identitätspolitik. Architektur und Bildkünste im
 Prozess der tschechischen Nationsbildung*, Cologne 2004; Michela
 Passini, *La fabrique de l'art national. Le nationalisme et les origines
 de l'histoire de l'art en France et en Allemagne 1870—1933*, Paris 2012;
 Éric Michaud, *Les invasions barbares. Une généalogie de l'histoire
 de l'art*, Paris 2015. For more bibliographical indications, see also
 the introduction of the present volume.

|01| ← Anton Pilgram,
Self-portrait at the chancel,
St Stephen's Cathedral, Vienna,
around 1515

131

|02| ↑ Anton Pilgram,
Portal of the Old
Town Hall of Brno,
around 1511

this construction is deeply embedded also after the Second World War, when German scholars, mostly pupils of the Vienna School such as Karl Oettinger, produced authoritative works on this figure. This first part of the essay is counterbalanced by a second focus. Within Czech historiography — also deeply impacted by the Vienna School — the figure of Pilgram remains aside because he is considered as an artist mainly formed within the German milieu. In the First Czechoslovak Republic, focus was thus given to artistic production which could be "ethnically" attributed to Czechs. Under the influence of Oettinger's monograph of 1951 — which to this day represents the authoritative volume — the reputation of the works of Pilgram was recognized notably by Albert Kutal. However, the artist's direct impact on Czechoslovakian art was largely refused by Czech art historians, represented for example by Jaromír Homolka.

As a consequence, Pilgram's fitting or not fitting into an art historical narrative becomes crucial in the construction of tools of inclusion or exclusion of ethnical or ideological elements from both sides. This exclusion can be very concrete, e.g., when one side ignores — sometimes for linguistic or practical reasons — the other one, more perverse, when one side decides to consciously ignore the other in order to follow and preserve their own traditional narrative.

WILHELM VÖGE AND THE CREATION OF A MYTHOLOGY

Bertold Bretholz (1862—1936) and August Prokop (1838—1915), Moravian natives, as well as Ignaz Schlosser (1893—1970), born in Austria, already contributed to the creation of a figure of Pilgram in Moravia — mainly in Brno — as well as in Vienna at the end of the nineteenth and in the early years of the twentieth century.[7] It seems however that before 1918, the question of Pilgram's origins or "ethnicity" is mostly absent from the historical or art historical discourse. This absence stems from the fact that the topic was, at that point in time, not a problematic question but simply a given: Brünn was for the German scholars a German city, and Pilgram was part of the German element of population.[8] Problems between the German and the Czechoslovakian parts of the population were present, and were exacerbated precisely during the years of the creation of the First Republic. This situation was intensely manifested in Brno, where the creation of the Czechoslovakian University in 1919 was clearly a national gesture directed against the overwhelming German authorities.[9] What emerges for example from Schlosser's brief book, which embodies the Austrian historical thinking of these times, seems to limit itself to outlining the notion of a Germanic Pilgram as a master

7 Bertold Bretholz, *Die Pfarrkirche St. Jakob in Brünn*, Brno 1901; August Prokop, *Die Markgrafschaft Mähren in kunstgeschichtlicher Beziehung. Grundzüge einer Kunstgeschichte dieses Landes mit besonderer Berücksichtigung der Baukunst*, Vienna 1904; Ignaz Schlosser, *Die Kanzel und der Orgelfuß zu St. Stefan in Wien*, Vienna 1925.

8 See Jan Galeta's chapter in the present volume.

9 For an overview, see Lukáš Fasora, *Historický pohled na století života Masarykovy university / A historical perspective of the centennial existence of Masaryk University*, Brno 2019.

|03| ↗ Photograph of
Wilhelm Vöge

at the threshold of two historical periods — an idea cease-
lessly repeated in later historiography:

*The artistry of Anton Pilgram flows from two sources —
from the craftsman tradition of the Middle Ages and
from the awakening self-consciousness of the modern
times.*[10]

The first scholar who gave a decisively "national" im-
pulse to the Pilgram question in art historical discourse
is, however, Wilhelm Vöge (1868–1952) |03|. During the
interwar years, this German art historian authored an
article titled "Konrad Meits vermeintliche Jugendwerke
und ihr Meister" (1927), chiefly aimed at assessing the
artistic identity of Pilgram ("*Künstlerpersönlichkeit*") by
extending the corpus of artworks attributed to the art-
ist.[11] Before we come to the content of the essay, it must
be said that Vöge — part of the "1860 generation" — was
an influential art historian at the institute of Freiburg

im Breisgau, of similar stature to Adolph Goldschmidt in Berlin or Heinrich Wölfflin in Basel.[12] Perhaps less read today than the other two, partly because of a writing style described as utterly untranslatable compounded with the fact of his early retirement, Vöge nevertheless remains an absolutely essential theoretician of medieval art, particularly renowned for his keen eye and sharp stylistic analyses.[13] In the essay of 1927, Vöge specifically turns his

10 *"Anton Pilgrams Künstlerschaft wird aus zwei Quellen gespeist, aus den handwerklichen Überlieferungen des Mittelalters und aus dem erwachenden Selbstbewußtsein der neuen Zeit"*, Schlosser, *Die Kanzel* (n. 7), p. 17.

11 Wilhelm Vöge, "Konrad Meits vermeintliche Jugendwerke und ihr Meister", in *Jahrbuch für Kunstwissenschaft*, Lepzig 1927, pp. 24–38.

12 On Vöge, see Willibald Sauerländer, "Wilhelm Vöge und die Anfänge der kunstgeschichtlichen Lehre in Freiburg", *Zeitschrift für Kunstgeschichte*, 61 (1998), pp. 153–167; Kathryn Brush, "Wilhelm Vöge and the Role of Human Agency in the Making of Medieval Sculpture: Reflections on an Art Historical Pioneer", *Konsthistorisk tidskrift*, 62 (1993), pp. 69–83; Eadem, *The Shaping of Art History. Wilhelm Vöge, Adolph Goldschmidt, and the Study of Medieval Art*, Cambridge 1996; on Vöge's method, see *Wilhelm Vöge und Frankreich*, (Akten des Kolloquiums, Frankreich-Zentrum der Albert-Ludwigs-Universität Freiburg i. B., 2. Mai 2003), Wilhelm Schlink ed., Freiburg im Breisgau 2004. His most prominent students included Percy Ernst Schramm and Erwin Panofsky. The roots of the latter's fascination with the artistic personality of Albrecht Dürer, so clearly discernable in his famous monograph of 1943, must be traced back to the teachings of Vöge.

13 His writing style is notably described by Erwin Panofsky, "Vorwort: Wilhelm Vöge (16. Februar 1868–30. Dezember 1952)", in Wilhelm Vöge, *Bildhauer des Mittelalters. Gesammelte Studien*, Berlin 1958, pp. IX–XXXII; Engl. transl. by Ernest C. Hassold as "Wilhelm Vöge: A Biographical Memoir", *Art Journal*, 28/1 (1968), pp. 27–37; on his style, see also Achim Aurnhammer, "Die Lyrik des Kunsthistorikers Wilhelm Vöge. Zur Krise der Beschreibungssprache in der Klassischen Moderne", in *Wilhelm Vöge und Frankreich* (n. 12), pp. 117–136, with further bibliography. In the same volume, see also Martin Büchsel, "Wilhelm Vöge zum mittelalterlichen Porträt: Dichtung und Methode", pp. 95–116.

attention to an entombment group in Munich as well as to a remarkable wooden statuette of a falconer showing traces of polychrome in the Kunsthistorisches Museum in Vienna and dated to around 1500 |04|.[14] In both cases, he is thus developing his argument on mobile and decontextualized artworks. Describing the statuette, Vöge states — contradicting former attributions to the young German sculptor Conrad Meit or Schlosser's attribution to a Paduan artist[15] — that we in fact do not have to look "far from home" to understand the origins of this artwork:

Yet it was the time where the terrestrial self-awareness came to light also in the North. What threatens us with aristocratic fire and disdain is embedded in the being of the German artistic figure that lies behind its execution. We know this figure — from the building registers of the Viennese St Stephen Cathedral.[16]

|04| ↑ Wooden statuette of a falconer, around 1500 / Kunsthistorisches Museum, Vienna

The Pilgram here created by Vöge is not only from his very nature German, but also a very self-aware individual, a psychologizing aspect which is once again instrumental in further considerations by both German- and Czech-speaking scholarship on the artist. Vöge goes on to identify in the traits of the haughty falconer a self-portrait of Pilgram, circa ten to fifteen years younger than in the two already-mentioned self-portraits at St. Stephen's Cathedral.[17] He argues not only for a self-portrait, but also identifies physiognomic and psychical traits

136

of the artist which correspond also to his literary biography, partly known from the building registers of the *Stefansdom*. The biographical dimensions and associations of an artist's character with his craft of course correspond to a genre deeply embedded within art history at least since the nineteenth century, with roots reaching deep into the Vasarian sixteenth century.[18] In the case of Pilgram, this interest in self-portraiture and its psychological implications on the consciousness of artists weaves together both a historiographical and national

14 Kunsthistorisches Museum, Vienna, Kunstkammer, Inv. Nr. 3968; pear wood, H: 31,3 cm (with base).

15 Julius von Schlosser, "Paralipomena aus der Skulpturensammlung des Allerh. Kaiserhauses. Nachlese zu der Abhandlung: Aus der Bildnerwerkstatt der Renaissance", *Jahrbuch der Kunsthistorischen Sammlungen des Allerhöchsten Kaiserhauses*, 31 (1913/14), pp. 347–362, esp. pp. 347–350; *Idem*, "Armeleutekunst alter Zeit", *Jahrbuch für Kunstsammler*, 1 (1921), pp. 47–66, esp. pp. 57–58.

16 "*Doch war es die Zeit, wo auch im Norden das irdische Selbstgefühl zutage drang. Was aus der kleinen Figur des Falkners an adligem Feuer, an Menschenverachtung uns androht, ist aus dem Wesen der deutschen Künstlerpersönlichkeit in sie eingeströmt, die hinter ihr steht. Wir kennen sie – aus den Bauakten der Wiener Stefanskirche*", Vöge, "Konrad Meits" (n. 11), p. 26.

17 "*Denn der Falkner ist nicht nur von Pilgrams Hand, es ist Pilgram selbst, der aus der kleinen Figur uns anblickt. Besonders das spätere der beiden Selbstbildnisse, das an der Kanzel, ist hierfür Zeuge [...] Der 'Pilgram-Falkner' ist ein Mann in mittleren Jahren, doch zwischen ihm und den Pilgram der Kanzel liegen sicherlich zwei bis drei Lustren*", Vöge, "Konrad Meits" (n. 11), pp. 28–29. The pulpit and sculpture of the organ had been published just two years prior by Schlosser, *Die Kanzel* (n. 7).

18 On this notion, see *Die Biographie – Mode oder Universalie? Zu Geschichte und Konzept einer Gattung in der Kunstgeschichte*, Beate Böckem, Olaf Peters, Barbara Schellewald eds, Berlin/Boston 2016. For an interesting case study of the progressive nationalization of an artist figure, see Leonid A. Beljaev, "Andrej Rublev: the Invention of a Biography", in *L'artista a Bisanzio e nel mondo cristiano-orientale*, (Giornate di studio, Pisa, Scuola Normale Superiore, 21–22 novembre 2003), Michele Bacci ed., Pisa 2007, pp. 117–134.

interest.[19] The emergence of the self-aware figure of the Gothic architect and sculptor, a figure embodied by the double-formation of Pilgram, becomes a classical topic of contentious discussions throughout the end of the nineteenth and the twentieth century. This supposed rise of individualism and subjectivity of artists, for which a point was made for example by Jacob Burckhardt in his *Cultur der Renaissance in Italien* (1860), also becomes a topic which deeply fractures the historiographical reception.[20] In this sense, "objective" stylistic analysis and psychologizing elements are combined in the creation of a Renaissance personality peculiar to the German cultural sphere. This movement is well known also in other cases, probably most famously with the case of Dürer. Of course, the creation of powerful artist personalities can have dangerous results, as tools of a nationalism which was particularly exacerbated in the years following 1933, and especially during the occupation of Bohemia and Moravia under the Protectorate.[21]

For the present topic, it must be said that the years following the essay of Vöge resulted in a vast broadening of the "Pilgram-sculptor" question, which was taken up by German scholars such as Rudolf Schnellbach, Theodor Demmler, August Steinhauser, as well as Karl Oettinger and Otto Benesch, to whom we will return.[22] What is thus crucial for German historiography is that the portrait and silhouette of the "German" Pilgram have been identified everywhere possible, trying to fill the gaps in the formation of the artist and shifting attributions mainly based on methods of style and connoisseurship. The spread of the empire, through artistic "avant-gardes" such as the travelling Pilgram, was a topic of immense importance. In this way, connoisseurship and attributionism became tools of fracture, but also, as we will see, of partial reconciliations.

KARL OETTINGER, OTTO BENESCH: FORMAL ATTRIBUTIONS BETWEEN OBJECTIVE SCIENCE AND NATION

Karl Oettinger's (1906–1979) monograph from 1951 had a decisive impact and remains to this day one of the most quoted works on the activity of Pilgram and his workshop, be it in the Czech or German speaking sphere |05|.[23] A student of Goldschmidt, von Schlosser, and Swoboda,

19 On these notions, see Kurt Gerstenberg, *Die deutschen Baumeisterbildnisse des Mittelalters*, Berlin 1966; Ingrid Severin, *Baumeister und Architekte: Studien zur Darstellung eines Berufsstandes in Porträt und Bildnis*, Berlin 1992, pp. 21–22; Corine Schleif, "The Making and Taking of Self-Portraits: Interfaces Carved between Riemenschneider and His Audiences", *Studies in the History of Art*, 65 (2004), pp. 214–233; Frits Scholten, "Johan Gregor van der Schardt and the Moment of Self-Portraiture in Sculpture", *Simiolus: Netherlands Quarterly for the History of Art*, 33/4 (2007/2008), pp. 195–220, esp. pp. 204–208; Yves Gallet, "Autoportrait et représentation de soi au Moyen Âge: le cas de Matthieu d'Arras à la cathédrale Saint-Guy de Prague", in *Autoportrait et représentation de l'individu*, Élisabeth Gaucher-Rémond ed. = *Le Moyen Âge*, 122/1 (2016), pp. 41–65.

20 Jacob Burckhardt, *Die Cultur der Renaissance in Italien: ein Versuch*, Basel 1860. On Burckhardt's conception of the individual and of modernity, cf. Roberta Garner, "Jacob Burckhardt as a Theorist of Modernity: Reading *The Civilization of the Renaissance in Italy*", *Sociological Theory*, 8/1 (1990), pp. 48–57.

21 See for example the situation highlighted by Evonne Levy, "Ernst Kris, *The Legend of the Artist* (1934), and *Mein Kampf*", *Oxford Art Journal*, 36/2 (2013), pp. 207–229.

22 Rudolf Schnellbach, "Ein unbekanntes Frühwerk des Anton Pilgram", *Wallraff-Richartz-Jahrbuch*, Neue Folge, 1 (1930), pp. 202–221; Theodor Demmler, "Der Kanzelträger des Deutschen Museum", *Jahrbuch der Preuszischen Kunstsammlungen*, 59 (1938), pp. 161–172; August Steinhauser, *Künstler und Kunstwerke des 15. Und 16. Jahrhunderts*, Rottweil 1939.

23 Karl Oettinger, *Anton Pilgram und die Bildhauer von St. Stephan*, Vienna 1951. The work of Oettinger was received mostly very positively, see the reviews of Anselm Weissenhofer, *Mitteilungen der Gesellschaft für vergleichende Kunstforschung in Wien*, 3 (1951), pp. 97–98; Theodor Müller, *Kunstchronik*, 4 (1951), pp. 295–298;

|ø5| ↗ Title page of Karl Oettinger, *Pilgram und die Bildhauer von St. Stephan*, Vienna 1951

Oettinger states that he had already outlined his study on Pilgram in 1943, one year after becoming ordinary professor at the University of Vienna.[24] The difficulties of accessing foreign scientific literature after 1944, a problem present on both Czech-speaking and German-speaking sides, had initially prevented him from carrying out this project entirely.[25] As a former member of the NSDAP, his right to teach also had been removed from 1945 to 1954: it is in those years that he wrote the main parts of his publication on Pilgram. Not unlike other members of the Vienna School, most notably Hans Sedlmayr (1896–1984), Oettinger's sympathies with the NS-regime cast a shadow on his scholarly work.[26] While it is not our goal and it is not possible to understand how far he was compromised ideologically, part of his problematic identity and his positions must also be identified in his earlier works. Milena Bartlová has for example outlined Oettinger's racializing attitude towards Bohemian art, one that was quite common amongst Austrian and German scholars.[27] Far from recognizing a Slavic "softness" correlated to the harmony of Italian art as done by Czech-speaking scholarship, Oettinger, to some extent following Wilhelm Worringer (1881–1965), identified in the Bohemian traits a clumsiness and crudeness

linked with racial and mental features — even using anthropological analyses to back formal claims.[28] To some extent, as Bartlová notes, these ideas would be paradoxically accepted and reworked by Czech Marxist scholarship after 1945, notably by Jaroslav Pešina (1912—1992), in order to prove the profoundly Slavic character of Bohemian art.[29] In this sense, the German-Austrian theories of the Vienna school (but not only) were appropriated and accepted by Czech historiography, not on the

Walter Hentschel, *Deutsche Literaturzeitung für Kritik der internationalen Wissenschaft*, 73 (1952), pp. 456—460. For the reception of the Czech scholarship, see *infra*.

24 Walter Jürgen Hofmann, "Nachruf auf Karl Oettinger (gest. am 8. Mai 1979)", *Zeitschrift für Kunstgeschichte*, 43 (1980), pp. 222—224.

25 Oettinger, *Anton Pilgram* (n. 23), p. 119.

26 See Maria Männig, *Hans Sedlmayrs Kunstgeschichte: Eine kritische Studie*, Cologne/Weimar/Vienna 2017, esp. pp. 38—96, 221—234; on art historians during the NS-period, see Heinrich Dilly, *Deutsche Kunsthistoriker: 1933—1945*, Berlin 1988, with pp. 82—88 partly on Sedlmayr; *Kunstgeschichte im "Dritten Reich". Theorien, Methoden, Praktiken*, Olaf Peters, Ruth Heftrig, Barbara Schellewald eds, Berlin 2008.

27 Milena Barlová, "'Slavonic Features' of Bohemian Mediaeval Painting from the Point of View of Racist and Marxist-Leninist Theories", in *Die Kunsthistoriographien* (n. 5), pp. 173—179.

28 Mostly in Karl Oettinger, "Der Meister von Wittingau und die böhmische Malerei des späteren 14. Jahrhunderts", *Zeitschrift des deutschen Vereins für Kunstwissenschaft*, 2 (1935), pp. 293—307; *Idem*, "Altböhmische Malerei", *Zeitschrift für Kunstgeschichte*, 6 (1937), pp. 397ff. On the question of "Gemanic" or "Slavic" traits, long-lasting problems in Czech historiography, see the contributions of Ondřej Jakubec as well as Jan Klipa in the present volume. Parts of this long-lasting thinking can be found already in texts of Johann Gottfried von Herder (1744—1803), see Alexander Maxwell, "Herder, Kollár, and the Origins of Slavic Ethnography", *Traditiones*, 40/2 (2011), pp. 79—95.

29 Bartlová, "'Slavonic Features'" (n. 27), pp. 175—176; on Pešina, see *Eadem*, "Jaroslav Pešina 1938—1977: čtyři desetiletí politických strategií českého historika umění" [Jaroslav Pešina 1938—1977: four decades of political strategies of a Czech art historian], *Opuscula historiae artium*, 66/1 (2017), pp. 74—85.

basis of their ideological roots, but of their theoretical and formal background as purely scientific and objective forms of scholarship.[30] Very similar and problematic mechanisms of appropriation and rejection can be identified in the Czech reception of Oettinger's authoritative monograph on Pilgram.

The very same year as Oettinger's monograph, the other side of Pilgram's identity, related to his architectural skills, was explored in a monograph by Rupert Feuchtmüller (1920—2010).[31] Consequently, this aspect began to be developed notably though the study of hundreds of architectural drawings (*Risse*) attributed to Pilgram and conserved mostly in Vienna.[32] Thus, the impressive dual figure of Pilgram continued to be, both in architectural drawing and sculpture, outlined as a pure "product" of the Renaissance. To some extent, it is once again the impressive personality of the "Austrian" artist which led Oettinger to attributions and stylistic judgments. His style is, according to the Oettinger, recognizable not only in the sculptural, but also in the architectonic elements. The sculptures of the town hall portal at Brno, probably created by Pilgram around 1511, give Oettinger the possibility for a comparison with the later works in Vienna |06|:

|06| ↑ Anton Pilgram, Sculpture of an armoured figure, from the Old Town Hall, Brno, around 1511

Thus, the statues of the Brno portal appear as the worthy predecessors of the Viennese late works. With the style of their robes, which points to Southwest German roots, such as the Crucifixion of Hans Seyfer in Stuttgart and Strasbourg parallels, they are a trace of the training of the master, which then, at the end of his Brno period, had already exceeded the height of life.[33]

142

The key element here remains the question of the chronology of Pilgram's works. The German roots of the works in Brno are found in Pilgram's early travels around the Empire, while the apex of his career can only be materialized in the late Viennese works. In this sense, Brno was but a further "provincial" city in which the great master practiced his excellent trade.

Also instrumental to the reevaluation of Pilgram's figure in these post-war years is the figure of Otto Benesch (1896–1964).[34] Also an Austrian art historian, a student of Max Dvořák at the Vienna School, Benesch, unlike Oettinger, directly suffered from the National-Socialist

30 On objectivity and German scholarship, cf. Christian Fuhrmeister, "*Reine Wissenschaft*: Art History in Germany and the Notion of 'Pure Science' and 'Objective Scholarship'", in *German Art History and Scientific Thought. Beyond Formalism*, Mitchell B. Frank, Daniel Adler eds, London/New York 2012, pp. 161–177; See Ján Bakoš, "From Universalism to Nationalism" (n. 6). See also Milena Bartlová, "Continuity and discontinuity; the legacy of the Vienna School in Czech art history", *Journal of Art Historiography*, 8 (2013) [online].

31 Rupert Feuchtmüller, *Die spätgotische Architektur und Anton Pilgram. Gedanken zu neuen Forschungen*, Vienna 1951.

32 See Bruno Grimschitz, "Die Risse von Anton Pilgram", *Wiener Jahrbuch für Kunstgeschichte*, 15 (1953), pp. 101–118; a good résumé of the question is to be found in Hans Koepf, "Zur Frage der Urheberschaft der 96 angeblichen 'Pilgram-Risse' der Wiener Sammlungen dargestellt an den Zeichnungen des Orgelfusses im Stephansdom und der Meiseheimer Gruppe", *Alte und moderne Kunst*, 20 (1975), pp. 9–14.

33 "*So erscheinen die Statuen des Brünner Portals als würdige Vorgänger der Wiener Spätwerke. Mit ihrem Gewandstil, der auf südwestdeutsche Wurzeln, etwa auf die Kreuzigung Hans Seyfers in Stuttgart und ihre Straßburger Parallelen weist, geben sie eine Spur für die Schulung des Meisters, der damals, am Ende seiner Brünner Periode, schon die Höhe des Lebens überschritten hatte*", Oettinger, *Anton Pilgram* (n. 23), p. 21.

34 Ulrike Wendland, "Benesch, Otto", in *Eadem, Biographisches Handbuch deutschsprachiger Kunsthistoriker im Exil. Leben und Werk der unter dem Nationalsozialismus verfolgten und vertriebenen Wissenschaftler*, Munich 1998, pp. 32–39.

regime. Because his wife was of Jewish origin, he had to emigrate from 1938 to 1947 to France, England, and the US, only after the war becoming professor at the University of Vienna and director of the Albertina until 1964.[35] He was a fine connoisseur and became one of the world's major experts of Rembrandt's drawings. In two papers published in 1953 and 1959, Benesch identified a total of four further statues by Pilgram, probably planned for winged altarpieces: in this, he arrived to partly the same conclusions as the Czech art historian Albert Kutal in 1956. At this point however, each scholar did not see the results of the other's works.[36] A letter from 1956 between the two attests that Benesch saw the common formal attribution as a proof of the correctness of this judgement, and as an opportunity for future collaboration.[37] Indeed, it is the only hint at a possibility for two scholarly worlds divided by the Iron Curtain of, in the words of Benesch, "opening the tunnel on both sides and happily meeting at the center".[38] In the statues of the two Dominican monks acquired by Kutal and to this day preserved in the Moravian Gallery in Brno, Benesch wanted to see exactly what Vöge had seen earlier in the Falconer — that is, the traces of a strong personality emerging from the artwork |07|:

There for the first time the personality came to the full liberation, the personality, which already had started to break loose in the Falconer and would reach its apogee in the busts of church fathers and self-portraits in Vienna.[39]

This strong personality which would bring Pilgram to quarrel with the corporation of masons in Vienna, is comparable, as Benesch continues in a footnote, to the difficult personality of architect Adolf Loos (1870—1933) — also born in Brno and active in Vienna.[40] Identifying two

144

further artworks of the late Viennese period at the end of 1958 — wooden sculptures of Saints Cosmas and Damian which he dates to 1511—1515 — Benesch argues again for the incomparable capacity of Pilgram to capture humanity in portraits |ø8|.[41] He continues by arguing that the

35 Wendland, "Benesch" (n. 34). See also Charles de Tolnay, "Otto Benesch 1896—1964", *The Burlington Magazine*, 107/745 (1965), pp. 206, 209.

36 Otto Benesch, "Eine Zeichnung des Schalldeckels der Pilgramkanzel aus dem 16. Jahrhundert", *Alte und Neue Kunst*, 2 (1953), pp. 32—40; *Idem*, "Zwei unerkannte Werke von Anton Pilgram", *Jahrburch der Berliner Museen*, 1 (1959), pp. 198—217, p. 198: "*Meine an wenig verbreiteter Stelle publizierte Bestimmung wurde drei Jahre nach ihrer Veröffentlichung von Albert Kutal, dem sie unbekannt geblieben war, bestätigt, indem er unabhängig zum selben Ergebnis gelangte*". On Kutal, see *infra*.

37 Letter from Otto Benesch to Albert Kutal, Vienna, 27 November 1956, Archiv Masarykovy univerzity, B 30 Albert Kutal, k. 1, II. C. Osobní korespondence, Zahraničí: "*Ich betrachte unsere völlig voneinander unabhängige übereinstimmende Meinung als einen Beweis der Richtigkeit unserer Zuschreibung. [...] Ich habe mich über die Koincidenz der Meinungen aufrichtig gefreut. Ich muß ihnen übrigens zur Erwerbung der beiden prachtvollen Plastiken für Ihr Museum herzlichst gratulieren*".

38 "*Wäre der Verkehr nicht so schwierig, so hätte ich schon längst früher mit Ihnen Gedankenaustausch über die beiden Plastiken von Pilgram gepflogen. So haben wir von beiden Seiten den Tunnel angebohrt und sind glücklich in der Mitte zusammengekommen*", Letter from Otto Benesch to Albert Kutal (n. 37).

39 "*Da ist zum erstenmal die Persönlichkeit zur vollen Befreiung gekommen, die Persönlichkeit, die sich schon im Falkner loszureißen begonnen hatte und in den Kirchenväterbüsten und Selbstbildnissen der Wiener Werke den Höhepunkt erreichen sollte*", Benesch, "Zwei unerkannte Werke" (n. 36), pp. 207—208.

40 "*Manche Charakterzüge hat der streitbare Meister mit seinem vier Jahrhunderte später lebenden engeren Landsmann Adolf Loos gemeinsam. Das Predigen eines neuen Evangeliums und künstlerischen Ethos ist beiden nicht gut bekommen*", *Ibidem*, p. 209, n. 19.

41 *Ibidem*, pp. 210—217. Once again, he writes to Kutal of his discovery in a letter dated 11 November 1958, asking for negatives of the portal of the town hall, see the Archiv Masarykovy univerzity, B 30 Albert Kutal, k. 1, II. C. Osobní korespondence, Zahraničí.

|07| ↑ Comparison between two
figures attributed to Pilgram, from
Otto Benesch, "Zwei unerkannte
Werke von Anton Pilgram",
Jahrburch der Berliner Museen, 1
(1959), pp. 198—217, fig. 10, p. 206.

|08| ← Anton Pilgram (?), Detail of
Saint Damian, sculpture on wood,
around 1500
/Kunsthaus, Zürich

sculptures could even have been made for the St Stephen. Cathedral, again activating the old topos, alive at least since Burckhardt, of the spiritual Middle Ages renewed by the creative and deeply humanist forces of the Renaissance: "These are Saturnian faces which look at us from these figures, embodiments not only of old spiritual powers, but also of new creative vital forces."[42]

In this, for Oettinger, Feuchmüller, or Benesch, it remains the Viennese context of the reception of earlier studies and intellectual traits which influences their work. Pilgram, like Loos, is a genius and tormented personality, the kind of figures which had existed in German Romanticism for decades. The specifically Viennese element can be seen in the deep interest for the psychologization of the Renaissance figure of the artist. Here, we must once again recall *The Myth of the Artist* by Kris and Kurz, but also Panofsky's later study on Dürer.[43] What thus emerges are national traits coupled to a very specific way of constructing artistic biographies and figures. What seems furthermore important is the continuous reenactment and re-activation of an artist figure whose narrative is presented as continuous and bridging the gap, or in Burckhardt's terms, able to tear away the veil ("*Schleier*") between the medieval world and the self-awareness of early Modernity. That the national characteristic of a German figure was able to achieve this was clear for German scholarship. Just as world domination had to be established by "Germanic" leaders ("*Führerfiguren*") and art history had established itself as a first-class

42 *"Es sind saturnische Gesichter, die uns aus all diesen Gestalten entgegenblicken, Verkörperungen nicht nur alter geistlicher Gewalten, sondern auch neuer schöpferischer Lebensmächte"*, Benesch, "Zwei unerkannte Werke" (n. 36), p. 217.

43 Kris/Kurz, *Die Legende vom Künstler* (n. 2); Erwin Panofsky, *The Life and Art of Albrecht Dürer*, Princeton 1943.

scientific field through the development of formal analysis by German art historians, so Pilgram — the artistic personality ("*Künstlerpersönlichkeit*") — could only possess national German traits. However, what is most outlined in the works of German-speaking scholars, both in the attributions and psychologizing aspects of the artist, is the self-awareness of the art historian in the creation of a continuous narrative.

A contrapposto with the Czechoslovak situation shows that this narrative can also be reversed, and instrumentalized in other ways. As already announced, the second part of the essay is thus dedicated to the Czech-speaking historiography of the twentieth century. The thresholds of our reflection are the years 1918, the creation of the new Czechoslovak state, and 1989, the collapse of the Communist regime in the country. We have decided to extract this (now traditional) time span because the aim of this essay is not to reflect on the (in)adequacy of grounding the historiographical research purely on political events. However, to pick an alternative delimitation would require more thoughtful explanation. We are convinced, nonetheless, that the revolutionary year 1989 did not represent an immediate turning point in the Czech art-historical scholarship and that the heritage of the past is still alive. This is why we consider opening a discussion on these topics to be crucial. The name and works of Anton Pilgram in Czech art history usually emerges in the general publications and only exceptionally are he and his works a focal point of a specialized survey. We will therefore focus on how Pilgram was (or was not) integrated into the narration of Czech art history and how the monuments attributed to him were perceived.

|09| ↑ Photograph of Eugen Dostál

THE NEW CZECHOSLOVAK REPUBLIC

In comparison with the German-speaking historiography of the twentieth century, the Czech-speaking one shows surprisingly little interest in the works and figure of Anton Pilgram, even though there are high-quality monuments attributed to him conserved in Brno. We suppose that the environment of the First Republic made it difficult to accept the notion of Pilgram as a "German genius", because the situation between Czechs and Germans was far from being settled. The first direct reception of Pilgram's work after the creation of the First Czechoslovak Republic is to be found in the work of Eugen Dostál (1889–1943) |09|.

In order to understand Dostál's intellectual background it is useful to note that he was born in Moravian Příbor within the Austrian-Hungarian Empire, and was a pupil of the Vienna School, where he was trained primarily by Max Dvořák.[44] Here we can find one of the fundamental traits already mentioned above: the shared intellectual background and methods of Czech-speaking and German-speaking scholars. As has been shown, the Vienna School's research subliminally defended the transnational character of the Habsburg empire, its cosmopolitanism, and centralism. In simple words, Vienna art history existed to serve the Empire's needs.[45] Dostál finished his dissertation in art history in Vienna at the brink of the First World War. When the war was over, his mother country did not exist anymore. Instead, new

44 "Eugen Dostál", in *Slovník historiků umění, výtvarných kritiků, teoretiků a publicistů v českých zemích a jejich spolupracovníků z příbuzných oborů (asi 1800–2008)* [Dictionary of art historians, art critics, theoreticians, and journalists in Czech lands and their collaborators from related fields (c. 1800–2008)], Lubomir Slavíček ed., vol. 1, Prague 2016, pp. 241–242.

45 Bakoš, "From Universalism to Nationalism" (n. 6), pp. 81–85.

nation countries were established. Dostál abandoned Vienna and returned to Moravia, coming to Brno, in the young Czechoslovakia. Soon, he was offered to become a lecturer ("*Privatdozent*") of art history at Masaryk University.[46] A new university, it had been founded in 1919. The creation of a university in Moravia had been planned since the 1860s. Among the Czech and German inhabitants of Moravia, there were differing opinions on the language character of the university, which caused severe problems and blocked its actual foundation. When the Austro-Hungarian Empire was defeated and broken up into nations, the Czechs perceived their new republic as the culmination of the national emancipation and an act of liberation from Habsburgs and Catholicism.[47] The Czech Revolutionary National Assembly, the highest state authority in the years 1918—1920, acted efficiently and, the year after the foundation of the new republic, the university was opened.[48] Its character corresponds with the atmosphere in the new republic: it was a Czech-language, anti-clerical, and anti-Habsburg university.

Yet Brno was the most important German-language enclave in Moravia, with ten neighbouring German municipalities; it was the institutional, educational, industrial, and cultural center of Moravian Germans. With the German population standing at sixty-six percent in 1910, it was the largest German city in Czech lands. In 1921, the number decreased radically to thirty-five percent — essentially it was caused by the creation of Great Brno in 1919, when the neighboring settlements were connected to the center. Moreover, this percentage is not absolute because the difference results from different methodologies and from the change of declared ethnicity in language enclaves by an abundant bilingual part of population, who were probably inclined to belong to the politically-dominant ethnicity.[49] Nationalistic

intellectuals of Brno demanded that the language en-
clave be joined to German Austria in October 1918. This
demand was rejected but this episode shows the unsta-
ble and tricky situation between the German and Czech
inhabitants in the town.[50] The founding of the Czech
university, as with other Czech state institutions, was in-
tended to secure and strengthen the positions of Czechs
in the city. This is the backdrop for Dostál's activity at
Masaryk University in 1921. He would become the first
professor in the Department of Art History, officially es-
tablished on 27 March 1929 with a very clear goal:

*It is important to consider that in Moravia, where the ar-
tistic production of this region is scarcely known, the de-
partment of the art history has a crucial cultural signifi-
cance. It must become a center which will educate young,
Moravian art historians and create an institution capa-
ble of analyzing the rich art historical material.*[51]

The department's mission was clearly established: to re-
search and systematize the unstudied or poorly studied

46 Jiří Kroupa, "Sedmdesát let dějin umění v Brně" [Seventy years of
 art history in Brno], in *Almanach, sedmdesát let Semináře dějin
 umění Masarykovy univerzity v Brně* [Almanac, seventy years of the
 Department of Art History at the Masaryk University in Brno], Jiří
 Kroupa, Lubomír Slavíček eds, Brno 1997, p. 5.
47 Zdeněk Kárník, *České země v éře První republiky (1918—1938)* [Czech
 lands in the era of the First Republic (1918—1938)], vol. 1, Prague 2000,
 pp. 315—325; Patrick Crowhurst, *A History of Czechoslovakia be-
 tween the Wars: From Versailles to Hitler's Invasion*, London 2015.
48 Fasora, *Historický pohled* (n. 9), pp. 10—15.
49 Kárník, *České země* (n. 47), vol. 1, pp. 84—89.
50 Richard Jašš, Miloš Fňukal, "The German Language Islands of Brno,
 Olomouc and Jihlava during German-Austrian Irredentism in the Au-
 tumn of 1918", *Moravian Geographical Reports*, 1/17 (2009), pp. 40—48.
51 "*Nutno také uvážiti, že na Moravě uměleckohistoricky skoro vůbec
 nezpracované, náleží stolici dějin umění také mimořádný význam*

|10| → Cover page of Eugen Dostál, *Umělecké památky Brna*, Prague 1928

art in Moravia, the second area after Bohemia inhabited by Czechs, in order to discover the domestic Czech art of the region. This approach yielded results some twenty years later in the 1935 exhibition at Brno's Moravian Museum titled *Gotické umění na Moravě a ve Slezsku* [Gothic art in Moravia and Silesia]. It was curated by Albert Kutal (1904–1976), one of the first graduates from the Department of Art History at the Masaryk University.[52] The aim of the exhibition was to map the Gothic art in Moravia and Silesia in order to show its equality with art in Bohemia, and to distinguish the domestic art in these regions to establish the Czech national narrative.[53]

For the needs of the nation Czech state, Dostál's method was very effective. He appropriated Viennese notion of immanent and continuous development of art and advanced the idea of a regional or national artistic organism arising from foreign sources but having a characteristic and relatively independent development.[54] Expressed in other words, he enhanced the genetic line of the Czech art within the world art, giving Czech art its distinctiveness yet interconnection with the most important artistic centers. Dostál mentions Pilgram's work in his handbook on Brno written on the occasion of the exhibition of contemporary art in Czechoslovakia (*Výstava soudobé kultury v Československu*) which took place in Brno in 1928. The exhibition celebrated the ten-year anniversary of the First Czechoslovak Republic and was visited by about 2.7 million people.[55]

Dostál's handbook of 1928, *Umělecké památky Brna* [Artistic Monuments of Brno], includes the most important monuments of the city |10|. He did not pay any particular attention to Pilgram's work, which also partly be due to the brevity of the volume. Dostál simply introduces Pilgram as the co-builder of the St Stephen Cathedral in Vienna. On his presumed works at the church

of St Jacob in Brno, Dostál argues that "[...] it is impossible to credit the church to famous master Pilgram, who worked at the building around the year 1510 as the mason's marks confirm".[56] Instead he points to a collective workshop, active in the 1530s in Doubravník (a small town c. 40 km from Brno), as the builders who created the church's outwardly appearance. He admits that it is possible that the masters, Anton Pilgram and Jindřich Parléř, participated in the construction. Their participation, however, has not imprinted a distinct characteristic onto the church. In other words, in Dostál's view the most prominent late-Gothic church in Brno does not belong to the line of

kulturní, neboť musí se státi střediskem, které povede vychování umě-leckohistorického dorostu moravského a vytvoří organizaci, schopnou všestranného zpracování bohatého materiálu uměleckohistorického", quotation from the definitive establishment of the chair of art history at the Faculty of Arts at the Masaryk university, in Praha, Archiv Akademie věd České republiky, fond Eugen Dostál. After Kroupa, "Sedmdesát let dějin umění" (n. 46), p. 5.

52 "Albert Kutal", in *Slovník historiků umění* (n. 44), vol. 1, pp. 775–777.

53 Lubomír Slavíček, "Objev nové pevniny. Brněnská výstava gotického umění Moravy a Slezska 1935/1936 a Albert Kutal" [Discover new lands. The Brno exhibition of Gothic Art of Moravia and Silesia 1935/1936 and Albert Kutal], in *Artem ad vitam: kniha k poctě Ivo Hlobila* [Artem ad vitam: Book in honor of Ivo Hlobil], Helena Dáňová, Klára Mezihoráková eds, Prague 2012, pp. 580–599.

54 Bakoš, "From Universalism to Nationalism" (n. 6), p. 88.

55 Zdeněk Müller [*et al.*], *Výstava soudobé kultury: Exhibition of contemporary culture: Brno 1928*, Brno 2008.

56 "[...] *nelze jeho stavbu* [kostel sv. Jakuba] *připisovati slavnému mistru Pilgramovi, který podle kamenických značek prý pracoval na stavbě okolo roku 1510*", Eugen Dostál, *Umělecké památky Brna* [Artistic Monuments of Brno], Prague 1928, p. 56.

Pilgram's nor of Parléř's artistic development, but is the product of a local Moravian workshop.

Dostál continues by stating that Pilgram's participation on the portal of the town hall is not attested in sources; he hypothesizes that the more likely creator was a pupil of Matyáš Rejsek, who was regarded as the real Czech architect at that time, and who also was famous for his self-portrait on the town hall of Prostějov in Moravia.[57] This would mean that the masterful artwork was created by a pupil of a Czech architect, and thus could be integrated into the artistic development of domestic art. It would not also be conceivable to admit that the glorious portal of the Moravian town hall originates from master who studied in Germany and created his greatest masterpieces in Vienna. Finally, according to Dostál, only the destroyed Jewish Gate, from which some pieces survived, bears the artistic involvement of Pilgram. It remains to question whether the traditional pro-German orientation of the Jewish community might be in the background of this attribution.[58]

Dostál's interpretation of Pilgram is certainly rooted in the assumed German ethnicity of the figure. Moreover, the Germans in Brno were interested in Pilgram and his work. They promoted initiatives on the reconstruction of the Jewish Gate, which was dismantled in the nineteenth century, but partially preserved in a depository. We do not know much about this anecdote, with the only source being a letter from Emil Filla to Albert Kutal in 1935. It is known from this letter that Maximilian Steif (1881–1942), a German art historian in Brno, addressed Filla, then editor of Volné směry [Free directions], and asked him to publish his article proposing the reconstruction of the Jewish Gate.[59] Therefore, we can conclude that Dostál had perceived Pilgram as a German artist, thus neglecting his involvement in Brno's most

important monuments and rather attributing them to Czech artists. When considering the political and cultural situation of Brno in the Interwar period as described earlier, we can propose a hypothesis that he strove to prove the Czech character of medieval Brno.

THE GENERATION BEYOND
THE IRON CURTAIN

The notion of Anton Pilgram as a German artist probably removed this figure from the interest of Czech scholars, as it happened as well in the case of the fifteenth-century Altarpiece from Znojmo. The altar (now preserved in the Kunsthistorisches Museum in Vienna but originally in the church of St Nicolas in Znojmo) was for decades considered to be a German-Austrian artwork, which arrived in Znojmo only accidentally. This explanation, created by Austrian art historians, was accepted by scholars on the Czech side; the extraordinary altarpiece was thus excluded from their inward facing attention.[60] However, the "immobility" of Pilgram artworks in Moravia, for

57 Dostál, *Umělecké památky* (n. 56), p. 134.

58 *Ibidem*, p. 142.

59 Filla asked Kutal for an advice in the matter of publishing the article. Kutal's reply is unknown. However, the article was never published in *Volné směry*. Letter from Emil Filla to Albert Kutal, 6. 7. 1935, Archiv Masarykovy univerzity, B 30 Albert Kutal, k. 1, II. Osobní korespondence, Československo: "[...] psal mi nějaký brňák jménem Dr. Maxmilian Steif, Brno, Jesuitská 15 vzhledem k Pilgramově bráně a chce, abych otiskl článek jeho týkající se znovuzřízení této brány. Patrně je to Němec. Prosil bych Vás o radu: kdo to jen ten pán a zda má smysl fedrovat znovuzřízení té brány. Nesledoval jsem tuto záležitost a nevím v jakém stádiu se nalézá."

60 Milena Bartlová, "Je Znojemský oltář rakouský, německý, český nebo moravský?" [Is the Znojmo altarpiece Austrian, German, Czech, or Moravian?], *Bulletin Moravské galerie v Brně*, (2003), pp. 140–147.

they consist mostly of architecture and architectural decoration, did not make it possible to completely erase them from the narratives of Czech art history. However, only the Moravian artworks are considered in scholarly research.

After the Second Word War, Czechoslovakia was isolated from Western Europe by the Iron Curtain, and academic discussion was limited in terms of freedom.[61] However, the leading figure in studies on medieval sculpture, Albert Kutal, exchanged letters with a long list of foreign scholars even before the liberalization process of the 1960s.[62] Kutal, for example, knew very well the monograph of 1951 by Oettinger on Pilgram and agreed with his attributions, as we can see from his general overview on Gothic art published in 1972.[63] Fifteenth-century art was, however, not the focus of the work of Albert Kutal, professor of art history at the Masaryk University and the leading figure in medieval studies in Czechoslovakia between the 1940s and 1970s. His research was focused on the sculptures in Bohemia and Moravia of the thirteenth and fourteenth centuries. Nevertheless, Kutal enlarged Pilgram's portfolio with two wooden sculptures of Dominican saints in the Moravian gallery in Brno.[64] Originally, Kutal mentioned these statues already in 1949 as works of Pilgram or close to his *maniera*. However, in 1956 — probably under the influence of Oettinger's book — he wrote a beautiful essay on these two sculptures, which he now attributed to Pilgram with certainty. We have already mentioned the fact that Otto Benesch made the same attribution as Kutal, without the two being aware of the other's work. In 1949, Albert Kutal described Pilgram as one of the most prominent representatives of the realistic stream in central Europe and integrated him into the Czech art of sculpture. Besides Vienna, he lists among his works monuments in

Brno, which are ascribed to him or close to his manner: the Jewish Gate, the town hall portal, and two wooden sculptures of Dominican saints in the Moravian gallery in Brno. He characterizes this style as an effort to objectively represent reality, which culminates in his own self-portraits at St Stephen's Cathedral — thus following the German narrative outlined above.[65] Furthermore, in the introduction to his 1949 essay on Czech medieval sculpture Kutal states that the colonization of the Czech lands in the thirteenth century brought many foreigners, mainly Germans, who violated the ethnic unity of the country. Because of the "German curtain", domestic art was cut off from the high-quality production of western and southern Europe; this was overcome in the fourteenth century.[66] Further, Kutal writes that even though a residue can be found in Pilgram's art of late-Gothic mannerism, which he received during his studies in the western Germany, his realism is so strong that it goes

61 Doubravka Olšáková, *Věda jde k lidu! Československá společnost pro šíření politických a vědeckých znalostí a popularizace věd v Československu ve 20. století* [Science goes to the people! Czechoslovak society for dissemination of political and scientific knowledge and popularization of sciences in Czechoslovakia in the twentieth century], Prague 2014; Riikka Palonkorpi, *Věda s lidskou tváří: činnost československých vědců Františka Šorma a Otty Wichterleho během studené války*, Prague 2017 (translated from the English original *Science with human face: the activity of the Czechoslovak scientists František Šorm and Otto Wichterle during the Cold War*, Tampere 2012).

62 As can be seen, e.g., in the Archiv Masarykovy univerzity, B 30 Albert Kutal.

63 Albert Kutal, *České gotické umění* [Czech Gothic arts], Prague 1972, pp. 167–168.

64 Albert Kutal, "Dvě nové práce Antonína Pilgrama" [Two new works of Anton Pilgram], *Umění*, IV (1956), pp. 93–106.

65 Antonín Matějček, Dobroslav Líbal, Albert Kutal, *České gotické umění* [Czech Gothic arts], Prague 1949, pp. 78–79.

66 *Ibidem*, p. 41.

beyond Gothic art. Kutal compares it with the realism of the Italian Renaissance, which was brought to Czech lands by 1495.[67] In a way, Kutal here invokes Vöge's ideas on an artistic personality uniting medieval tradition with Renaissance innovation. From Kutal's viewpoint, this innovation brings a connection with southern European high-quality production, surpassing its German influences.

In the late 1970s, a collective summary of late-Gothic art in Czech lands was published. The volume is dedicated mainly to Bohemia, but Moravia was incorporated as well, though to a lesser extent. The introduction of this volume admits that the art in Moravia was difficult to identify and incorporate into the narrative of Czech art history because the artistic development differed from that of Bohemia; the strongest link was only the common artistic tradition.[68] What is clear from this introduction is spontaneity in seeking the common artistic language in Bohemia and Moravia and its absence calls for explanation. There is no doubt that these overviews serve the important function of creating and supporting the national myth and identity.[69] Jaromír Homolka, the author of sections on Moravian art, stated that there was a noticeable development of the Matthias Gerhart school in Moravia, due to the political situation — Moravia was incorporated into the Kingdom of Hungary. However, Moravian sculpture creatively participated in the development of idealizing and classicizing ("*idealizující a klasicistní*") tendencies of central Europe, which might be perceived as a late-Gothic parallel to Beautiful Style.[70] It is noteworthy that Beautiful Style was understood as an autonomous branch of international Gothic, which was typical for the domestic art in the Czech lands and apparently the same tendency is sought also in this later

period. The idealizing and classicizing tendencies of late Gothic art are the focal point of Homolka's essay as they are treated as domestic art trends. The work of Anton Pilgram is mentioned to a minor extent, mostly by quoting what Kutal had stated about him. Homolka categorizes his work as a portrait realism, marginalized in this volume. He limits himself to declaring Anton Pilgram the greatest sculptor active in Brno at the end of the Middle Ages. However, his artistic programme was a rare example in Moravia and did not affect the development of art in Moravia. For Homolka, though he accepts the high quality of Pilgram's work, he deems him a foreign element, and not one that can be considered part of the development of Moravian sculpture. He was outside the idealizing and classicizing trends, parallel to the Beautiful Style, a distinctive Czech art.

EPILOGUE

From the early twentieth century to the 1970s, these few lines show how Pilgram can serve as a mirror of the fractured historiography between German-speaking and Czech-speaking scholarship. We have focused only on a part of the reception of the master, voluntarily avoiding the question of his architectural drawings, which give way to another historiographical tradition in the German-speaking milieu, but have almost completely been ignored in the Czechoslovak space. In the end, as we have mentioned at the beginning, it remains only to

67 Matějček/Libal/Kutal, *České gotické umění* (n. 65), p. 79.
68 Jaromír Homolka [*et al.*], *Pozdně gotické umění v Čechách, 1471—1526* [Late Gothic Art in Czech Lands, 1471—1526], Prague 1978, pp. 10—11.
69 For art history, see Milena Bartlová, *Naše, národní umění* [Our, National Art], Brno 2009, pp. 10—15.
70 Homolka, *Pozdně gotické umění* (n. 68), pp. 232—233.

say that many attributions to Pilgram as a contrasted figure of a "Renaissance genius" have since been revised. Furthermore, some of his works are still debated from the point of view of attribution, dating, and localization. Pilgram himself, despite what we know of his late life from the building registers of St Stephen's, remains a sketchy and overall he is a little-documented figure. For Vienna, he remains clearly visible in his portraits at the cathedral; in Brno he remains more mysterious — present at the town hall, at St Jacob's through his recognizable stonemasonry symbol, and in the remains of the Jewish Gate conserved at the castle. However, the small Falconer of Vienna, on which Vöge had begun to build the legend of a haughty and self-aware German master, is, in a twist of fate, no longer attributed to him. Thus it remains only historiography in the making.

→ # IMAGES AND REFLECTIONS OF MEDIEVAL BRNO IN THE NINETEENTH AND TWENTIETH CENTURY

JAN GALETA

The aim of this study is to examine how historians and art historians have looked at the medieval past of the city of Brno, once the capital of the Margraviate of Moravia and of the Land of Moravia-Silesia.[1] In this analysis, I will use only some of the ideas given at the time as examples. The breadth of the topic means that the analysis deals mainly with general publications rather than specific studies: these very general texts are those constituting a historicized image of the city among the broad, and even lay audience.

1 This study is a compilation of two previous papers. The first was given at the workshop *Auto-Referentiality in Local Identity: Artworks from Brno and Olomouc in Medieval and Late Modern Time through the Historiography of the 20th Century*, (Brno/Olomouc, 1—3 October 2016), and titled "Historiographical Images of Medieval Brno". The second was for the *International Summer School: (Moravian) Middle Ages in the Mirror of the 20th Century*, (Brno, 9—12 September 2018) and titled "Reflections of Medieval Brno: Historiography, Monuments and Re-Medievalization". The study is also part of the Masaryk University grant project MUNI/A/1378/2018.

To show the various images of medieval Brno, it is necessary to make a very short historical introduction.[2] Although there were large settlements in the broader area of today's Brno from the Chalcolithic to the Great Moravian era in the tenth century (e.g., the hillforts at Obřany or Líšeň), there is evidence of only a handful of minor, non-urbanized settlements from the La Tène culture to the Germanic tribes in the area of the current city center. The first significant settlement of the area was, according to latest archaeological research and hypotheses, *Staré Brno* (Old Brno); here, in the eleventh century, was erected the Přemyslid fortress, a gord (*hradiště* in Czech) between the branches of Svratka river. This location is first mentioned in the sources (notably in Cosmas' *Chronica Boemorum*, 1125) as "Brnen" for the gord and "Brnno" for the settlement. From the etymological point of view, the name Brno derives from the old Slavic word *brnje*, which means "mud", "soil", "clay" or "swampy place", an apt description of *Staré Brno*, located by the river.[3] This name was later transferred to the new location established on the other side of the Petrov hill. From the twelfth century circa, there was a Slavic settlement in the southern corner of today's city center around the Church of St Michael. Around the year 1200, the Moravian Margrave Vladislav Jindřich (Vladislaus Henry) established a market settlement nearby, which was colonized by populations from the Holy Roman Empire, in a wave called the German colonization or *Ostsiedlung*. German, Flemish, and Walloon settlers also built two new churches — St Jacob and St Nicolaus. Soon, Jews also settled in the area, and all these communities melted together, creating an urbanized organism called Brno. Formal town privileges were granted by the king of Bohemia, Václav I (Wenceslaus I) in 1243. During the Middle Ages, Brno was mostly inhabited by German

Moravians, with a strong minority of Czech Moravians and a Jewish community. Czech and German language were used simultaneously, for example in administrative documents, but Germans held political power in the city until the First World War. It is thus only during the long nineteenth century that the struggles between the Czechs and Germans started. By way of examples: the city council refused to extend Brno by annexing surrounding villages and small towns because these localities were mostly inhabited by Czech Moravians; German riots often happened when Czech associations held festivities in the city; Czech schools were not supported by the city council and so on. When Czechoslovakia was established, Czechs took political power in the city, and repaid Germans many of the former iniquities (e.g., the city theatre was originally solely German, but after 1918 it was reserved for Czechs). But the situation reversed again in 1939, when Nazi Germany occupied Czechoslovakia. The severe regime under the Protectorate of Bohemia and Moravia led to a brutal Czech reaction: the expulsion of almost all Germans in 1945–1946 after the Second World War.

HISTORIOGRAPHICAL IMAGES

Two of the strongest images of medieval Brno that emerge from the historiography of the years 1850–1950 could be

2 See Jaroslav Dřímal [*et al.*], *Dějiny města Brna 1* [History of the City of Brno 1], Brno 1969; *Dějiny Brna 1. Od pravěku k ranému středověku* [History of the City of Brno 1. From Prehistoric times to the early Middle Ages], Rudolf Procházka ed., Brno 2011; *Dějiny Brna 2. Středověké město* [History of Brno 2. The Medieval town], Libor Jan ed., Brno 2014.

3 Ivan Lutterer, Luboš Kropáček, Václav Huňáček, *Původ zeměpisných jmen* [The origin of geographical names], Prague 1976, p. 27.

Wanning, des Quadenkönigs, Heerschau.

Der altdeutsche

Volksstamm der Quaden.

Von

Heinrich Kirchmayr,
Professor an der Landes-Oberrealschule, Schriftführer der historischen Section der
mähr.-schles. Gesellschaft in Brünn ꝛc. ꝛc.

Bd. I.

Mit 15 Vollbildern nach Ölgemälden

Fräulein Marie und Sofie Görlich.

Brünn.
Im Commissions-Verlage von Franz Deuticke in Wien und Leipzig.
Druck des Vereines „Deutsches Haus in Brünn". — Druck von Rudolf M. Rohrer.
1888.

|01| ↑ Title page with picture by Marie and Sophie Görlich, Heinrich Kirchmayr, *Der altdeutsche Volksstamm der Quaden*, Band 1, Brno 1888

called "German Brünn" and "Czech Brno".[4] They exist simultaneously in dialogue, or more precisely, in delimitation, and their mutual competition was fuel for new hypotheses and ideas. In the nineteenth century, during the rise of nationalism, Czechs and Germans in Moravia and Brno competed with each other in many fields, among which the study of history. Thus, when nineteenth-century historians put forward the hypothesis that Germans settled in Brno during the *Ostsiedlung* in the thirteenth century, it was widely accepted.[5] But at the end of the nineteenth century, German historians from Moravia came up with another proposition. Among these historians is Heinrich Kirchmayr (1845—1901), a secondary school teacher in Brno. In his book about the heroic histories of the ancient Germanic tribe of the Quadi, Kirchmayr introduced the hypothesis that the German

population of Brno and all of Moravia were descendants
not only of the high medieval settlers, but also of the
tribe of the Quadi from the second century AD |ø1|.[6] This
Urgermanentheorie, as it was called,[7] gained more popu-
larity some years later, namely in the works of Berthold
Bretholz (1862—1936), another historian involved in Brno,
who was director of the Moravian state archive.[8] In his
posthumously published book *Brünn: Geschichte und Kul-
tur* (1938), Bretholz writes:

*In the seventh or eighth century the Slavs came from the
east to this Moravian land which was first inhabited
by Germanic people — and it was the same in Bohemia,*

4 Both names were used and valid throughout the centuries and are
 still used now. Almost all towns and villages in Czech lands have
 Czech and German names, some of Slavic, some of German etymology.

5 Not only by Czech historians (such as Palacký), but even by Ger-
 man authors, see e.g. Christian d'Elvert, *Beiträge zur Geschichte
 der königl. Städte Mährens insbesondere der k. Landeshauptstadt,*
 Brno 1860, pp. 7—8.

6 Heinrich Kirchmayr, *Der altdeutsche Volksstamm der Quaden,* vol. 1,
 Brno 1888, vol. 2, Leipzig 1893, this volume pp. 68, 86.

7 See Josef Žemlička, "Die Deutschen und die deutschrechtliche Kolo-
 nisation Böhmens und Mährens im Mittelalter", in *Historiographi-
 cal Approaches to Medieval Colonization of East Central Europe:
 A Comparative Analysis against the Background of Other Euro-
 pean Inter-Ethnic Colonization Processes in the Middle Ages,* Jan
 M. Piskorski ed., New York 2002, pp. 107—143; Dorota Leśniewska,
 *Kolonizacja niemiecka i na prawie niemieckim v średniowiecznych
 Czechach i na Morawach w świetle historiografii* [German coloniza-
 tion and German law in medieval Bohemia and Moravia in the
 light of historiography], Poznań/Magdeburg 2004, esp. pp. 80—85;
 Mila Řepa, *Moravané, Němci, Rakušané. Vlasti moravských Němců
 v 19. stoleti* [Moravians, Germans, Austrians. Homelands of Mora-
 vian Germans in 19th century], Prague 2014.

8 Bertold Bretholz, *Geschichte Böhmens und Mährens, bis zum Aus-
 sterben der Přemysliden (1306),* Munich 1912, p. 29; *Idem, Geschichte
 Böhmens und Mährens. Erster Band. Das Vorwalten des Deutsch-
 tums, bis 1419,* Reichenberg 1921, pp. 23—33.

B. BRETHOLZ
GESCHICHTE
DER
STADT BRÜNN

HERAUSGEGEBEN VOM DEUTSCHEN
VEREINE FÜR DIE GESCHICHTE MÄHRENS
UND SCHLESIENS
ERSTER BAND

BRÜNN 1911 · VERLAG DES VEREINES
DRUCK VON RUDOLF M. ROHRER

|02| ↑ Book cover, Bertold Bretholz, *Geschichte der Stadt Brünn I*, Brno 1911

Silesia and the other lands. They received the soil and the land from them to be tilled for rent and other taxes, and Slavs lived alongside the German settlements in their own communities, according to their manners, custom and language.[9]

He thus presumed not only that the descendants of Quadi still inhabited Moravia in the eighth century, but also their superiority with respect to the Slavs. The theory that lays emphasis on German superiority was politically suitable in turbulent times in the nineteenth as well as in the twentieth century but was roundly rejected by Czech historians.[10]

This fascination with the Quadi goes so far that one of the key personalities of Brno in the nineteenth century, German industrialist Friedrich Wannieck (1838–1919), claimed that Quadic King Vannius, who ruled in the first century AD, was his ancestor, and that the surname Wannieck was derived directly from the king's name;[11] although it have Czech origins, deriving from the name Václav.[12] As a key member of the nationalistic association *Deutsches Haus*, Wannieck had arranged the publication of Kirchmayr's books, commissioned statues of Quadic kings and queens, including Vannius, from the sculptor Carl Wollek, and paintings of gods and Quadic history from the sisters Marie and Sophia Görlich for the interior of German national house (*Deutsches Haus*).[13] He was also a sort of patron of the writer Guido List, who wrote historical novels and plays, such as *König Vannius. Ein Deutsches Königsdrama* (Brno 1899).[14] List was also an occultist and Germanic neopagan, whose works later influenced the Nazis.[15]

In the eyes of German historians and also for the average German Moravian, medieval Brno had thus always been a German town. It is clearly stated once again by Bretholz in his *Geschichte der Stadt Brünn* (1911) |02|:

And here a strange phenomenon unmistakably comes to light. Of the three nationalities which until, as it were, co-operate in the building and development of the town, Germans, Romanic people and Slavs, only the first assert their national character, and have influenced the whole community in language and law. However, before we

9 *"Im 7. oder 8. Jahrhundert kamen dann in dieses zuerst von Germanen besiedelte Mährenland — ganz ähnlich war es in Böhmen, Schlesien und sonst — Slawen aus dem Osten, erhielten von ihnen Boden und Land zum Bebauen gegen Zins und andere Abgaben, lebten neben den deutschen Niederlassungen in ihren Siedlungen, nach ihren Sitten, Gebräuchen, in ihrer Sprache"*, Idem, *Brünn. Geschichte und Kultur*, Brno 1938, p. 15.

10 See Josef Pekař, *Objevy Bretholzovy, čili od které doby sedí Němci v naší vlasti* [Discoveries of Bretholz, or since what time the Germans have been sitting in our homeland], Prague 1922.

11 Petr Pytlík, *Guido List in Brünn*, Ph.D. dissertation, Masaryk University, Brno 2017, p. 27, [online: https://is.muni.cz/th/ndjh1, last accessed 25. 3. 2019].

12 Dobrava Moldanová, *Naše příjmení* [Our surnames], Prague 2010, pp. 205, 218; Miloslava Knappová, *Naše a cizí příjmení v současné češtině* [Our and foreign surnames in contemporary Czech], Liberec 2002, pp. 15, 157.

13 See Pavel Cibulka, "Historicko-mytologické motivy výzdoby Německého domu v Brně" [Historical-mythological motifs of decoration of the German House in Brno], in *Paměť míst, událostí a osobností: historie jako identita a manipulace* [Memory of places, events and personalities: history as identity and manipulation], Milan Hlaváčka, Antoine Marès, Magdaléna Pokorná [*et al.*] eds, Prague 2011, pp. 348—365.

14 Pytlík, *Guido List* (n. 11), p. 27.

15 Nicholas Goodrick-Clarke, *The Occult Roots of Nazism. Secret Aryan Cults and Their Influence on Nazi Ideology*, New York 2004, p. 37; on Guido List specifically, see Pytlík, *Guido List* (n. 11).

follow this first clear proof of the existence of the German town of Brünn, we must turn our attention to an important preliminary stage of urban development, namely the colonization of the flat lands around Brno.[16]

But it is significant that the part of the sentence mentioning the existence of the "*German town of Brünn*" in one particular copy of the book from the Moravian State Library is crossed out in pencil and marked with a question mark, certainly added by a dissenting Czech reader.[17]

Gustav Trautenberger (1836—1902), another historian and Protestant pastor in Brno, wrote his monumental *Chronik der Landeshauptstadt Brünn* in five volumes between 1891 and 1897 |03|. In the preface, he proclaims that, in the Moravian context, absolute objectivity is a delusion, thus deciding to write his books from a strictly German point of view. He also stated that Brno has risen as a German town, and even divided his books into chapters named after the successive rulers of the Holy Roman Empire.[18] An art historian and professor at the German Technical University in Brno, Karl F. Kühn (1884—1945), titled his book about the Špilberk Castle *Der Spielberg in Brünn: eine deutsche Markgräfliche Pfalz, ein Beitrag zur Geschichte der Kunst des Mittelalters im deutschen Osten* (1943).[19] His perspective — undoubtedly influenced by the German occupation of Moravia and the atmosphere of the Third Reich — is clear.[20] For Kühn, Moravia was an inseparable part of German territory, and the Špilberk Castle was thus without hesitation a German palace.

Christian d'Elvert (1803—1896), historian, politician and twice elected Brno mayor, was, in contrast, more

|03| ↑ Title page, Gustav Trautenberger, *Chronik der Landeshauptstadt Brünn I*, Brno 1891

cautious and more conciliatory in his works. His conviction about the German dominance in Brno and the whole Moravia was nevertheless strong, and is clearly perceptible reading between the lines of his texts. For example, he emphasizes the role of the German medieval clergy in Czech lands and stressed that, even before the *Ostsiedlung*, there were already Germans in Moravia, although he admitted they were not present "in compact masses" and that they were guests in Slavic land. The less radical attitude of d'Elvert can be perceived in the following statement:

Brünn, Olmütz, Znaim [...] were in the thirteenth century towns with absolutely German character, with

16 "*Und hier tritt nun eine merkwürdige Erscheinung unverkennbar zu Tage. Von den drei Nationalitäten, die bisher gleichsam nebeneinander an dem Ausbau und der Entwicklung der Stadt mitgewirkt haben, Deutschen, Romanen und Slawen, behaupten nur die ersten ihre nationale Art und prägen diese dem ganzen Gemeinwesen in Sprache und Rechtsgewohnheit auf. Bevor wir aber diese ersten deutlichen Beweise von der Existenz der deutschen Stadt Brünn im Einzelnen verfolgen, müssen wir noch einem wichtigen Vorstadium der der städtischen Entwicklung, nämlich der Kolonisation des flachen Landes um Brünn wenigstens in einem Beispiel unsere Aufmerksamkeit zuwenden*", Bertold Bretholz, *Geschichte der Stadt Brünn*, vol. I, Brno 1911, p. 28.
17 Moravian State Library, sig. 4-0039.084,1.
18 Gustav Trautenberger, *Chronik der Landeshauptstadt Brünn*, vol. I, Brno 1891.
19 Karl F. Kühn, *Der Spielberg in Brünn: eine deutsche Markgräfliche Pfalz, ein Beitrag zur Geschichte der Kunst des Mittelalters im deutschen Osten*, Brno 1943.
20 Kühn was never directly a National-Socialist but was a German nationalist. For his biography, see Jaroslav Zeman, "Pozapomenutý historik umění Karl Friedrich Kühn (1884–1945)" [The forgotten art historian Karl Friedrich Kühn (1884–1945)], in *Sborník Národního památkového ústavu, územního odborného pracoviště v Liberci* [Proceedings of National Heritage Institute, regional department in Liberec], Jiří Křížek, Olga Křížková, Martin Nechvile eds, Liberec 2007, pp. 85–89.

*German language as dominant and administrative
language, although not with completely German inhab-
itants.*[21]

Architect, museologist, pedagogue, and art historian Au-
gust Prokop (1838—1915) was relatively cautious in his
four volumes of *Die Markgrafschaft Mähren in kunstge-
schichtlicher Beziehung* |04|[22] and in other writings.[23] He
did not deal directly with the national character of Brno,
but, from his point of view, Brno was a German city.

 This insistence on the German character of the city
was not only part of the disputes among historians, but it
was an everyday reality until the end of the First World
War, and again under Nazi occupation during the Second
World War. German Moravians perceived themselves as
natives in Brno and considered the town and the country

as their homeland. They wanted, naturally, to defend the majority and power. Czech Moravians, on the other hand, wanted to take the city into their hands, because Brno was also their home. Thus, the Germans in Brno sought their roots deep in the past, and the long continuity was their main argument — although the myth about the Quadic origins today obviously seems too deeply embedded in the Romantic ideal. But similar national legends were common in those times — like those of the Czech manuscripts of Dvůr Králové and Zelená Hora.[24]

21 *"Brünn, Olmütz, Znaim [...] waren im 13. Jahrhundert Städte mit durchgängig deutschem Charakter und mit deutscher Sprache als Regierungs- und Verwaltungs-Sprache, wenngleich nicht durchgängig mit deutscher Bevölkerung"*, Christian d'Elvert, *Zur Geschichte des Deutschthums in Oesterreich-Ungarn, mit besonderer Rücksicht auf die slavisch-ungarischen Länder*, Brno 1884, pp. 133—135, 140.

22 It is the first compendium about art history of Moravia from ancient times to Prokop's days: August Prokop, *Die Markgrafschaft Mähren in kunstgeschichtlicher Beziehung*, t. I—IV, Vienna 1904.

23 E.g., August Prokop, *Zur Bau-Geschichte der Brünner Domkirche*, Vienna 1884.

24 These manuscripts contain poems written in Old Czech and set in pre-Christian Slavic Bohemia during the early Middle Ages. They were "discovered" in 1817 and 1819 respectively by the philologist Václav Hanka and proclaimed as the oldest Czech literature, proving the high cultural degree of old Slavic Bohemians. For a long time they were considered authentic (even František Palacký was a supporter), but around 1890, it was proved that they were forgeries (most probably by Václav Hanka and his friend, the writer Josef Linda). Nonetheless, before that they were fuel for the Czech National Revival as well as for art — statues of the heroes from the manuscripts are part of the façade of the National Theatre in Prague. See Dalibor Dobiáš [*et al.*], *Rukopisy královédvorský a zelenohorský a česká věda (1817—1885)* [The manuscripts of Dvůr Králové and Zelená Hora and czech science (1817—1885)], Prague 2014. In English, see e.g., John Neubauer, Marcel-Cornis Pope, "Introduction: Folklore and National Awakening", in *History of the Literary Cultures of East-Central Europe*, John Neubauer, Marcel-Cornis Pope eds, Amsterdam/Philadelphia 2007, pp. 269—284, here pp. 277 ff.

As a counterweight to German scholarship and mythological history, the creation of an image of Czech Brno was a quest for the Czech Moravians. They dealt with similar topics as their German colleagues, but both versions were often reversed, like a mirror image. When the German historians came up with the hypothesis that the town of Eburodunum, from Ptolemy's world map (second century AD) is the predecessor of Brno as Quadic settlement, a teacher at a Czech *gymnasium* František Šujan (1859–1944) answered in his paper "*Počátky Brna a jeho jméno*" [The beginnings of Brno and its name, 1900]. There, he stated that Eburodunum had been a Celtic town, and that the name Brno is thus of Celtic origin.[25] In doing so, Šujan tried to weaken the link to the Germanic tribes.[26] He also wrote the first monographic and comprehensive (and also slightly Romantic) treatise about the history of Brno in Czech, titled *Dějepis Brna* [History of Brno, 1902]. Before this first monograph, there was only one article, "*O Brně za nejstarší doby*" [About Brno in the oldest times, 1869] from another gymnasium teacher, Václav Royt (1827–1907).[27] After that, the next comprehensive history of the city was written only in 1969. Clearly, in this domain the Czechs lagged far behind the Germans. Evidently alluding to Trautenberger's *Chronik der Landeshauptstadt Brünn*, Šujan divided his work into chapters corresponding to the years of rule of the margraves of Moravia and kings of Bohemia.[28] A similar mirroring of themes can be noted in the texts of the Catholic priest and church historian Jan Tenora (1863–1936). In 1928, he wrote that when Brno was endowed with town privileges based on German law by King Wenceslaus II, it "in consequence left the Czech population at the mercy of the German population. The German element ruled, and forced their national character upon the whole town in law and language".[29] These words follow in the wake of

d'Elvert or Bretholz, but the King's decision in his eyes becomes a dishonour. The same historical events and almost the same words mean two absolutely different things to the Germans and to the Czechs. From Tenora's point of view, the king's act was "an impossible injustice" (*"křivda neodčinitelná"*).[30]

Czech Moravian historians also hypothesized that when the Slavs came in the sixth or seventh century, Moravia was de facto an empty land.[31] Their opinions were diametrically opposed to those Germans regarding many other events: the case of the foundation of Margraviate of Moravia and its relation to the Empire and Bohemia (1182), town law, parish borders in the town (1293), etc. But most important was the question of the national character of medieval Brno, because it was not only a historical problem, but one that was always present. For this purpose, Royt emphasized the diversity of medieval Brno, inhabited by Slavic Moravians, Germans from various parts of the Empire, Walloons, and Jews.[32]

25 František Šujan, "Počátky Brna a jeho jméno" [The beginnings of Brno and its name], *Časopis Matice moravské*, XXIV/3 (1900), pp. 213—220.

26 It must be added that these Celtic theories were strong opposed also on the Czech side; Vincenc Prasek (1843—1912) disproved it as early as 1901. See Vincenc Prasek, "Eburodunum. Brno", *Časopis Matice moravské*, XXVI/1 (1901), pp. 14—33.

27 Václav Royt, "O Brně za nejstarší doby" [About Brno in the oldest times], *Časopis Matice moravské*, I/2 (1869), pp. 68—74.

28 František Šujan, *Dějepis Brna* [History of Brno], Brno 1902.

29 "[...] *ve svých následcích vydalo na pospas české obyvatelstvo německému; živel německý opanoval a opravdu vtiskl pak svůj nacionální ráz celému městu v řeči i právním řízení*", Jan Tenora, "K dějinám Brna v nejstarší době" [About the history of Brno in the oldest times], *Hlídka*, XV/1 (1928), pp. 16—25, esp. p. 19.

30 *Ibidem.*

31 Šujan, *Dějepis* (n. 28), p. 40.

32 Royt, "O Brně za nejstarší doby" (n. 27), p. 71.

EUGEN DOSTÁL

UMĚLECKÉ PAMÁTKY

· BRNA

JAN ŠTENC PRAHA

1 9 2 8

KOSTEL SV. JAKUBA, KNIHOVNA. KANONOVÝ LIST MISÁLU
Č. 8. (KOL. 1410.)

|ø5| ↑ Title page, Eugen Dostál, *Umělecké památky Brna*, Praha 1928

The same propositions surfaced later in articles in two promotional books about Brno.[33] Šujan in 1902, for example, emphasized the Czech-German "national dualism"[34] in Brno. Moreover, in Czech writings, the German settlers were often marked by the word *"cizí"* — so as strangers / aliens / foreigners — in any case not as the natural part of the population. This term is used by Royt,[35] Šujan,[36] the above-mentioned promotional books,[37] but also for example by art historians such as the founder of the Department of Art History at Masaryk University, Eugen Dostál (1889—1943),[38] or Václav Richter (1900—1970),[39] later founder of the Department of Art History at Palacký University in Olomouc.

If we take a closer look at the field of art history, the first monographic and comprehensive work about Brno is Eugen Dostál's *Umělecké památky Brna* [Artistic monuments of Brno, 1928] |ø5|. Not only does the book begin

with the statement that regarding monuments Brno lacks all that Prague has, but this statement is repeated over and over again. The book is full of disagreeing sentences against the previous German government of the city in the times before the First World War.[40] Between the lines, Dostál blames the Germans for ruining the historical shape of the city, although rarely does he express this outright. Much of what he rejects was due to his modernist view which spurned historicism, but the national context is also strongly present in between the lines. *Brno, stavební a umělecký vývoj města* [Brno, building and artistic development of the city], the second large book about the art history of the city, was published in 1947 by the later director of Brno City Museum, Cecilie Hálová-Jahodová |06|. Like other Czech historians, she especially stressed the Czech character of Brno in the fourteenth and fifteenth century, enumerating a series of Czech names and surnames of the burghers.[41]

33 František Šujan, "Od podhradí k velkoměstu" [From the settlement to the city], in *Zemské hlavní město Brno* [The land capital city of Brno], Alois V. Kožíšek ed., Brno 1928, p. 11—17, sp. p. 12; Vladimír Burian, "Z minulosti Brna" [From the past of Brno], in *Brno. Město a okolí* [Brno. City and surroundings], Alois V. Kožíšek ed., Brno 1938, pp. 7—10, esp. p. 7.

34 Šujan, *Dějepis* (n. 28), p. 74.

35 Royt, "O Brně za nejstarší doby" (n. 27), p. 71.

36 Šujan, *Dějepis* (n. 28), p. 60.

37 Otakar Peterka, "Vzrůst města Brna a jeho obyvatelstvo" [Growth of the city of Brno and its population], in *Zemské* (n. 33), pp. 14—23, esp. p. 14.

38 Eugen Dostál, *Umělecké památky Brna* [Artistic monuments of Brno], Prague 1928, p. 12.

39 Václav Richter, "Brno", *Časopis Matice moravské*, LX/2 (1936), pp. 293—314, esp. p. 299.

40 Dostál, *Umělecké* (n. 38), esp. pp. 26, 54, 141, 142, 145, 151.

41 Cecilie Hálová-Jahodová, *Brno, stavební a umělecký vývoj města* [Brno, building and artistic development of the city], Prague 1947, p. 60.

C. HÁLOVÁ-JAHODOVÁ

BRNO

STAVEBNÍ A UMĚLECKÝ VÝVOJ MĚSTA
СТРОИТЕЛЬНОЕ И ХУДОЖЕСТВЕННОЕ РАЗВИТИЕ ГОРОДА
BUILDING AND ARTISTIC DEVELOPMENT OF THE TOWN
ÉDIFICATION ET DÉVELOPPEMENT ARTISTIQUE DE LA VILLE

1947

PRAŽSKÉ NAKLADATELSTVÍ V. POLÁČKA

|06| ↑ Title page,
Cecilie
Hálová-Jahodová,
*Brno, stavební
a umělecký vývoj
města*, Prague 1947

This is again a mirroring of Bertold Bertholz's writing, as he did the same in 1911, but concluding that German burghers were dominant.[42] However, Hálová-Jahodová is excessively polemical in stating that "Brno's Germans had no respect for the city traditions. They never got used to them, for they have always lived in an enclave amongst us, and remains strangers here, living by their own anaemic and derived culture".[43] This harsh and untruthful sentence says little about the Germans of Brno, but much about Czechs and about the atmosphere after the Second World War — one that lead to the expelling of Germans from Czechoslovakia.

However, looking closely at the passages about medieval art in the books of Dostál and Hálová-Jahodová, we can see that they are written according to a principle of supposed objectivity, and thus only rarely indicate something like a national character of art.[44] In this sense, they are similar to the above-mentioned works of August Prokop. It is not coincidental that both Dostál and Hálová-Jahodová quote their older German colleagues. And although the German image of Brno is now gone — as a kind of dead branch of historiography — the German authors mentioned are still referenced. For the field of art history, this include August Prokop and his comprehensive work about Moravia, but also Karl F. Kühn, who, among other works, carried out precise excavations and drawings of medieval relics on the Špilberk Castle in the 1940s. Present art historians are still dealing with them, and still endeavour to expand on their works and correct possible mistakes.

These two sides of the coin form the two images of the medieval town in Czech and German historiography. It must be noted, closing this paragraph, that a similar division between Czech and German Brno was also already in use in the 1920s, e.g., in the foreword of the promotional book *Zemské hlavní město Brno* [The land capital city of Brno] (1928) by the mayor of the city Karel Tomeš (1877–1945).[45]

ARTISTIC REFLECTIONS

The past of the city is still reflected by various means in our present. In some examples, I will try to introduce how and what kind of reflections of the Middle Ages can be seen in Brno today. The neologism "re-medievalization" could be used here, although it is mainly used to describe nineteenth-century Gothic revival transformations of churches and castles.[46] In this paper, the term

42 Bretholz, *Geschichte* (n. 16), pp. 334–340. There is also a present-day study of this topic, see Veronika Němcová, "Česká a německá jména obyvatel Brna zaznamenaná v berních rejstřících z roku 1348, 1387 a 1432" [Czech and German names of the inhabitants of Brno recorded in the tax records of 1348, 1387 and 1432], *Brno v minulosti a dnes*, XVII (2003), pp. 97–111.

43 "[...] zaniklo mnoho památek zcela zbytečně, bez piety k tradici města. Brněnští Němci ji neznali. Nikdy se s naším prostředím nesžili, věčně mezi námi tvořili enklávu a zůstali u nás cizinci, žijícími vlastní nedokrevnou, odvozenou kulturou", Hálová-Jahodová, *Brno* (n. 41), p. 330.

44 For example, when Dostál wrote about the church library at St Jacob's, he puts some of the manuscripts in the line of "development of Czech illuminations". But it is uncertain whether he meant it nationally as Czech, or territorially as from Czech lands. Dostál, *Umělecké* (n. 38), p. 158. Likewise for Hálová-Jahodová, *Brno* (n. 41), p. 82, but she mostly used the neutral label of "art of Brno".

45 Karel Tomeš, "Úvod", in *Zemské* (n. 33), pp. 9–10.

46 For example in connection with the Tower of London, see Geoffrey Parnell, *Book of the Tower of London*, London 1993.

is however taken in a broader sense. In my point of view, "re-medievalization" is when the Middle Ages are recalled in some way within the urban space or in individual buildings. Less directly, it can be also when a street in Brno is named Joštova — after Jobst of the House of Luxembourg, the last independent Moravian Margrave at the beginning of the fifteenth century and also a Roman king, buried at the nearby church of St Thomas. This particular "re-medievalization" as a type of memorial is even stronger because Jobst is represented by two statues on the Moravian square, one baroque and one contemporary. "Re-medievalization" is also the attempt of stylistic completion of space, as it happened in 1906 at St Jacob's square, where the new houses were built by architects Maxim J. Monter and Germano Wanderley in Gothic revival style, thus creating a stylistic background for the real Gothic monument — the church. Thus, I believe that viewed in this way, "re-medievalization" could be a practical illustration of the outlined images of medieval Brno. I will demonstrate it in two examples.

The first example is the "Royal Chapel", founded by the Bohemian King Wenceslaus II, and built at the beginning of the fourteenth century |07|.[47] It was a rather unique Gothic space, with the vault carried by a single central pillar. But in 1904, when most of the city center was developed and modernized, local authorities wanted to demolish it. Some experts like the local architect Ferdinand Hrach or above-mentioned historian Bertold Bretholz, as well as Viennese figures such as the professor of art history Alois Riegl or Josef Helfert, director of the Austrian monument commission, protested against this plan. They had strong arguments about the historic and artistic value of the chapel. But the authorities insisted and the chapel was torn down in 1908. The story of the demolition of this monument is the story of a struggle

between experts and city authorities — and both were Germans. At that time, Czechs in Brno expressed no interest in the case. But the situation changed after the formation of Czechoslovakia in 1918, when the Czechs took political power in the city. First, in 1919, the main Czech newspaper *Lidové noviny* [The People's Newspaper] stated that the chapel was destroyed in order to erase the Czech history of Brno. Jan Tenora then wrote an extensive article about the chapel in 1932, stating that the authorities had demolished it because of its dedication to Cyril and Methodius — patron saints of the Slavs.[48] This opinion was shared also by Cecilie Hálová-Jahodová in 1947. She wrote that the chapel had been destroyed because of its dedication to Czech national saint, Wenceslaus.[49] In my opinion, these statements are attempts to remedy the earlier lack of interest in the monument, but also to put the blame on the Germans by highlighting how badly they had managed the city.

Nevertheless, it must be noted that in the end the chapel was taken apart and removed, but not destroyed. The valuable pieces of masonry (such as ribs, columns, moldings, traceries etc.) were preserved, and in 1908 the city authorities promised the chapel would be built again in some form. This has still not happened. In not so distant past, there were however two interesting efforts of

47 Most recently with bibliography, see Jana Severinová, Karel Severin, "Královská kaple v Brně" [The Royal Chapel in Brno], *Brno v minulosti a dnes*, XIX (2006), pp. 295—350; Věra Šlancarová, Rudolf Procházka, "Stavební vývoj a projevy umění" [Building development and art expressions], in *Dějiny*, 2014 (n. 2), pp. 779—811, esp. pp. 794—797.

48 Jan Tenora, "Kaple sv. Cyrila a Metoděje v Brně. Její zrušení a zboření" [Chapel of Sts Cyril and Methodius in Brno. Its abolition and demolition], *Hlídka*, XLIX/1, 2, 3, 4, 5 (1932), pp. 1—8, 37—45, 73—81, 113—133, 149—156.

49 Hálová-Jahodová, *Brno* (n. 41), p. 44.

architect Petr Hrůša. The first (2009) is somewhat bizarre. Hrůša proposed to place the chapel on the roof of a car park in the city center — not as a sacred space, but as one for culture and exhibitions.[50] The second attempt, by the same architect (2011), proposed to return the chapel to its original place at the corner of the Dominican square — not in the original way, but covered by the modernistic outer envelope of a white cube.[51] Again, it was planned not as a sacred space, but as a kind of spiritual and cultural center. This case shows how nowadays very little is sufficient for the restoration of a medieval monument — neither place, nor original form, nor even original function are needed. What is also interesting is that, to a certain point, national struggles faded away and the authorities today feel continuation with their German predecessors from 1908 in wanting to fulfil the old promise (and improve their own image before elections).

The second great example of "re-medievalization" is the Špilberk Castle.[52] Over the centuries, the complex lost its medieval look almost entirely, mainly in the seventeenth and eighteenth century, when it was rebuilt as a baroque citadel with a bastion layout. When the castle was transformed into military barracks for the Wehrmacht and to a prison for opponents of the Nazi regime during the occupation of Czechoslovakia in 1939, it was rebuilt as the symbolic Germanic fortress, the so-called *Adlerhorst*, in the style of Nazi historicism.[53] To support this transformation, art historian and director of Moravian Heritage Institute Karl F. Kühn, who made archaeological surveys, put forward the hypothesis that the castle had originally been a palace (*Pfalz*) from the times of Friedrich Barbarossa in the twelfth century. Therefore, the baroque chapel of the castle was changed into a celebration hall and memorial for German soldiers; some new sgraffiti, all based on the symbolism of chivalry, as

well as newly sculpted or painted coats of arms mostly representing the imperial eagle were made on the façades. Many other changes were carried out in the interior as well as the exterior of the castle, under the direct supervision of Karl F. Kühn and architect Herber Neubert — three inner staircases |08|, restoration of the bastion in the south wall, a new low wall with castle loopholes on the southern terrace, etc. The aim of the solid and cold style of this architecture was to transform the Špilberk from baroque fortress back to knight's castle, now inhabited by modern knights — the soldiers of the Wehrmacht. In this sense, this transformation has a similar symbolic meaning like for example the Italian royal and then fascist reconstruction of the Palace of the Grand Master of the Knights of Rhodes in the years 1937—1940.

But the story of Špilberk does not end with the Nazis. From 1994 to 2000, the walls of the east wing were increased by circa three meters, opened by new pointed

50 Hana Fasurová, "Kaple na střeše: odborníci jsou proti" [Chapel on the roof: experts are against], *Brněnský deník.cz*, 11. 8. 2009, [online: https://brnensky.denik.cz/zpravy_region/kaple-na-strese-odbornici-jsou-proti20090810.html, last accessed 25.3.2019].

51 Barbora Lukšová, "Před sto lety rozebrali u náměstí kapli, nyní má šanci se tam vrátit" [A century ago, the chapel was dismantled at the square, now it has a chance to return there], *iDNES.cz*, 16. 7. 2001, [online: https://www.idnes.cz/brno/zpravy/pred-sto-lety-rozebrali-u-namesti-kapli-nyni-ma-sanci-se-tam-vratit.A110713_1617449_brno-zpravy_mav, last accessed 25.3.2019].

52 Most recently with bibliography, see Miroslav Plaček, "Brněnský hrad (Špilberk)" [The Brno castle (Špilberk)], in *Dějiny*, 2014 (n. 2), pp. 615—623; Jiří Vaněk, "Hrad Špilberk" [Špilberk Castle], in *Dějiny Brna 7. Uměleckohistorické památky. Historické jádro* [History of Brno 7. Art-historical monuments. City centre], Jiří Kroupa ed., Brno 2015, pp. 117—192.

53 Petr Kroupa, "Špilberk — stavební úpravy za 2. světové války" [Špilberk — construction work during World War II], *Forum Brunense*, III (1990), pp. 95—106; Alexandr Brummer, Michal Konečný, *Brno nacistické* [Nazi Brno], Brno 2013, pp. 74—75.

arched windows, and covered by a new pitched roof eight meters high that changed the whole silhouette of the castle, as well as the panorama of the entire city |09|. The inner space was very freely changed to the so-called Přemyslid Royal Chapel and remade on the basis of very few original Gothic elements.[54] This reconstruction was widely debated by experts. Many of them were critical,[55] seeing it as a step backwards, a destruction of baroque shapes of the castle and the "making of a dream about Gothic architecture of the thirteenth century".[56] On the other hand, the new form is supposed to be a free remembrance of the Gothic period and the Moravian Margrave, later Bohemian King Přemysl Otakar II (Ottokar II of

54 See Zdeněk Chudárek, "Příprava a metoda obnovy východního křídla hradu Špilberk v letech 1985 až 2000" [Preparation and method of restoration of the eastern wing of Špilberk Castle from 1985 to 2000], in *Znovuzrození hradu. Prezentační publikace stavební společnosti Tocháček, s.r.o., Brno* [The rebirth of the castle. Presentation publication of the Tocháček building company], Brno 2000, pp. 15—37.

55 E.g., Miroslav Plaček, *Hrady a zámky na Moravě a ve Slezsku* [Castles in Moravia and Silesia], Prague 1996, p. 332; Karel Kuča, *Brno: Vývoj města, předměstí a připojených vesnic* [Brno: Development of the city, suburbs and connected villages], Brno 2000, p. 16; see also Tereza Štefaňáková, *Rekonstrukce architektonických památek v historickém centru Brna po roce 1989* [Reconstruction of architectural monuments in the historical center of Brno after 1989], B.A. thesis, Masaryk University, Brno 2008, pp. 14—17. Conciliatory in their opinions are Martin Horáček, *Za krásnější svět* [Toward a more beautiful world], Brno 2013, pp. 309—310 and Mojmír Kyselka, "Váš názor: Čtyři problematické brněnské památkové rekonstrukce" [Your opinion: Four problematic reconstructions in Brno], *Události na VUT v Brně*, XV/11 (2005), pp. 18—19.

56 "[...] *vytváření snu o gotice třináctého století* [...]", This was said by the former director of Brno city museum (of which the seat is at Špilbek) Jiří Vaněk, see Jan Doubravnický, "Špilberk: účelná dostavba, nebo hnus?" [Špilberk: effective completion or disgust?], *Cestování Idnes.cz*, 2. 2. 2007, [online: https://www.idnes.cz/cestovani/po-cesku/spilberk-ucelna-dostavba-nebo-hnus.A070125_164342_igcechy_tom, last accessed 25. 3. 2019].

|08| ↖ Staircase in the west wing, Špilberk Castle, Brno 1939—1941

|09| ← New gothic-like shape of East wing, Špilberk Castle, Brno 1995—2000

Bohemia), founder of the castle. The preservationist and author of the reconstruction Zdeněk Chudárek, said in a newspaper interview that "it is necessary to rehabilitate the monument in its Gothic shape and take away its stigma of the main prison of the Austrian monarchy and of the Nazi regime".[57] The director of the Czech Heritage Institute and expert on Gothic architecture, Dobroslav Líbal (1911–2002), also stated in 1964 and again in 2000 that the Špilberk had to be "de-Nazified".[58] So, the conversion of the castle (no matter how problematic from the position of heritage conservation) had a similar basis as in the Nazi times: the remembrance of a glorious past and the direct denial of the parts of history which are not suitable. I find this resemblance of arguments fascinating as the last offshoot of the mirroring of German and Czech attitudes towards the history of Brno.

57 "[...] je nutné rehabilitovat památku v její gotické podobě a odejmout jí nálepku žaláře rakouské monarchie a nacistického vězení.", IR, ČTK, "Přestane být Špilberk památkou?" [Špilberk ceases to be a monument?], *Lidové noviny*, IX/171 (24. 7. 1996), p. 10.
58 Dobroslav Líbal, "Úvodní slovo Dr. Líbala k rekonstrukci východního křídla hradu Špilberk" [Introduction by Dr. Líbal about the reconstruction of the eastern wing of Špilberk Castle], in *Znovuzrození* (n. 54), pp. 13–14.

INDEX OF NAMES

193

INDEX OF PLACES

→ *Index by Ruben Campini, Elena Martellotta,*
Annalisa Moraschi, Adrien Palladino, Nicolas Samaretz.

COPYRIGHT RULES

PHOTOGRAPHIC CREDITS

Porträtarchiv, Deutsches Kunstarchiv im Germanischen Nationalmuseum; **05**, **07**: from *Die Hohe Straße: Schlesische Jahrbücher für deutsche Art und Kunst in Ostraum*, vol. 1, Gustav Barthel ed., Wroclaw 1938; **06**: from Theodor Brückler, "Die Österreichische Denkmalpflege 1945—1947: 'Resurrectio' oder 'Reanimatio?'", *Österreichische Zeitschrift für Kunst und Denkmalpflege*, LVIII/3—4 (2004), pp. 390—443, p. 416; **08**: from Tadeusz Dobrowolski, *Sztuka na Śląsku*, Katowice/Wroclaw 1948; **09**: © Jiří Kroupa, Department of Art History, Masaryk University, Brno; **10**: © Instytut Historii Sztuki UAM, Poznań; **11**: from Alicja Karłowska-Kamzowa, *Malarstwo śląskie 1250—1450*, Wroclaw/Warsaw/Krakow/Gdansk 1979; **12**: © National Museum, Wroclaw.

PALLADINO—ROSENBERGOVÁ → **01**: © photo Adrien Palladino; **02**: from August Prokop, *Die Markgrafschaft Mähren in kunstgeschichtlicher Beziehung*, Vienna 1904, fig. 846, p. 589; **03**: from Kathryn Brush, *The Shaping of Art History. Wilhelm Vöge, Adolph Goldschmidt, and the study of Medieval Art*, Cambridge 1996, fig. 1 p. 6; **04**, **05**, **06**: from Karl Oettinger, *Anton Pilgram und die Bildhauer von St. Stephan*, Vienna 1951, fig. 31 and fig. 46; **07**, **08**: from Otto Benesch, "Zwei unerkannte Werke von Anton Pilgram", *Jahrburch der Berliner Museen*, 1 (1959), pp. 198—217, fig. 10, p. 206; **09**: from *Sborník prací filosofické fakulty brněnské university*, XVII 1968: **10**: scan of book cover of Eugen Dostál, *Umělecké památky Brna*, Prague 1928.

GALETA → **01**: from Heinrich Kirchmayr, *Der altdeutsche Volksstamm der Quaden*, Brno 1888; **02**: from Bertold Bretholz, *Geschichte der Stadt Brünn I*, Brno 1911; **03**; from Gustav Trautenberger, *Chronik der Landeshauptstadt Brünn*, Brno 1891; **04**: from August Prokop, *Die Markgrafschaft Mähren in kunstgeschichtlicher beziehung*, Vienna 1904; **05**: from Eugen Dostál, *Umělecké památky Brna*, Prague 1928; **06**: from Cecilie Hálová-Jahodová, *Brno, stavební a umělecký vývoj města*, Prague 1947; **07**: © Brno City Archive, U5 Ic2; **08**, **09**: © photo Jan Galeta.

PARVA Convivia 6

Inventing Medieval Czecho~ slovakia 1918—1968

Between Slavs, Germans, and Totalitarian Regimes

Ivan Foletti — Adrien Palladino eds

Printed and binded by Quatro Print, a. s., Heršpická 6, 63900 Brno on the paper Fuego Matt Natural 285 g/m² and Amber Volume 90 g/m². Design and typesetting is done with use of the typefaces Kitsch and Kitsch Text.

First edition, Brno—Roma 2019, 200 pages.
Number of copies: 500.

info@earlymedievalstudies.com
info@viella.it

www.earlymedievalstudies.com
www.press.muni.cz
www.viella.it